English Architecture

A concise history

RIVERSIDE CITY COLLEGE
LIBRARY
Riverside, California

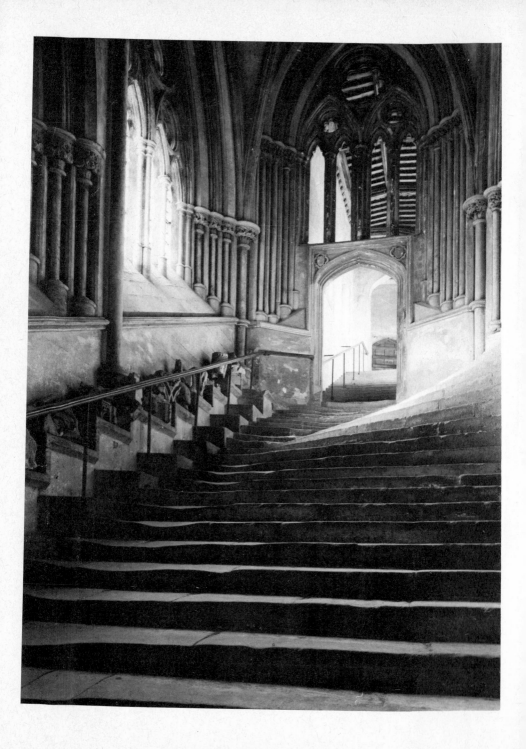

DAVID WATKIN

English Architecture

A concise history

NEW YORK AND TORONTO

OXFORD UNIVERSITY PRESS

1979

Frontispiece: stairs leading to the chapter house of Wells Cathedral,
c.1270

Library of Congress Cataloging in Publication Data
Watkin, David, 1941–
 English architecture.

 (World of art series)
Bibliography: p.
 Includes index.
 1. Architecture — England — History. I. Title.
NA961.W37 1979 720'.942 79–4409
ISBN 0–19–520147–7
ISBN 0–19–520148–5 pbk.

Printed in Great Britain by Jarrold and Sons Ltd, Norwich

CONTENTS

Preliminary Note

ANY ATTEMPT TO GIVE a balanced account of the major masterpieces of English architecture within the compass of a single book must inevitably leave out certain categories of building. Apart from omitting Scotland, Ireland and Wales, this book does not cover the architecture of industry, transport or engineering, or the history of vernacular architecture or town planning. The omission of vernacular architecture is a matter of special regret, since the modest Georgian houses found in most English towns, and the cottages and farmhouses in the villages and countryside, undoubtedly form one of the most attractive aspects of the English heritage of building. However, the emphasis of this book is on the high points of English creative genius as expressed in the noble art of architecture.

A further word of warning concerns the high valuation which historians, especially those of art and architecture, put on *change*. This is partly a consequence of the Hegelian origins of art history, but also of the need to select a few incidents or monuments from almost countless examples. In his concern to write interesting history which appears to have a sequence, a plot or a purpose, the architectural historian is prompted to select buildings which seem to point forward to the next stylistic development. Though a convenient technique for writing history, this may well create a false picture of the past, since many people tend to regard change as a disruptive and unsettling rather than as a beneficent influence. Buildings are thus frequently commissioned not in order to look different from anything that has gone before, but in order to resemble something seen and admired. Especially was this so in the Middle Ages where we find orders for new buildings that are to be copied, down to precise measurements, from existing buildings elsewhere.

I am grateful to Dr Paul Crossley and Dr Richard Gem for their comments on the first draft of Chapters 1 to 3.

D.J.W.
Peterhouse, Cambridge, September 1978

1

Anglo-Saxon and Norman Architecture

Pre-Conquest building

IT IS NO DOUBT UNFAIR to judge a remote civilization by the few haphazard remains that have survived, but since this book is centred on buildings that people can actually see today, pre-Conquest architecture will have to play little part in it. In many respects Anglo-Saxon culture was one of extreme richness, as we can immediately appreciate by looking at seventh-century sculpture and painting from the north of England, like the Bewcastle cross and the Gospel Books of Durrow and Lindisfarne. The tradition reflected in this art is that of Celtic Christianity, which had been imported via Iona from Ireland by St Columba and St Aidan in the later sixth and early seventh centuries – stylistically a combination of the local dense abstract patterning with influences from Roman sculpture and possibly mosaic. Architecturally it was disappointing, producing mainly rather modest timber churches. The most interesting survivals are a group of churches which represent a grafting of Italo-Gallic traditions on to this early Christian stem: the crypts of two churches built by St Wilfred (c. 709) at Hexham in Northumberland and at Ripon in North Yorkshire, and three churches in the north-east, Monkwearmouth, Jarrow and Escomb. None of them is visually impressive.

Further south, the classical influence is much stronger and we find at least one building on a major scale, the church of Brixworth, Northamptonshire. Possibly dating from the eighth century, Brixworth may have been built for the Benedictine monks from the nearby abbey of Peterborough, although the connection has not been established. It represents the importation to England of a Mediterranean or Gaulish type of architecture by the Catholic missionaries who came from Rome under St Augustine at the end of the sixth century. A nave with clerestory windows leads to a presbytery of the same width terminated by a small polygonal apse. Originally there were arcades on each side of the nave, opening into aisles, so that the church was close in type to an early Christian basilica, but the aisles have been demolished and the arcades bricked in. A tall screen of three arches between nave and presbytery and a two-storey porch at the west end have also been destroyed.

The earliest phase of this style is represented by a group of about eight churches in Kent and Essex, of which the most striking was St Peter and St Paul in Canterbury, founded by St Augustine himself in c. 600. One of the surviving fragments from this group is the simple mid-seventh-century nave of St Peter-on-the-Wall at Bradwell-juxta-Mare, Essex.

Monkwearmouth church, co. Durham, the west tower

Brixworth church, Northants., from the south-west

Brixworth, interior looking west; the arches, now closed, originally led into aisles

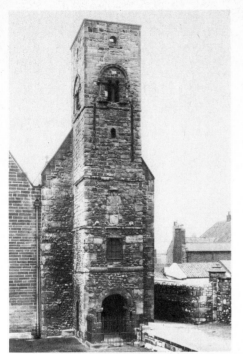

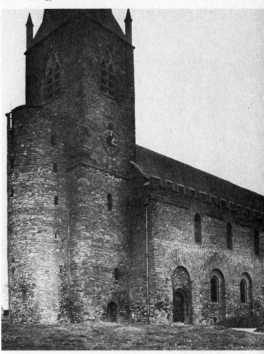

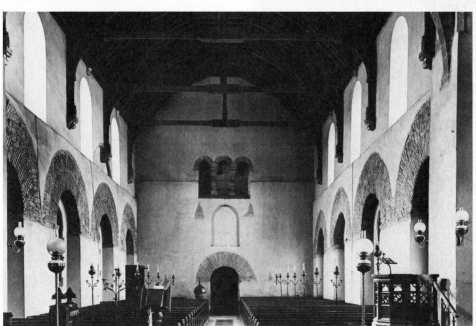

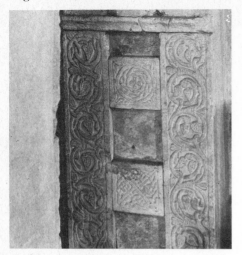

Scrolls on the north arch of St Peter, Britford, Wilts.

St Mary, Deerhurst, Glos., interior of the west wall

Italo-Gallic influences remain predominant in eighth- and early ninth-century architecture, as, for example, in St Peter, Britford, Wiltshire (possibly early ninth century). This is memorable for the low arches that lead from the nave into north and south porches. The north arch is carved with a fine pattern of repeated foliated scrolls.

The Carolingian Renaissance, following Charlemagne's coronation in Rome in 800 as Emperor of the West, emphasized antique Rome as both a political and an artistic model. The ideal Carolingian monastic church in France and the Empire would have towers and transepts at both the east and west ends with subsidiary buildings grouped round a court or cloister. This noble tradition seems to have had little immediate effect in England, but during the monastic revival of the late tenth and early eleventh centuries aspects of this architectural arrangement were imitated at Ely and Durham (both known from documents), at Winchester (known

from excavations), at Canterbury, at St Mary, Dover, at St Lawrence, Bradford-on-Avon, Wiltshire, with its high narrow proportions, and at St Mary, Deerhurst, Gloucestershire. The blankness and lack of sophistication which characterize buildings like that at Deerhurst suggest that the special gifts of the Anglo-Saxons may have lain in decoration rather than in architecture.

Towers are the most striking survival from tenth and eleventh-century church buildings, for example at Deerhurst, Clapham in Bedfordshire, Barnack and Earls Barton in Northamptonshire, and Barton-upon-Humber, Humberside. The last three are especially well known for their prominent decoration with 'long and short work'. This ornamental use of pilaster strips seems to be at the same time a reflection of indigenous timber-frame buildings and also of a more sophisticated tradition imported from Carolingian Germany and remotely based on antique Roman architecture itself.

Major monuments of the mid-eleventh century include the important towered cathedrals at Sherborne, Dorset, and North Elmham, Norfolk, and the church of St Mary at Stow, Lincolnshire, where we can still see the impressive crossing with arches, 36 feet (11 metres) high, opening into the transepts, nave and chancel. One of the most interesting buildings of this period must have been the rotunda at St Augustine's Abbey, Canterbury. This was begun (though never completed) by Abbot Wulfric as a link between the two existing churches of St Mary and of St Peter and St Paul. The rotunda, octagonal outside, circular inside, was important, first as evidence of a concern to make a single unified building out of a number of small early sanctuaries,

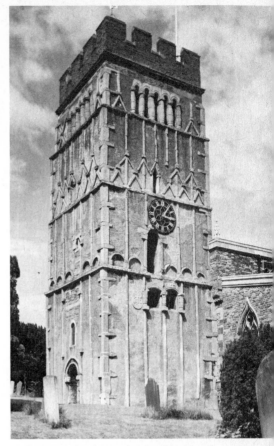

Earls Barton church, Northants., the west tower

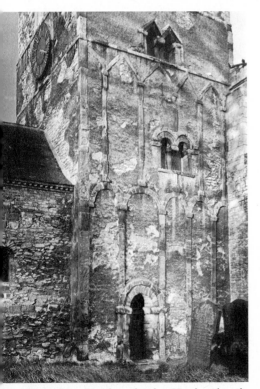

Barton-upon-Humber church, Humberside, the west tower

and second as an example of Continental influence from the early-eleventh-century rotunda of St Bénigne at Dijon, a building which itself recalls Charlemagne's Palatine Chapel at Aachen of 792–805, as well as the fourth-century Sta Costanza in Rome.

The beginnings of the Romanesque style, or Norman as it is often known in England, may be conveniently traced in the following three varied buildings: the churches at Langford in Oxfordshire and Sompting in West Sussex, which may date from the time of Edward the Confessor or

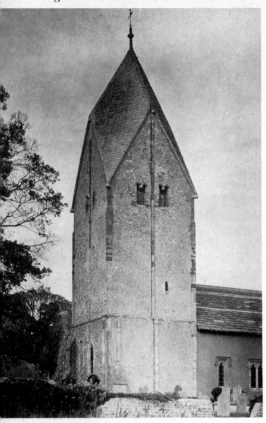

Sompting church, Sussex, the west tower

southern Italy. The Confessor's mother, Emma, was herself a Norman and her son spent his first twenty-five years in exile in Normandy. His long residence there before assuming the English crown explains not only his readiness to fill the high offices of the church with men imported from Normandy and Lower Lorraine but also his decision to model his great church of Westminster Abbey (1045–50) on Jumièges Abbey (1037–66). The huge scale and solidity of churches like Jumièges represent powerfully that notion of the Church Militant as the instrument of the state which the Duke of Normandy had borrowed from Ottonian Germany. The face of England was now to be transformed by buildings conceived in this spirit by William the Conqueror after 1066. But the style he chose had already been adopted at Edward the Confessor's Westminster.

The 1070s and 1080s saw monumental building at the cathedrals of Canterbury, Winchester and Lincoln, and the Benedictine abbey churches of St Albans, Ely and Worcester. The first Norman archbishop of Canterbury, Lanfranc, rebuilt his cathedral from 1070 to 1077. Although little of this now survives, it is clear that it was very closely based on St Etienne at Caen, of which he had been abbot. St Etienne was founded by the Conqueror himself in 1064–66 and was finished by 1077. Winchester was really the joint capital of England with London, and the Conqueror was crowned in both cities. His kinsman, Bishop Walkelin, was the first Norman bishop of Winchester and he began rebuilding the cathedral in 1079. We can appreciate the quality of his work from the two surviving transept arms. What immediately distinguishes all these churches from pre-Conquest buildings is the 'thick-wall' technique imported from such work in Normandy as St Etienne. This technique can be seen, for example, in the nave at St Albans and, more stylishly, in the Winchester transepts with their division into three roughly equal arcaded storeys, articulated with wall-shafts. The

just after, and the Confessor's Westminster Abbey. St Matthew, Langford, has a central tower with twin coupled bell-openings on all four sides, and the tower at Sompting has the famous cap with a pyramidal form of Rhineland origin.

The impact of the Normans

With the accession of the penultimate Saxon king, St Edward the Confessor (reigned 1042–66), comes the beginning of a definite change. It was during his lifetime that the Normans became the dominant power in Europe through their crusades and their conquests of Sicily and most of

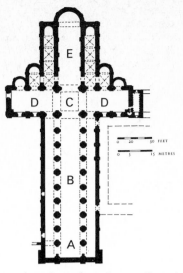

St Albans, plan: A west front; B nave; C crossing; D transepts; E choir

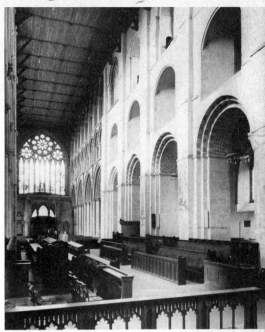

St Albans Abbey, Herts., the nave looking west. The western half is thirteenth century and the west window a nineteenth-century replacement

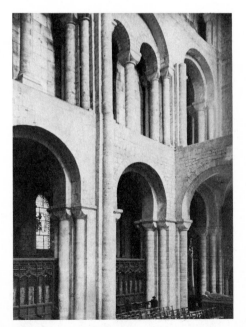

Winchester Cathedral, interior of north transept

top storey contains the clerestory windows with a narrow passage passing in front of them, while the central storey contains huge galleries beneath which run the ground-floor aisles.

Bishop Walkelin's brother, Abbot Simeon, began rebuilding the Benedictine abbey church at Ely in 1083. The transepts, stylistically close to those at Winchester, may date from soon after this time, but the nave and elaborate west end were not built until the early twelfth century. The great nave of Ely, with its thirteen bays compared with the eight of Jumièges, still overpowers us today by its size and grandeur even though we are used to the enormous size of modern buildings. How much more overwhelming must it have seemed in the twelfth century! To appreciate it fully we must forget its present emptiness and imagine it full of the richness of Catholic worship: there would

13

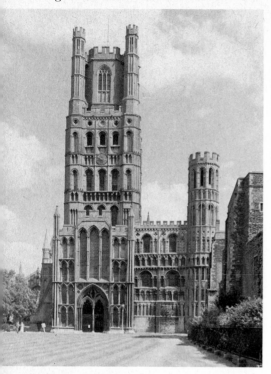

Ely Cathedral, the west front. A north-west transept, now destroyed, originally balanced the south

about 1200. Much of the projecting porch is mid-thirteenth century while the upper stages of the central tower are late fourteenth century. In contemplating this great western front we have moved some way from the Norman period. However, the complex tiers of varied blank arcading which characterize the Early English style of *c.* 1200 at Ely or at Castle Acre Priory, Norfolk, can in a sense be seen as a development from the rich linear patterns which the designer of the early-twelfth-century nave at Ely had built up from the increasingly plastic articulation of his wall surfaces. The growth of this kind of pattern is characteristic of later Norman or Romanesque architecture in England. It sets it apart from its austere origins in Normandy and has sometimes been seen as evidence of the continuing vitality of the Anglo-Saxon decorative tradition. Norwich, begun in 1096, and Peterborough,

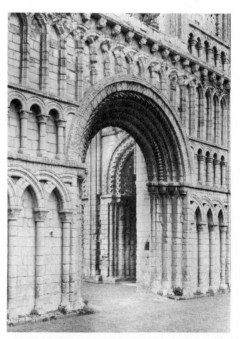

Castle Acre Priory, Norfolk, the west front

be several small side altars with enclosing screens and, rising almost to the cap of the arcade three bays west of the crossing, a great stone screen separating the monks' choir, with its sonorous chanting, from the body of the church.

The extraordinary west end of Ely, with its transepts to north and south (the former now destroyed) and its tremendous central tower, may have its immediate origin in Bury St Edmunds, but it is ultimately derived from churches in the territory of the Empire ruled by Charlemagne's successors in north-eastern France, the Low Countries and, especially, western Germany. The dating of this work at Ely remains uncertain, though it seems that it proceeded through the twelfth century until the west tower was completed in

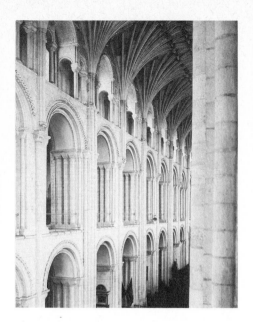

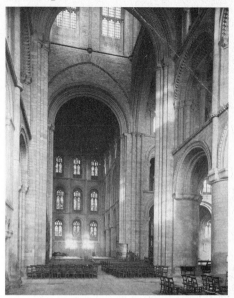

begun in 1118, develop this particular tradition into what has sometimes been called the 'second generation' Norman style.

Norwich combines an apsed east end and ambulatory with what we can begin to recognize as a characteristically English feature, a nave of great length – fourteen bays. The principal nave piers now have as many as sixteen shafts and the arches are adorned with billet-mouldings and chevron ornaments – those zigzag patterns which dominate Norman architecture from about 1115 onwards. There is also a circular pier at Norwich ornamented with powerful spiral grooves of a type initiated at Durham, which will be examined later. Peterborough continues this overall richness of effect and the growing indifference to the kind of structural logic found in Normandy.

One of the finest survivals from the early period is the crypt of the choir built at Canterbury Cathedral by St Anselm between 1096 and 1130. With its high groin vaults and its two rows of twenty-two columns with their splendid figured capitals, this was the largest crypt in

Norwich Cathedral, the nave; the vault is an addition of the fifteenth century (above left)

Peterborough Cathedral, the crossing looking north; tracery in the windows is a later addition

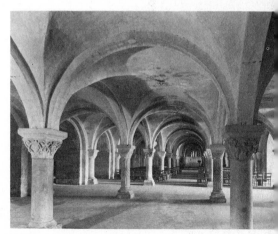

Canterbury Cathedral, the crypt

England at the time. The choir which it supported had two pairs of transepts like the exactly contemporary third abbey church at Cluny in France. Though the choir was damaged by fire in 1174 and largely rebuilt we can still see some of its rich ornament on the exterior of the south-east transept with its interesting billet-moulded arches. It is also a characteristic example of the fact that in twelfth-century Norman architecture in England there was not necessarily any sense of conflict between housing in a wooden-roofed building such rich and sophisticated decoration as stained glass, stone sculpture, marble pavements and wall paintings.

Tewkesbury and the West Country school

Exciting variants are found in the design of the west fronts of Lincoln and Tewkesbury. At Lincoln, begun in *c.* 1090, we have a kind of Roman triumphal arch with a brooding power that dominates later additions to the west front from the mid-twelfth to the fourteenth century. At the Benedictine Tewkesbury Abbey, built during the first half of the twelfth century, there is a similar triumphant expression of the sculptural power of a huge round-headed entrance arch. At Tewkesbury also we have one of the most massive of all Norman towers as well as a nave, possibly complete by 1121, dominated by colossal cylindrical columns for which there is no precedent in Anglo-Saxon or Norman architecture. This is radically different from the 'Roman aqueduct effect' produced by the unsubdivided gallery openings that derive from St Etienne at Caen. This form can still be seen at the very end of the eleventh century at Norwich Cathedral and at the priory churches of Blyth, Nottinghamshire, Binham, Norfolk, and Colchester, where the massive arcuated naves inevitably recall antique Roman architecture such as the Pont du Gard at Nîmes.

In fact, Tewkesbury forms part of a recognizable West Country school to-

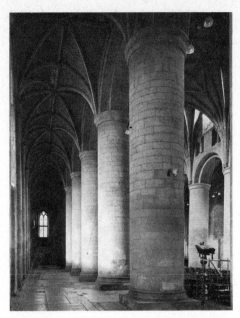

Tewkesbury Abbey, Glos., the south aisle looking west

gether with Evesham, Pershore, Hereford and Gloucester. The row of massive drum-piers which lines majestically the naves at Tewkesbury and Gloucester rises two storeys to the full height of aisles and tribune gallery combined: a kind of 'Giant Order', to use the classical term. Indeed, the effect which can still be appreciated in the transepts at Tewkesbury is perhaps not so distant from the early-fourth-century basilica at Trier, the prosperous Gallo-Roman city on the Moselle, which makes similar use of giant arches to link two storeys. The west of England was in especially close touch through its clergy with the Continent so that it would not be surprising to find architectural links with, say, Burgundy and the Rhineland. Appreciation of the antique at this time must not

Lincoln Cathedral, the west front; the five arched openings represent the original structure of c. 1090; sides, upper parts, and towers added later

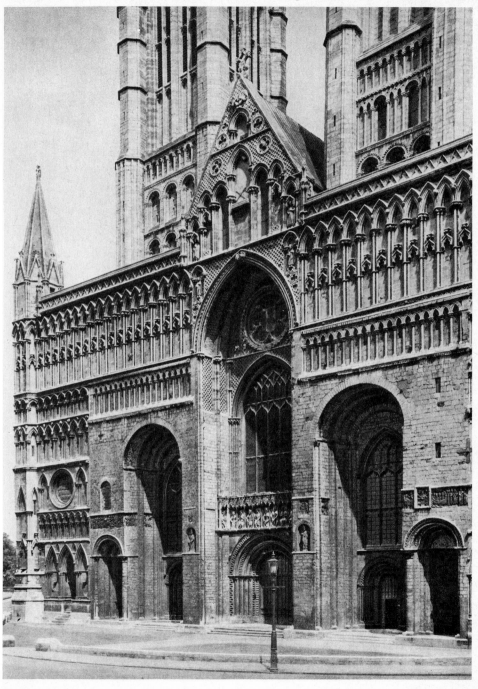

be ignored. A specific instance of an English patron caught up in enthusiasm for ancient Rome is afforded by Henry of Blois, brother of King Stephen, Bishop of Winchester and Abbot of Glastonbury, who brought home from Rome in 1151 a number of antique statues.

Durham

It is time we looked at what is probably justly regarded as the finest Norman building in England and, in some ways, the most important building of its date in Europe, Durham Cathedral. The ecclesiastical and political status of the County Palatine of Durham was unique in England. Indeed, the mitre of the Bishop of Durham is unique in that it is to this day represented heraldically with the rim encircled by a ducal coronet, indicative of temporal power. Here he had his own

parliament and his own army; here on his magnificently set acropolis he guarded the relics of the great St Cuthbert and, somewhat distantly, the border with Scotland. Here, too, by an often repeated English anomaly, unfamiliar on the Continent, his cathedral was also the abbey church of a Benedictine monastery. The other cathedrals of which this was the case until the Reformation are Canterbury, Winchester, Ely, Norwich, Rochester, Worcester, Bath and Coventry.

The foundation stone of the new church was laid in 1093 by its French Bishop, William of St Carileph (i.e. St Calais), who had been called to Durham by William the Conqueror in 1081. Work began at the east end where the choir was ready by 1104; the nave was started in 1099 and was complete by 1133. The handling of the nave has an authority and power which went beyond anything that had been seen

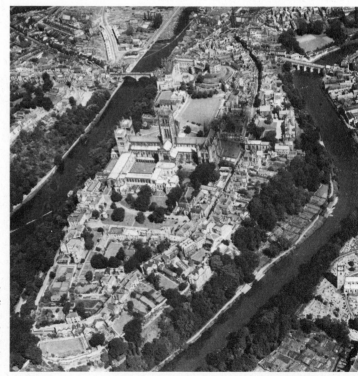

Durham from the south; the cathedral with its claustral buildings dominates the centre of the promontory formed by the River Wear, with the castle beyond.

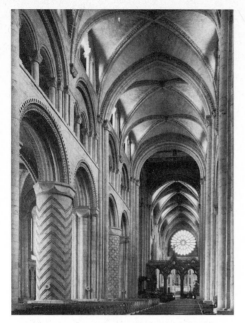

Durham, the nave looking east; the east rose window was rebuilt in the eighteenth century

logically out of the articulation of the walls. Until this time most English naves had flat ceilings like the remarkable painted canted ceiling of *c.* 1220 that survives at Peterborough. The roofing of a great space in stone that would be noble, enduring and fireproof was one of the ambitions, though not the chief one, of eleventh-century architects. Barrel vaults and the constructionally similar groin vaults were inappropriate for large-scale interiors since they involved masses of inert masonry resting heavily on solid walls. By conceiving the rib vault at the end of the eleventh century the master of Durham solved this problem as well as helping to make possible the constructional and aesthetic achievements of the whole of Gothic architecture. In some ways a rib vault is actually simpler to construct than a groin vault because once the ribs and the transverse arches have been erected on their own centring, the cells (or surfaces of the vaults) can be formed separately and with much less substantial masonry. This system is important for the development of Gothic architecture where the whole building becomes a kind of rib vault – or rib cage, as it were – in which the infilling between the apparently structural members is often of glass.

Late Norman variety

While at Durham we should look at the curious and beautiful narthex or galilee added at the west end, by Bishop Hugh de Puiset in *c.* 1170–75 to serve as a Lady chapel. In form it is inspired by the aisled narthexes of Burgundian or Cluniac churches with its five aisles divided by slender coupled columns. The dominant chevron patterns and the waterleaf foliage on the capitals, together with the diaper patterns and interlaced arches of the exterior, combine to create a rich and delicate mood which is characteristic of much late Norman work, but which is in striking contrast to the earlier work at Durham. Architectural sculpture was combined here, as in many Romanesque

until then, and it is worth remembering that it is later in date than the start of work at, for example, Canterbury, Ely, Worcester, St Albans, Lincoln, Winchester and Gloucester. The gallery and clerestory are less prominent features of the interior than in earlier churches. Instead, the tremendous arcade, high and massive, dominates the whole. The compound piers have wall-shafts projecting insistently into the nave while the alternate cylindrical piers are no less assertive with their vigorously incised zigzag and diamond patterns. Indeed, the overall patterning of Durham – not in the sense of superficial decoration but of a will to unify all parts of the structure in a linear web – has been seen as one of the principal ways in which it looked to the future.

The principal innovation at Durham, however, is the presence throughout the church of rib vaults which seem to grow

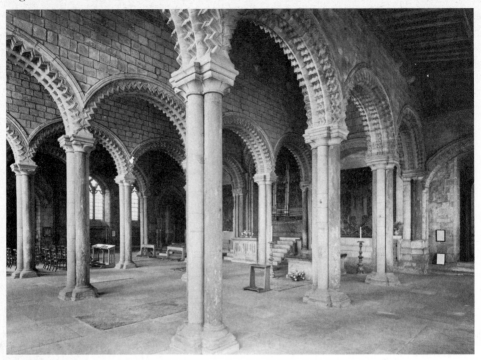

Durham, the galilee

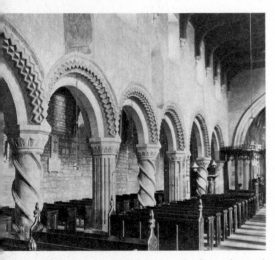

St Lawrence, Pittington, co. Durham, the north arcade

buildings, with monumental wall paintings of which some fragments survive. It was at this time that Bishop de Puiset gave an exuberant north arcade to the parish church of St Lawrence at Pittington in co. Durham. The alternate circular piers are wrapped round with a snaky spiral moulding that has an almost Baroque barley-sugar form.

Late Norman architecture is indeed a personal and in some ways rather 'Baroque' style. At St Frideswide's Priory, Oxford (now Christ Church Cathedral), the arcade is based on the giant columns of the Tewkesbury type; the triforium is not placed above them, however, as one would expect, but is oddly tucked between them. At another Augustinian house, Worksop (or Radford) Priory, Nottinghamshire, there is a similarly complex and unexpected internal elevation in which the tribune has a busy tripartite rhythm with a huge central arch

cutting right into the clerestory area. In the nave walls of St David's Cathedral, Dyfed, begun in 1180, a remarkable spatial effect is achieved. Two-storey window arches contain within them both the triforium and its passage, and a large clerestory passage.

Parish churches

On a smaller scale the parish church affords equally interesting and varied examples of Norman inventiveness and solidity. The powerful two-tiered tower of Castor church, Cambridgeshire, dates from *c.* 1120, while one of the best preserved parish churches is Iffley, near Oxford, of *c.* 1170–80, with its aisleless nave, central tower and chancel and its rich geometrical decoration. The exuberant sculpture of its south doorway contains figurative and abstract forms clashing in fecund violence. Indeed, the sculptural ambitions of the

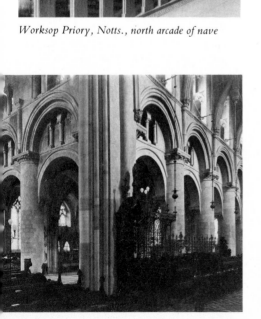

Worksop Priory, Notts., north arcade of nave

Castor church, Cambs., the central tower

Christ Church Cathedral, Oxford, choir and north transept

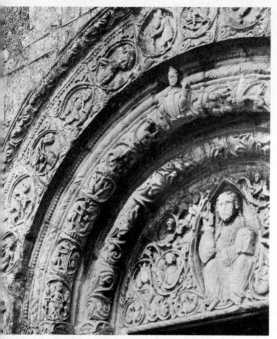

Tympanum of Barfreston church, Kent

Norman style were often best expressed in the design of doorways. The sumptuously carved little parish church at Barfreston, Kent, has an elaborate and zestful south doorway which may derive from work at Rochester Cathedral like the west tympanum, itself a product of influence from the mid-twelfth-century Aquitaine school.

Perhaps the finest of all such doors is the south porch at Malmesbury Abbey, Wiltshire, of *c.* 1160–70. Eight continuous bands or friezes of carved decoration run round the entire doorway. They depict, among many other things, biblical cycles based on parallels between the Old and New Testaments. A Christ in Majesty is carved inside the porch in the central tympanum, and on the side walls are two further tympana, each with six seated apostles over which passes an angel. The tense and moving drama of these eloquent elongated figures with their vigorously linear drapery folds recalls Burgundian sculpture like that at Autun of about thirty years earlier.

Finally we should remember the strange group of circular churches associated with the Knights Templars and Knights Hospitallers, which were founded to guard the Holy Land and the Holy Sepulchre. These round churches, of which five survive, were intended to recall the rotunda that formed part of the church of the Holy Sepulchre in Jerusalem. One example is the church of the Holy Sepulchre at Cambridge dating from *c.* 1130, though very thoroughly restored by Salvin in 1841. The others are the chapel of Ludlow Castle, the Temple Church in London, and churches at Northampton and Little Maplestead, Essex.

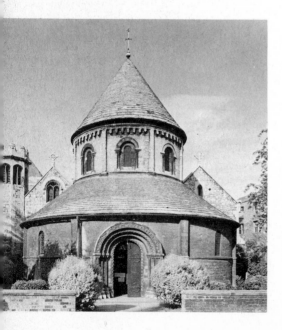

Church of the Holy Sepulchre, Cambridge; the upper parts rebuilt in the nineteenth century by Anthony Salvin

Right: Malmesbury Abbey, Wilts., the south porch

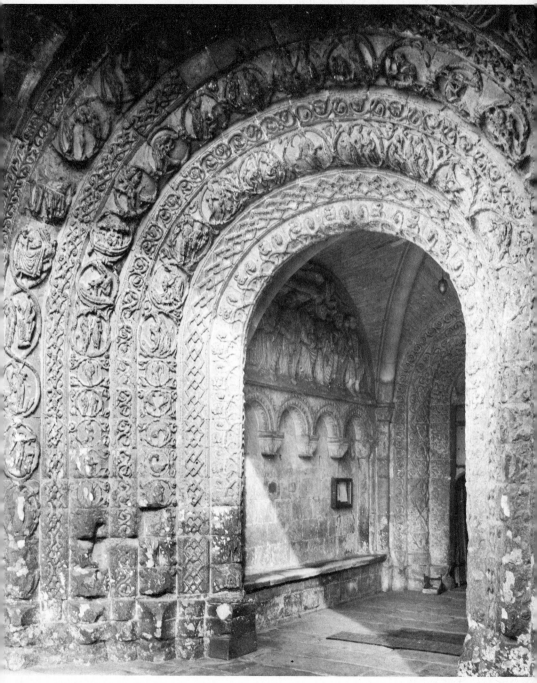

Buildings other than churches

It should have become clear by now that the Norman warriors attached tremendous importance to the building of churches and monasteries. William of Malmesbury, writing in *c.* 1125, sums up the character of their achievement as follows:

As I have said, they wished to have huge buildings, but modest expenses; to envy their equals, to surpass their betters; to defend their subjects from outsiders while robbing them themselves. Upon their arrival they raised the standard of religion which in England had died down; you may see everywhere churches in the cities, monasteries in the villages and towns, rising in a new style of building; the country flourishing after a modern manner.

The passion for architecture on a gigantic scale extended to the palaces and castles of bishops and kings, though these buildings have largely disappeared. The second Norman king, William Rufus, built a great hall at the end of the eleventh century at his palace of Westminster, 238 feet (72·5 metres) long; it was the largest hall north of the Alps. It was completely remodelled in the fourteenth century, though with the original dimensions preserved, and to understand something of its power today we must visit the admittedly much smaller and later aisled hall of Oakham Castle in Leicestershire.

The most familiar secular monument of the Norman period is the White Tower in the Tower of London. This was built by William the Conqueror between 1077 and 1097 under the direction of Bishop Gundulf of Rochester. The stone was brought across the Channel from Caen. The walls are 12 feet (3·6 metres) thick, but the tower was intended for residential as well as military purposes. Each floor is divided into three principal apartments and on the second floor is the chapel of St John, an impressive aisled space with an apse which projects prominently on the exterior of the tower.

Oakham Castle, Leics., interior of the hall

Similar in date and general arrangement is Colchester Castle. Though even larger (151 by 110 ft, 46 by 33·5 m) than the White Tower, it is far less impressive because the third storey was removed in the seventeenth century and it has lost most of its original stone facing. Interestingly, it was built round the podium and resting on the vaults of a Roman temple, which helps to account for its immense size. Taller than either the White Tower or Colchester is Rochester Castle built between 1126 and 1137 by William of Corbeuil, Archbishop of Canterbury, to guard the Medway crossing on the road from London to Dover and thence to the Continent. Inside, a great hall occupies the whole of the third and fourth storeys. It is divided down the centre by an arcade like the refectories at Fountains Abbey and Rievaulx Abbey in North Yorkshire. Possibly by the same designer as Rochester

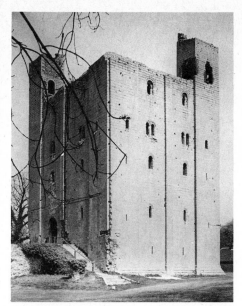

Castle is Castle Hedingham, Essex, built for the de Veres, earls of Oxford, in *c.* 1140. It has a fine two-storey state apartment divided by an immense arch spanning the whole internal width of the keep. Finally, no one should miss the spectacular keep of Norwich Castle, built in *c.* 1160 though refaced in the 1830s by Salvin. What makes it spectacular is the elaborate non-functional system of blank arcading with which its exterior walls are adorned. Military architecture on the other side of the Channel can offer no parallel to this kind of obsessive patterning which is so characteristic of English design of the time.

The sense of almost overwhelming power and dignity conveyed by the Norwich keep is reflected in the great Norman gate built some time between

Castle Hedingham, Essex, exterior and view looking across the main chamber

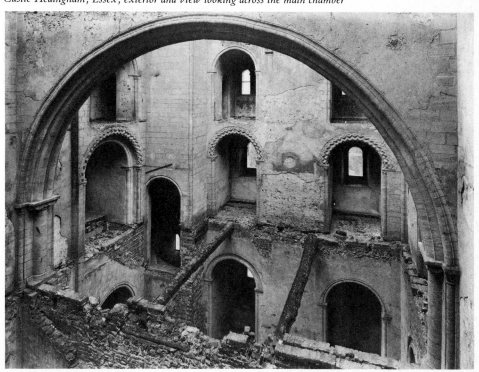

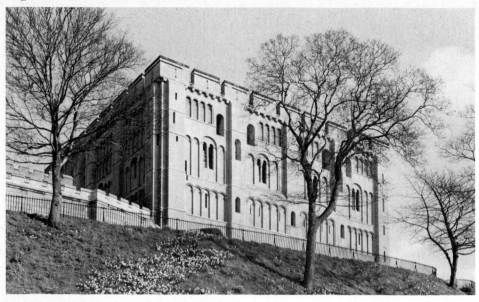

Norwich Castle, refaced in the 1830s by Anthony Salvin

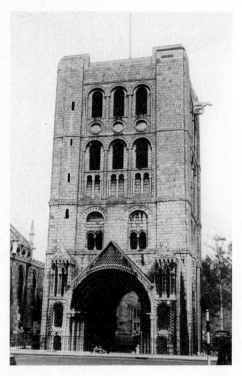

1120 and 1148 at Bury St Edmunds Abbey. We can sense from this magnificent tower that this Benedictine abbey was one of the wealthiest and most important in the country. The loss of its great church and monastic buildings at the Reformation is one of the great tragedies of English architecture. However, the fate of Bury St Edmunds is, on the whole, untypical, and monastic buildings of this period have survived more completely in England than on the Continent. This is due, ironically, to the Reformation which, in suppressing the monasteries, ensured that no further architectural additions would be made to them. On the Continent, by contrast, the survival of monastic institutions into the seventeenth and eighteenth centuries naturally led to their being rebuilt to follow changing architectural fashions.

The plan of Norwich Cathedral shows the characteristic layout of a great English monastic cathedral. Apart from the abbey church, where monks spent much of the

Bury St Edmunds Abbey, Suffolk, monastic gateway

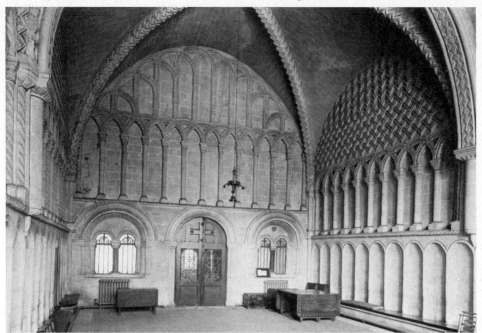

Bristol Cathedral, interior of the chapter house

day and night chanting their office in the choir, the most important monastic building was the chapter house. A particularly richly decorated example, dating from *c.* 1150–70, is that at the Augustinian abbey of Bristol, raised to cathedral status by Henry VIII in 1542. The dominant abstract patterning of the north and south walls provides one of the most characteristic examples of English Norman taste. Polygonal chapter houses, of which there are as many as thirty in England, are another typically national characteristic. The earliest example is the twelfth-century chapter house built for the Benedictines at Worcester. It is 56 feet (17 metres) in diameter and has a circular interior with a central column supporting groin vaults. It

Norwich Cathedral, plan as originally built (the easternmost chapel and the chapel on the south transept no longer exist): A west front; B nave; C crossing; D transepts; E presbytery

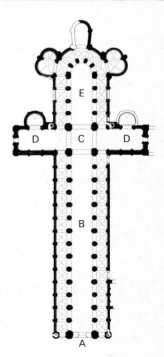

27

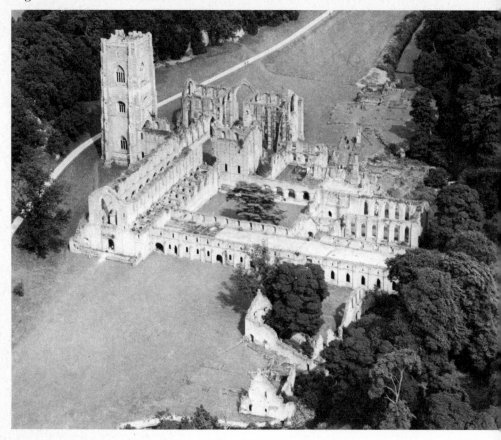

was the first step on the path that led to the superb Gothic chapter houses at Westminster, Salisbury, Lincoln, Wells, Southwell and York.

Gatehouses as we have seen at Bury St Edmunds, and refectories (i.e. dining halls) were important features of the monastic plan, though few have survived unaltered. The beautiful ruins of Fountains Abbey, North Yorkshire, in their equally beautiful setting, perhaps give one the clearest idea of a great monastic house of the later twelfth and early thirteenth centuries. The refectory, 110 by 47 ft (33·5 by 14·3 m), was divided by a central arcade, a characteristically French feature. That is not surprising since Fountains was a house of the Cistercian order, a French rule

Fountains Abbey, Yorks.; the large tower over the north transept was added in the sixteenth century in defiance of early Cistercian rules

imported into England at Waverley Abbey, Surrey, in 1128. The Cistercians, of whom we shall see more in the next chapter, were a reformed branch of the Benedictines. They reacted against what they took to be the lax and self-indulgent interpretation of the rule of St Benedict characteristic of contemporary Benedictine houses. What is of interest to us at the moment is that this reaction should have involved opposition to the elaborate Romanesque art of the day. Thus, in a celebrated *Apologia* of *c.* 1124 the great

reforming mystic St Bernard of Clairvaux complained that:

In the cloisters under the eyes of the brethren engaged in reading, what business has there that ridiculous monstrosity, that amazing mis-shapen shapeliness and shapely mis-shapenness? Those unclean monkeys? Those fierce lions? Those monstrous centaurs? Those semi-human beings? . . . on all sides there appears so rich and so amazing a variety of forms that it is more delightful to read the marbles than the manuscripts, and to spend the whole day in admiring these things, piece by piece, rather than in meditating on the Law of God.

To remind ourselves of the kind of art that St Bernard had in mind we should look at the fantastically carved Prior's Door and Monks' Door, probably of the 1130s, leading from the cloister at Ely into the south aisle of the church; or at the south doorway of Kilpeck church, Hereford and Worcester, of roughly similar date. St Bernard was not alone in his opposition to this rich and rather wild art. Around the middle of the twelfth century many patrons and designers gave their minds to the creation of a new Christian art that would be characterized by lightness, clarity and order – the style we now call Gothic.

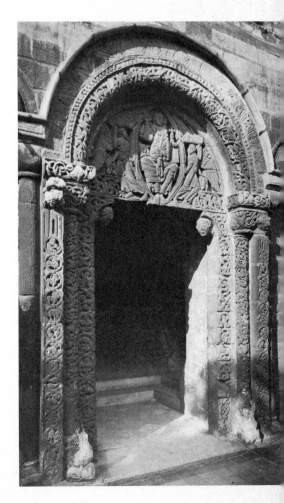

Ely Cathedral, the Prior's Door

2

The Early Gothic Style

Cistercians and the North

WE HAVE SEEN the decisive importance of Normandy on the development of English architecture in the eleventh century. In the next century France exercised an even more important influence through the Cistercians in the north of England and through William of Sens in the south. Between 1128 and 1150 no fewer than thirty-five Cistercian houses were founded in England. The Cistercians, as we saw in the last chapter, were an order of recent French origin founded to follow the rule of St Benedict with greater authenticity and austerity than the Benedictines themselves. Possibly because of their disapproval of undue ornament, the Cistercian architects seem to have been open to functional innovation, and it was in their buildings that the three features that were to characterize Gothic architecture – the pointed arch, the rib vault and the flying buttress – first came together and percolated through Western Europe. There is no reason to suppose that Cistercians in the north of England were particularly committed to Gothic but if, in the third quarter of the twelfth century, one wanted a type of architecture that was both French and austere one could hardly avoid getting Gothic.

Kirkstall Abbey, West Yorkshire, was founded in c. 1152 by monks from Fountains Abbey, and work seems to have begun at once on the church. Whereas Fountains employed the pointed barrel vaults of Romanesque Burgundy, home of the Cistercian mother-houses, the chancel and nave aisles at Kirkstall were rib-vaulted. Also, although the windows and doors were round-headed in the old Norman way, all constructive arches were pointed. Instead of the square nave piers of Rievaulx and the round ones of Fountains, the Kirkstall nave piers are of compound section with numerous projecting shafts and lobes.

Roche Abbey, in South Yorkshire, which was probably begun in 1160–70, makes a more definite move away from the Anglo-Norman style. Its plan, with straight-headed chancel and two short straight-headed chapels on either side, is the standard Cistercian plan derived from Fontenay in Burgundy (c. 1139) and echoed at Fountains and Kirkstall. In elevation, however, as can be seen from the surviving transepts, it *looks* Gothic: there are vaulting shafts descending to the ground, thus linking the rib vaults with the articulation of the wall; the central shafts on the compound piers have a pointed section; and between the arcade and the clerestory there is a tall triforium with coupled blind pointed arches. The introduction of a triforium was a refined elaboration which until this date the Cistercians had done without. However, one is still very conscious both of the mass of the wall lying immediately behind the triforium, and of the somewhat unhappy contrast between the old-fashioned round-headed clerestory windows and the pointed arcade. The fact that Roche only 'looks' Gothic is immediately brought home if one compares it with a 'real' Gothic building in contemporary France, for example Notre Dame in Paris (begun c. 1163) or Laon Cathedral (begun c. 1170).

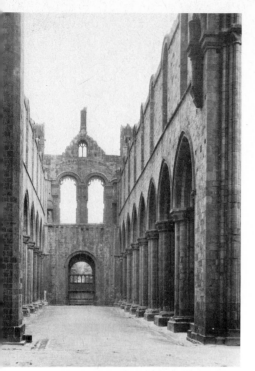

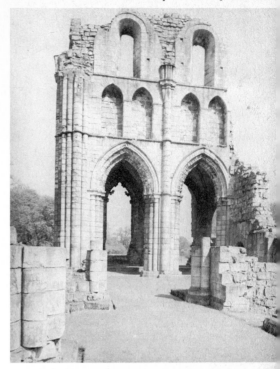

Kirkstall Abbey, Yorks., the nave looking west

Roche Abbey, Yorks., fragment of the east side of the south transept (above right)

Roche Abbey, plan: A west front; B nave, used by laity; C monks' choir; D transepts; E presbytery; F cloister; G chapter house; H monks' dormitory (upper floor); J infirmary building; K refectory; L lay brothers' refectory and dormitory; M abbot's lodging; N lay brothers' infirmary

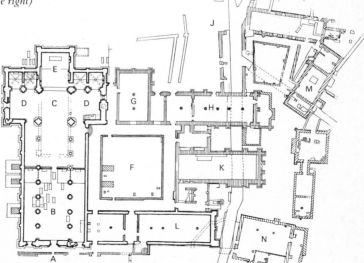

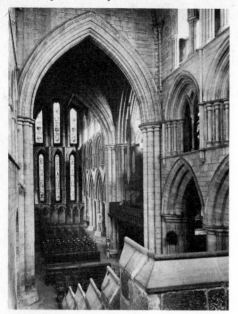

Hexham Priory, Northumberland, the crossing looking north

Here, developing rapidly from the first tentative expressions of Gothic in France at St Denis in the 1140s, the wall is well on the way to being entirely dissolved in a rippling vertical movement of shafts, arches and colonnettes. The English, as we shall see, tended to be less interested in the system of structural logic of which this patterned verticality was a part, than in exploiting its potentialities for surface decoration.

The beginnings of this can perhaps be seen at another Cistercian abbey, Byland in North Yorkshire (probably built in 1175–77). Not a great deal survives of Byland, but work in a similar style can still be seen in the transepts and choir at Ripon Minster, North Yorkshire, built in *c.* 1179

York Minster, the north transept Five Sisters Window

by Roger of Pont l'Evêque, Archbishop of York. To understand the extent to which patrons like Archbishop Roger must have made conscious choices between different styles, it is useful to compare Ripon with the elaborate Romanesque choir and crypt he had built earlier at York. Bishop Hugh de Puiset experienced a similar change of heart, as can be seen by comparing his galilee at Durham with St Cuthbert, Darlington.

The starting point at Ripon is the old thick-wall technique on to which has been grafted a rich articulation of shafts and, in the choir, a wall passage similar to those pioneering French cathedrals of St Denis and Sens in the 1140s. The Ripon system was imitated in *c.* 1200 in the beautiful upper parts of the church at the nearby nunnery of Nun Monkton. The originally aisleless nave of Ripon was remodelled in

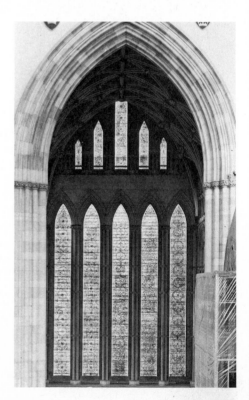

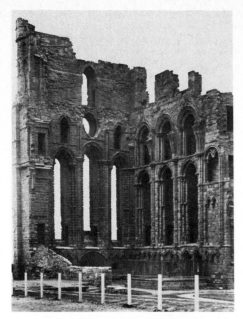

Tynemouth Priory, Tyne and Wear, ruins of the choir

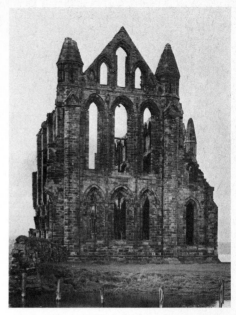

Whitby Abbey, Yorks., exterior of the east end

the fifteenth century, and we must go to Hexham Priory, Northumberland, to see a surviving example of the next stage in the development of this early northern Gothic. The north transept which appears to date from the earliest part of the thirteenth century, is a sophisticated elaboration on the theme of the choir at Ripon. The insistent pattern of tall lancets in the north wall is the hallmark of Early English in the north of England as strikingly demonstrated at St Cuthbert, Darlington (begun 1192); the east ends of Tynemouth Priory, Tyne and Wear (*c.* 1200), and Whitby Abbey, North Yorkshire (*c.* 1220); in the west front of Ripon (*c.* 1220–50); and in the north transept of York Minster (*c.* 1253) with its breathtaking Five Sisters window containing five equal lancets, all 55 feet (16·7 metres) high.

These closely related masterpieces all have a grave classic balance which is

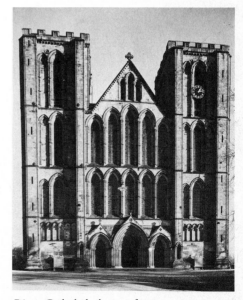

Ripon Cathedral, the west front

33

immediately recognizable. The use of the term 'classic', however, does not imply that kind of overall structural and decorative logical unity which one can begin to expect at this time in French Gothic in the Ile de France. Thus, the chancel at Tynemouth was designed with little relationship between the east and south walls, particularly in terms of window heights; even more strikingly, the west front at Ripon projected to north and south, clear of the aisleless nave, thus making a decorative screen of what in France would be a logical two-towered termination of nave and aisles; finally, the Gothic style still did not necessarily carry with it expectations of a stone rib-vaulted roof, so that the Whitby choir (*c.* 1220) and the nave and probably the chancel of Ripon were planned for timber ceilings. Of course, later on the timber roofs of parish churches became one of the great glories of English architecture, but at this early stage in cathedral or large-scale monastic architecture serious experimentation with Gothic would have implied stone vaults.

Canterbury and its impact

In the meantime, what of southern England? We should return to the great Metropolitan Cathedral of Christchurch, Canterbury, where a disastrous fire in September 1174 engulfed everything east of the central tower. Rebuilding, which began immediately and lasted until 1184, was entrusted to a French architect, William of Sens, who imported the much-favoured building stone from Caen in Normandy. The opportunity of constructing a great church in up-to-date French cathedral Gothic, which seems to be implied in the deliberate choice of a French architect from the Valenciennes area, was not fully taken up and we are left with a Picturesque English compromise. To begin with, the monks were anxious to preserve as much as possible of the burnt-out Norman choir so that although William of Sens was able, in spite of their

wishes, to replace the piers, he had to raise his Gothic choir on a Norman plan. Also, the growing cult of St Thomas à Becket, after his murder in the cathedral in 1170, necessitated a new shrine east of the existing east end. This meant that the cathedral, of which the choir was already both longer and wider than the nave, was to become even more rambling and unbalanced in plan. The dramatic rise in the floor level as we pass from the choir to the Trinity Chapel containing Becket's shrine, is also unusual by any standards.

Aspects of the work that are specifically French are the semicircular ambulatory, the flying buttresses (though here hidden under the aisle roofs), and the beautiful acanthus capitals of the choir. From Sens itself, where the choir was begun in *c.* 1140 immediately after the pioneering St Denis, come the coupled columns in the retrochoir and, more important, the two-bay sexpartite vaults. Certain aspects of the interior elevation also derive from Sens, such as the great height of the arcade in relation to that of the gallery, although the unusual constructional system still owes much to the Norman thick-wall technique. The division of the vault at Sens into six parts was a consequence of the desire for greater variety expressed by the alternating supports in the arcade, where the composite piers are major divisions and the round piers minor ones. One effect of this is to transform a quadripartite vault into a sexpartite one, because two minor ribs now run from the round piers to meet the four major ribs running from the composite piers. Although the sexpartite vault is imitated at Canterbury, the effect of the alternating supports is much diminished because it consists merely of alternation between round and octagonal piers.

We are fortunate in having a unique contemporary account of the year-by-year progress of the building of the new choir between 1174 and 1184, written by Gervase of Canterbury, one of the monks in the community. Not surprisingly, he emphasizes the liberal use of Purbeck

Wells and the West

The west of England, like the north, went some way to developing its own indigenous Gothic before, or independently of, Canterbury. Just as there had been a West Country school of Romanesque, so now there was a Gothic school, of which the important early works are the pointed arches in the naves of Malmesbury (*c.* 1165) and of Worcester (*c.* 1175), the ribbed vault and Gothic capitals of the otherwise Anglo-Norman Glastonbury Lady chapel (1184–86) and the abbey church at Glastonbury (begun 1185) with an elevation which can be read as a pointed-arched version of the Romsey or Oxford type.

The principal achievement of the early West Country school is Wells Cathedral as planned between *c.* 1185 and 1200. The master of Wells created a recognizably English Gothic style not notably dependent on Cistercian or French architecture, except for the oblong quadripartite vaults, or even on Canterbury. The taut and aspiring verticality to which French Gothic was moving in the twelfth century and which culminated in Chartres in 1195, was rejected at Wells in favour of a more relaxedly diffuse patterning, and a readiness to emphasize horizontals. This is particularly striking in the nave arcades where, first, the ribs of the vault are not carried down the height of the walls in the form of shafts, second, the triforium is a continuous band of narrow lancets forming an insistently horizontal flickering line annihilating the vertical bay division so dear to the French, and finally, the piers heighten the decorative play by their almost unbelievably complex section of twenty-four attached shafts supporting arch mouldings of similar richness.

One of the special pleasures of Wells is the profuse display of carved foliage-capitals. These seem to be part of the concern for rich surface display which is also expressed in the splendidly elaborate north porch of *c.* 1210–15 and, above all, in the west front of *c.* 1220–40. Since the

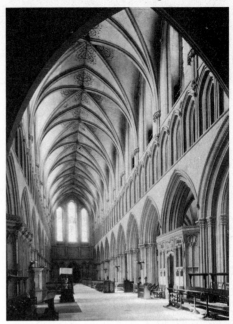

Wells Cathedral, the nave looking west

main entrance was through the north porch, the designer of the west façade could give himself over much more freely to the display of sculpture than would be the case in France, where great portals take their place naturally and logically as dominant accents in the composition. The Wells façade has been criticized as an unhappy compromise between the English type of west front as a screen, as we shall see at Lincoln and Salisbury, and the French type which tends to be narrower and more concentrated, with side portals placed in front of the aisles. The tremendous breadth of the early-thirteenth-century façade at Wells would imply towers of virtually impossible height, so that in visual terms the existing south and north towers, built respectively in the 1380s and 1420s, were almost doomed to failure. But most visitors today, as no doubt in the thirteenth century, will not worry about that but will allow them-

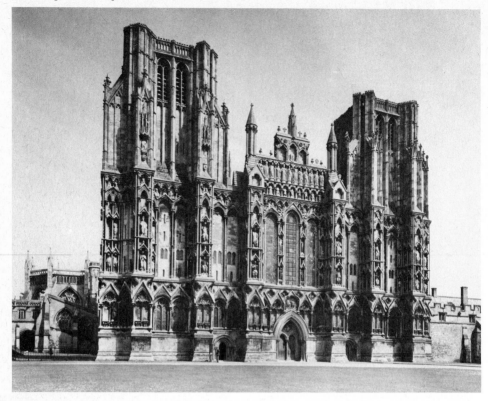

selves to be entertained by the novelty of what is effectively a gigantic open-air reredos of nearly four hundred carved figures, originally painted so that the resemblance to an actual reredos would have been even greater. The quality of the sculpture may not be up to the contemporary work at, say, Reims or Chartres, but the overall effect of so much figure sculpture in so many quaintly gabled niches is both overwhelming and delightful.

Lincoln and its impact

The rebuilding of Lincoln Cathedral, as a result of an earthquake, was begun in 1192 under the French-born St Hugh of Lincoln, the holy Carthusian monk who became its reluctant bishop in 1186. His architect was Geoffrey de Noiers who,

Wells Cathedral, the west front; the upper parts of the towers were added in the 1380s and 1420s

despite his name, need not necessarily have been brought from France. He created what is generally regarded as the classic English cathedral of its date, uniting boldly imaginative effects of his own with decorative and structural elements borrowed from Canterbury and to a lesser extent from Wells. His happy inventiveness is typified by the 'syncopated arcading' in both the eastern transepts and in the aisles of St Hugh's choir. Here an extraordinary game has been played with the theme of detached Purbeck shafting inspired by Canterbury. Against the wall is set pointed blank arcading with limestone

shafts, in front of which runs another tier of pointed trefoiled arches with black Purbeck shafts setting up a counter-rhythm of their own. This kind of 'crazy' Picturesqueness recurs in what has indeed been described as the 'Crazy Vault' of Lincoln, which is perhaps the most important feature of St Hugh's choir. This rib vault is original in the following ways: first, it has a longitudinal ridge rib, a wholly un-French idea; second, related to this, it is the first in Europe to have tiercerons, that is to say decorative or secondary ribs which do not lead to the central point of the vault but to a place along the ridge rib; finally, its wilfully diverging ribs also help to destroy the logic by which, up to this date, vaults had always been clearly related visually to the bay system. Perhaps the key word in this rather technical descr.....ion is 'decorative', for a revolution had indee..rred when a rib vault was openly displayedsual and decorative in intention rather u... ...n purely functional. Contemporaries were struck by the novelty of this work and the author of a Latin poem called the *Metrical Life of St Hugh* (c. 1225) described the roof of the eastern parts of the church in a beautiful analogy, 'as if it were conversing with the winged birds, spreading out broad wings, and like a flying creature striking against the clouds'.

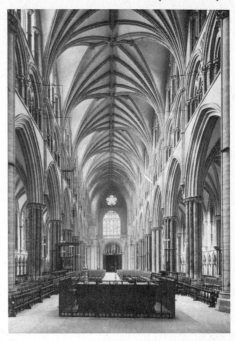

Lincoln Cathedral, the nave looking west

Lincoln Cathedral, arcading in St Hugh's choir; the spandrels of the foreground arches were probably originally open, exposing the tops of those behind

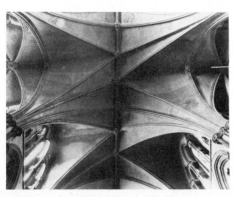

Lincoln Cathedral, the 'Crazy Vault'

39

The richly articulated interior elevations of St Hugh's choir with their free use of Purbeck marble shafting are continued into the nave, which was built by Geoffrey de Noiers's successors, probably in the 1220s and 1230s. The author of the *Metrical Life* wrote charmingly of the piers how 'the little columns which surround the large column seem to perform a kind of dance'. The irregularity of rhythm that we have already noticed at Lincoln recurs in the vaulting of the south aisle of the nave where the ridge rib is not continuous but vanishes unexpectedly between the tiercerons of one bay and those of the next. The span of the arcades is of exceptional width which makes for greater lightness and spatial complexity by allowing the eye to take in the aisles at the same time as the nave. The nave vault continues the tierceron and ridge-rib pattern established in St Hugh's choir but in a form that is at once symmetrical and yet more complex. It begins to resemble the palm-tree effect which we find later in the thirteenth century at Exeter and which we also find in the beautifully vaulted polygonal chapter house at Lincoln, built during the second quarter of the thirteenth century. In the *Metrical Life* we read of the chapter house that 'the like of its pointed roof never Roman possessed . . . within, its space is round, vying with Solomon's Temple in material and craftsmanship'.

The Norman west front of Lincoln was extended to form a screen in the Early English style probably around 1230. The seemingly endless tiers of blank arcading create a not entirely pleasing and insistently horizontal effect in marked contrast to the lively spirit of movement and energy that marks the design of the body of the church.

The impact of the spectacular and sparkling work at Lincoln is not hard to trace. In 1224 work began on providing the monastic cathedral of Worcester with new eastern parts, equalling the Norman nave in length, so as to provide a fit setting for the much visited shrine of St Wulfstan. A choir of four aisled bays was followed by eastern transepts, as at Canterbury, Wells and Lincoln, and then by a three-bay retrochoir with a simple one-bay Lady chapel projecting at the extreme east end. It should, perhaps, be emphasized at this point that this compartmental plan with double transepts and straight-headed chancel, later repeated at Beverley, Southwell and Salisbury, would be impossible at this date on the Continent, with its more unitary approach to Gothic planning. At Worcester there is much rich play with Purbeck shafting and, in the choir triforium, the entertaining device of superimposing one layer of arcading on another in a deliberately clashing rhythm, a technique borrowed from Lincoln.

Worcester inspired the rebuilding of the chancel at nearby Pershore Abbey between 1223 and 1239. Here, unusually, there is a two-storey not a three-storey elevation, and an elegant double clerestory with an open screen in front of the lancet

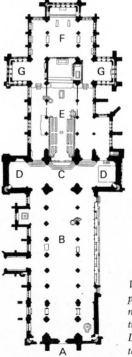

Worcester Cathedral, plan: A west front; B nave; C crossing; D transepts; E choir; F Lady chapel; G eastern transepts

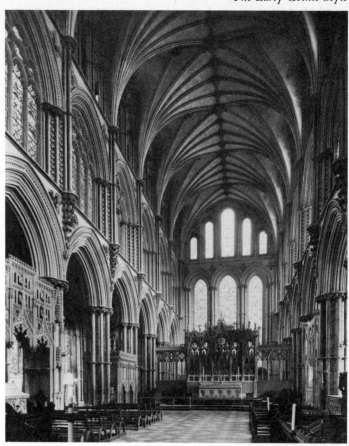

Ely Cathedral, the choir looking east

windows, which is probably based on the windows in Worcester east transept.

Ely went so far as to provide a new chancel, which was a virtual copy of the nave at Lincoln. Built in the 1230s, though not finally complete till 1252, it created a new well-lit presbytery and a retrochoir for the shrine of the seventh-century founder of Ely, St Etheldreda. It is one of the loveliest and most profuse of all Early English interiors. Like Lincoln, its elevation still retains the deep, old-fashioned gallery which had been given up in France with the birth of High Gothic, just before *c.* 1200, in favour of triforia.

Contemporary with Ely is the great south transept at York which has a northern or Cistercian austerity. It was built under Walter de Grey, Archbishop of York, who in 1234 decided to rebuild the eastern parts of Southwell Minster, Nottinghamshire. At Southwell there is a clarity and solidity which combines northern with Lincoln elements, but perhaps the most striking feature is that, as in the Pershore choir, the whole choir wall consists not of three but of two storeys. The combination of northern and Lincoln elements is seen again in the superb east end of Beverley Minster of the 1230s. Though Beverley does not imitate the tierceron vaulting of Lincoln, it does contain characteristic Lincoln touches such as the syncopated arcading in the trifor-

41

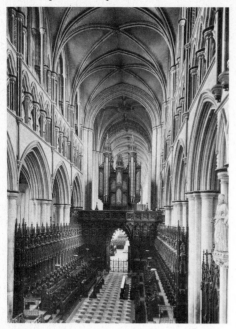

Beverley Minster, Yorks., the choir looking west

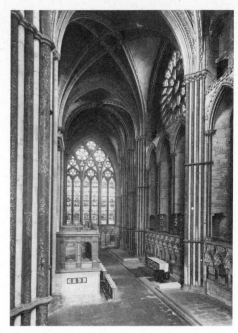

Durham Cathedral, the Chapel of the Nine Altars

ium, an important position where its polychromatic sparkle is much more noticeable than at Lincoln. Similarly Lincolnesque is the elegant double staircase leading to the former chapter house. In front of the stairs free-standing vaulting shafts rise like frail scaffolding to the aisle vaults. Apart from its gaiety of surface detail, Beverley is remarkable for its rather French air, its great height in proportion to its width and its simple, low triforium in the French pattern, as opposed to the great triforium galleries of Anglo-Norman churches.

The other masterpiece of this period in the North is the great Chapel of the Nine Altars built behind the shrine of St Cuthbert at Durham Cathedral. Though work did not begin until 1242, under the architect Richard of Farnham, its general form seems to have been settled in the mid-1230s by Bishop Poore who, while still Bishop of Salisbury, had begun work

on the new Salisbury Cathedral in 1220. It was an extraordinary conception to terminate the east end of a cathedral with what looks like a transept projecting to north and south. Indeed the only parallel is the east end of Fountains Abbey, completed in *c.* 1240, which must be the source for Durham. The exterior of the east wall at Durham, with its nine austere lancets, is a massive expression of power emphasized by the immense buttresses which enable the interior to luxuriate in the non-load-bearing decorative fantasy produced by the deeply projecting bundles of myriad slender shafts of local marble.

Salisbury Cathedral

After Canterbury, Wells and Lincoln, Salisbury is the fourth in the quartet of great Early English cathedrals. Its peaceful setting amidst shaven green lawns blending into the pastoral landscape recorded by

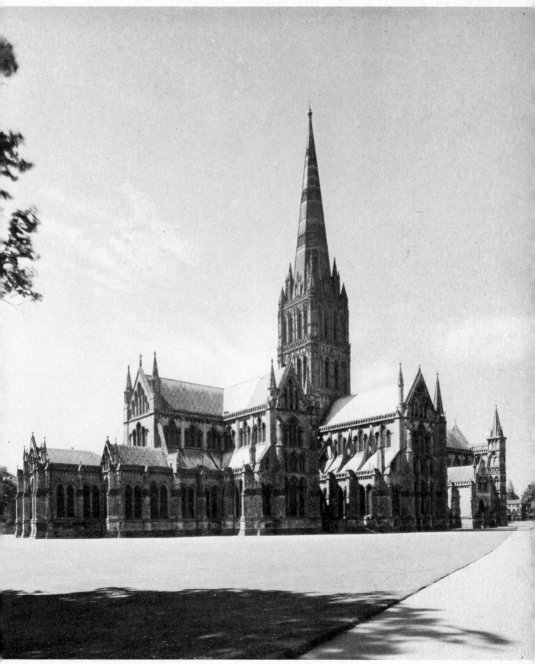

Salisbury Cathedral, from the north-east

Constable makes it for many the quintessentially English cathedral. Yet in many ways it is something of an anomaly: in that it was begun *de novo* in the thirteenth century on a virgin site; in being largely completed, save for the tower and spire, according to the original design; and in its calm rectangular style which is immediately distinguishable from the churches we have seen so far in this chapter and, it need hardly be said, from thirteenth-century Gothic in the Ile de France.

The designer of Salisbury seemed to want to emphasize the way in which he had logically separated part from part: thus the long two-bay north porch projects boldly and uncompromisingly from the nave; the choir, nave and the two sets of transepts are of identical height and are all given equal stress; and the same is true of the much lower Lady chapel, retrochoir and aisles. The regular repetition of simple lancets and buttresses may lack variety but it creates an impression of a steady and

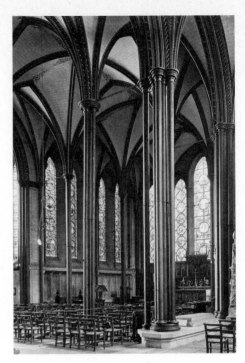

Salisbury Cathedral, interior of the Lady chapel

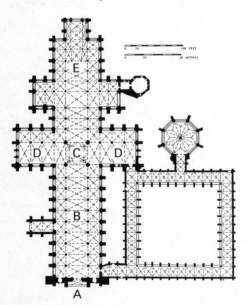

Salisbury Cathedral, plan: A west front; B nave; C crossing, with spire over; D transepts; E choir with its own smaller transepts

deliberate order. That impression is maintained by the unified interior with its repetitive but restrained decorative elements. It must be remembered, however, that the light, open effect is partly due to the loss of the original stained glass and coloured decorations painted on the walls, and also to the removal of the screens.

One of the most characteristic interiors at Salisbury is the Lady chapel at the extreme east end. This is a miniature hall church; that is to say a room with aisles the same height as the nave. The vaults are supported on quite extraordinarily slender marble shafts which allow the space to flow freely around them and into the ambulatory, and which seem to be the product of a 'less is more' aesthetic. Indeed, it is almost easier to define Salisbury by what it does not have than by what it does. It lacks, for example, much of what we

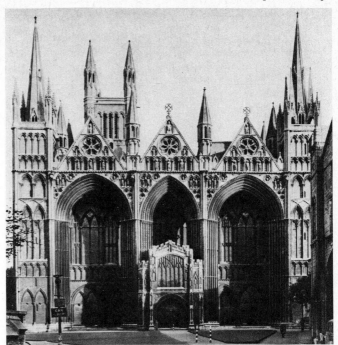

Peterborough Cathedral, the west front; the small porch in the centre is a fourteenth-century addition

find in Early English buildings inspired by Lincoln: wall-arcading under aisle windows, ridge rib and tierceron vaults, syncopated arcading, piers of complex section and rich displays of Purbeck shafting. An exception to the last is in the openings of the possibly rather squat nave gallery, for Salisbury – like Lincoln, Ely and Westminster – still has a gallery, unlike Gothic cathedrals in the Ile de France at this date.

The west front of Salisbury is an eccentric and scarcely very coherent design. It is a decorative screen covered by endless tiers of arcading which do not create an intelligible pattern. At its foot is a small triple porch which looks almost ludicrously out of scale since the three openings represent and stand at the end of the nave, not the nave and aisles.

A more original and in some ways astonishing west front in this characteristically English screen form was built at Peterborough in *c.* 1200–30. The three

immense arches of identical height have an overpowering magnificence as though they were the gateway to the Kingdom of Heaven itself. The analogy with the Kingdom of Heaven, though a familiar one, is not far-fetched. With their soaring height, shimmering marbles and glittering shrines to holy men, these noble buildings were undoubtedly intended to impress the joy and the wonder of the Christian message on the illiterate laity.

Parish churches

The great cathedrals and abbey-churches are what we must concentrate on in a book of this size, but many parish churches were also rebuilt in the Early English style, often repeating in miniature the pattern of cathedral development by adding a new chancel to a Norman nave. A specially pleasing small parish church built in its entirety in *c.* 1247 is St Giles at Skelton near York, with a multi-shafted south door

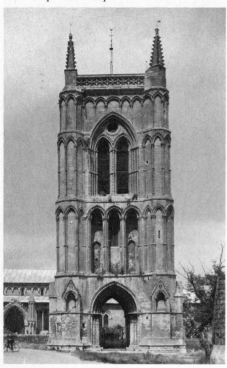

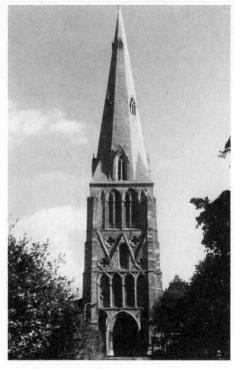

St Mary's West Walton, Norfolk, the bell tower *Raunds, Northants., the west tower*

sprouting into particularly vigorous stiff-leaf capitals. Another Yorkshire church wholly in the Early English style is the sparsely windowed St Oswald, Filey, with its dour central tower. The Norman parish church of St Leonard at Hythe in Kent, one of the prosperous Cinque Ports, was given a spectacular aisled chancel in *c.* 1230 on a cathedral scale with a three-storey elevation, most unusual in a parish church.

One of the finest Early English parish churches is St Mary, West Walton, built in *c.* 1240 in the Norfolk fen and inspired by Lincoln and Ely. The broad arcades of the nave support a clerestory with an alternating pattern of blind and open arches, but what remains indelibly printed on the memory at West Walton is the detached three-storey campanile rising with the utmost nobility from its completely open

ground stage. Other detached towers were built in marshy ground where it was thought dangerous to raise them on the body of the church, for example at Long Sutton, Lincolnshire, and Tydd St Giles, Cambridgeshire. It should not be forgotten that detached bell-towers were a feature of a number of major churches, for example Westminster Abbey, Norwich, Tewkesbury, Worcester, Romsey, Chichester and Evesham – though of these only the last two survive today.

Northamptonshire masons, drawing on the fine building stone from Barnack, developed from the 1220s an influential type of octagonal stone spire rising from a square tower, generally known as the broach spire. One of the earliest experiments was the octagonal upper stages added to the Saxon tower at Barnack. Far

more confident and sophisticated are the spires at Raunds and Polebrook in Northamptonshire and the later crossing tower and spire at Ketton in Leicestershire.

Westminster Abbey

It is debatable whether Westminster should come at the end of the Early English chapter or at the beginning of the Decorated chapter. It could equally well be given a chapter of its own. What is clear is that it ended the Early English style by offering a stylish alternative based on up-to-date French court art. It did not necessarily usher in the Decorated style though its decorative consequences were, as we shall see in the next chapter, considerable.

In 1220 King Henry III had laid the foundation stone of a new Lady chapel at Westminster Abbey, but twenty-five years later he initiated a much more ambitious building campaign at the east end prompted by a desire to create an adequate setting for the shrine of his favourite saint, Edward the Confessor. The king's master mason at Westminster between 1243 and 1253 was Henry de Reynes. Whether he came from Reims or from Reynes in Essex is not clear; what is certain is that Henry III had visited France in the 1240s and 1250s and must have been impressed by the work carried out for Louis IX, his brother-in-law and a future saint, at Reims, St Denis and the Sainte-Chapelle, the important royal shrine for the relics of the True Cross and the Crown of Thorns. In his excitement, Henry de Reynes largely ignored the English style of the day and imported the French High Gothic of the Ile de France and Paris. What this means is that the plan of Westminster, unique in England for that date (with a

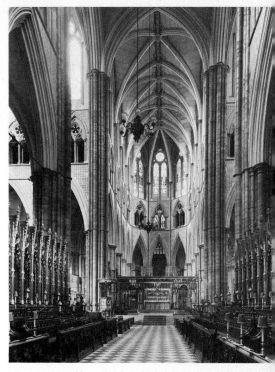

Westminster Abbey, the choir looking east

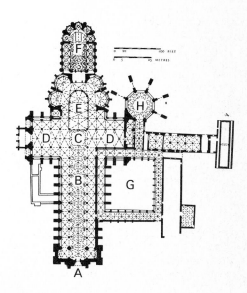

Westminster Abbey, plan: A west front; B nave; C crossing; D transepts; E choir, with royal tombs; F Henry VII's Chapel; G cloister; H chapter house

French chevet, i.e. polygonal apse, radiating chapels and ambulatory), as well as the tall narrow elevation seem to have been based on Louis IX's favourite royal abbey of Royaumont (1228–36) or on Reims (finished by 1242). Although the transepts project far more than the French would have allowed, the great height of the church (103 feet [31·3 metres] as compared with 74 feet [22·5 metres] at Lincoln and 117 [35·6] at Reims) is French, as is the use of flying buttresses and the absence of a wall passage in the clerestory, thus indicating that the masons now dared to make the walls thin. Other French features are decorative, such as the naturalistic foliage-capitals (as opposed to Early English stiff-leaf), the censing angels in the transept spandrels, the ubiquitous diapered spandrels and, above all, the extensive use of traceried windows. Plate-tracery, in which the window lights look as if they have been punched out of the solid wall, had been used at Salisbury, but the idea of treating the whole window as a single unit and separating the lights simply by thin stone ribs (bar-tracery) gave the designer very much more inventive freedom. The important decorative innovation of bar-tracery had been known in France since the second decade of the thirteenth century, when it had appeared in the chancel at Reims as part of the process of negating the wall in favour of window space. At Westminster, the tracery of the triforium screen consists of two lancets with trefoiled heads surmounted by bar-tracery with a cinquefoil in a circle, as in the apse windows of the lower storey of the Sainte-Chapelle. Themes from recent French tracery were developed in a particularly striking way in the north and south walls of the transepts at Westminster which contain, above the bar-tracery windows carried round from the triforium, huge rose windows. With their up-to-date glazed spandrels, they derive from the Sainte-Chapelle and the north transept at Notre Dame. Another Westminster novelty was the gallery windows in the eastern chapels and in the east aisle of the south

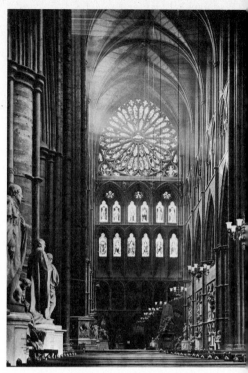

Westminster Abbey, interior of the north transept

transept. These are curved or spherical triangles containing an eight-foiled circle. They are taken directly from recent French work such as the west front of Amiens, where they appear for the first time, or more probably from the ground floor of the Sainte-Chapelle.

The great octagonal chapter house, completed by 1250 or 1253, shows how far the Westminster masons were prepared to go in their new-found enthusiasm for French bar-tracery as developed at Amiens and the Sainte-Chapelle from the 1220s to 1240s. The chapter house windows are far more expansive than those in the church, being grouped in four lights surmounted by two quatrefoils and then by a large six-foiled circle. The closest French parallel is in the south nave chapels of Notre Dame,

added in the 1240s, although by some baffling chance the form had appeared by 1244 in the spectacular west window at Binham Priory in Norfolk. At Westminster, in a centrally planned building of a type unfamiliar in France, they are used to create an astonishing space almost entirely surrounded by glass threaded together with stone tracery. The tracery in the chapter house vestibule and in the north and part of the east walks of the adjacent cloister is even richer, with a pungent tripartite rhythm recalling the Sainte-Chapelle and other royal buildings of the 1240s such as Tours Cathedral and Nogent-les-Vierges.

It has been difficult to avoid making the account of Westminster Abbey into a catalogue of French High Gothic sources. This undoubtedly tells us something about the character and impact of the building, but it is also worth remembering first that the full decorative system of the recently completed Lincoln nave vault with ridge ribs and tiercerons was adopted by *c.* 1260 for the Westminster nave vault, and

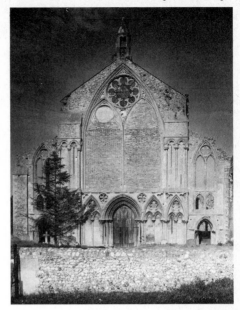

Binham Priory, Norfolk, the west front

second that features such as tracery, diapering, figured and foliage sculpture were often assembled with a concern for pattern-making, for rich surface textures, which recalls less the spirit of French art than that of the Anglo-Saxon and Norman decorative tradition. We shall see in the next chapter what happened to English architecture as a consequence of this ornamental, fashionable, selfconscious and costly building, this much-visited shrine of a great English saint and king.

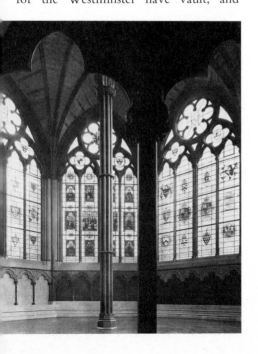

Westminster Abbey, interior of the chapter house

Decorated, Court Style and Perpendicular

The Geometrical style and the influence of Westminster and Lincoln

THE IMPACT of northern France on English mediaeval architecture can hardly be overestimated. We have seen Edward the Confessor looking to Jumièges for inspiration in the eleventh century, the monks of Canterbury to Sens in the next century, and Henry III to Louis IX, Reims and Amiens in the thirteenth century. In investigating the Court style and the origins of Perpendicular in this chapter, we shall see further evidence of this feeling that the most important events were happening on the other side of the Channel.

The first stage of the Decorated style, up to the adoption of ogee curves in about 1290, is sometimes called 'Geometrical'. This term originated as a description of window tracery and is thus a good indication of the impact of Westminster. That impact led to the new passion for the great window, which also coloured the Decorated style of the later thirteenth century and first half of the fourteenth. At the old St Paul's Cathedral in London, begun in 1258 probably to rival Westminster Abbey and destroyed in the Great Fire of 1666, the east end consisted of a huge rose window with spandrels pierced with tracery resting on a row of seven cusped lancets. This was taken directly from the Westminster transepts which were themselves based on Pierre de Montreuil's south transept at Notre Dame. A virtual copy of the Westminster chapter house and cloisters was built at Salisbury from c. 1270. Of course, as a cathedral served by secular priests not living in common under a monastic rule, Salisbury required a chapter house but not cloisters, and the original designers of the cathedral fifty years earlier had made no provision for them. The decision to add them can therefore be seen as an indication of the powerful attraction of Westminster, though it should be remembered that by a pleasing anomaly five more of the nine cathedrals served by secular canons also acquired these decorative rather than functional cloisters: Lincoln, Wells, Chichester, Hereford and old St Paul's. In these cases, however, they probably reflect the extent to which the great Benedictine cathedrals and monasteries had formed people's expectations of what a great church ought to look like.

Despite their commitment to austerity, two Cistercian monasteries with royal connections also adopted aspects of the new ornamental style. Henry III became patron of Netley Abbey, Hampshire, in 1251 and the great traceried windows at the east end and in the south transept, which doubtless date from this time, are modelled on the Westminster chapter house windows. At Hailes Abbey, Gloucestershire, a chevet with five radiating chapels was added between 1271 and 1277 on the direct pattern of Westminster. It contained a shrine for a celebrated relic of the Holy Blood given in 1268 by Henry III's nephew, Edmund, Earl of Cornwall.

In c. 1270 the Norman nave and aisles at Chichester Cathedral were widened by the addition of rows of external chapels rather in the way that chapels had been incorporated between the buttresses of the

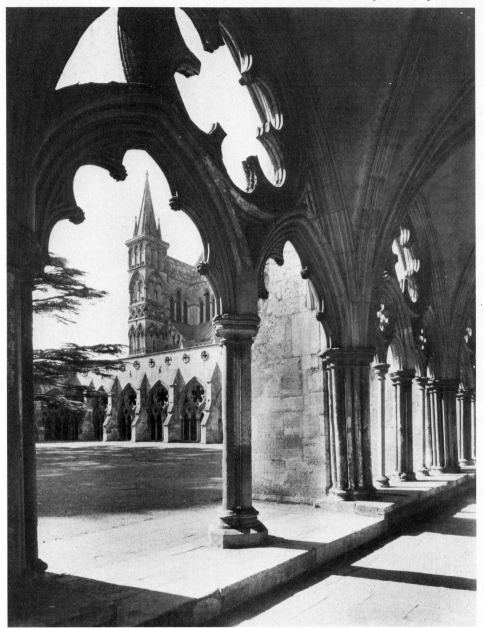

Salisbury Cathedral, east walk of the cloister, looking towards the north

nave aisles at Notre Dame from the 1240s. The bar-tracery is indeed of the Notre Dame–Westminster kind and, as at Notre Dame, there was originally a gable over each external bay. The magnificent parish church of St Mary the Virgin at Stone in Kent probably dates from the same years as Chichester. The spandrels of the trefoiled blank arcading in the chancel are exquisitely carved with foliage and are presumably the work of the royal masons at Westminster.

What we have seen so far is largely sporadic detail, inspired particularly by the Geometrical tracery at Westminster. However, at Lichfield, Hereford and Lincoln a more consistent and independent style was achieved on the basis of Westminster. The graceful new nave at Lichfield Cathedral, begun in *c*. 1258, is memorable both for the way in which the slender vaulting shafts cut piquantly through the five-foil circles in the arcade spandrels, and for the spherical-triangle windows, copied from Westminster, in the clerestory. This work was done under Bishop Longespee, the king's nephew, who had spent much of his life in France. The west front, of *c*. 1280, is evidently an attempt to echo the Continental two-towered type, but it still betrays an affection for the English screen in its markedly horizontal tiers of statues and in being wider than the nave and aisles. Of even more mature and sophisticated design is the Lady chapel which was built at the east end in *c*. 1320–35. The vault, which is of timber, is of the ridge rib and tierceron construction familiar from Lincoln and Westminster; the windows have a fine display of Geometrical tracery with unencircled trefoils exactly like those at Westminster, but their extreme height is uncommon in an English church. The sparkling metallic quality is undoubtedly of French inspiration and recalls in particular the Sainte-Chapelle, which itself had many of the characteristics of a sumptuous metalwork shrine. The whole form of the Lady chapel with its polygonal end, again unusual in England, is based on the Sainte-Chapelle, as are such internal

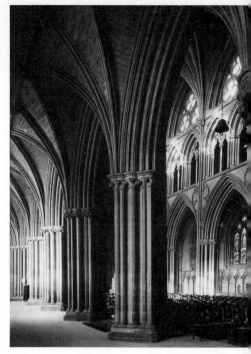

Lichfield Cathedral, the nave from the south aisle

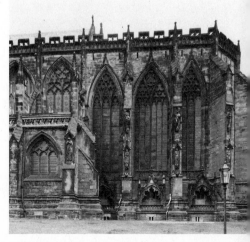

Lichfield Cathedral, the Lady chapel

details as the canopied statues supported by corbels attached to the piers. In fact, what we are looking at at Lichfield is the Court style of St Louis as expressed, even before the Sainte-Chapelle, in buildings like the royal chapel at St Germain-en-Laye of the 1230s and as exported from Paris to, say, Carcassonne and Narbonne in *c.* 1270.

At Hereford we find evidence of similar aesthetic intentions as early as the 1250s or 1260s in the north transept, which is dominated by windows of extreme attenuation. Built by Bishop Peter of Aigueblanche, a close friend and adviser of Henry III, it has been described by Professor Peter Brieger as 'a high chapel sparkling with light, set in a thin framework of mincing elegance: the dream of a courtier with an exotic taste'. Despite the mannered and individual hand that is recognizable in the overall design, the details come from Westminster: for example, the spherical-triangle windows enclosing foiled circles in the clerestory and the diapered spandrels in the triforium. A special delight in one of the transept chapels is the tomb of Bishop Aigueblanche (or Aquablanca), who died in 1268. The gables and traceried arches of this highly strung monument are wiry and alert, tense like a greyhound.

Virtually the whole north wall of the north transept at Hereford is devoted to a vast six-light window, 50 feet (15·2 metres) high. At Lincoln, at about the same time, an even larger window of similar design filled the east end of the Angel choir. This Lincoln window is, indeed, the earliest eight-light window to have been preserved anywhere. It was widely imitated into the fourteenth century, particularly in the north of England, for instance at Ripon, Guisborough, Selby, York and Carlisle. The magnificent Angel choir (or retrochoir) that it lights was begun in 1256 to replace the apse of St Hugh's choir and to provide a more splendid shrine for his relics. The new five-bay choir was apparently complete in 1280 when King Edward I and Queen Eleanor attended the solemn translation of the shrine of St Hugh.

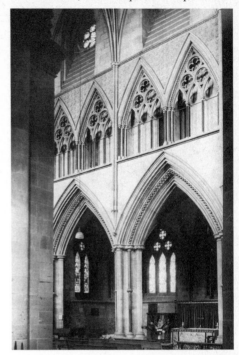

Hereford Cathedral, east side of the north transept

In 1252, four years before the start of work on the Angel choir, the retrochoir at Ely had been dedicated in the presence of King Henry III. It is this work that is the stylistic link between the nave and the Angel choir at Lincoln. Thus, just as the Ely retrochoir had looked for inspiration to the Lincoln nave, so now the Lincoln retrochoir was to look to the Ely retrochoir. The two retrochoirs are, in fact, extremely close in design and in general profusion of detail, and ultimately Westminster accounts for much of this similarity. However, Lincoln significantly rejected the chevet of Westminster in favour of the square east end of Ely. In the gallery at Ely the twin lancets are trefoiled, but there is as yet no bar-tracery in the spandrels, nor is there any of the figure sculpture that plays an important part at

53

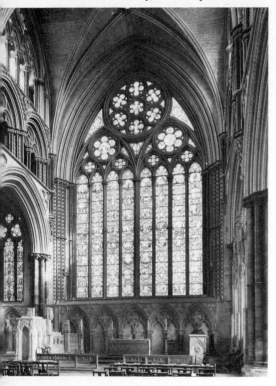

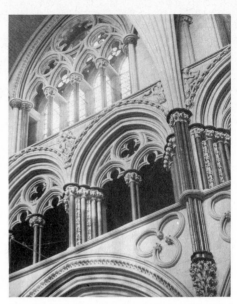

Lincoln Cathedral, the Angel Choir, with detail showing double tracery in the clerestory

Westminster and Lincoln. Indeed, the Angel choir derives its name from the twenty-eight carved angels that fill so delightfully the gallery spandrels, where they recall the angels in the corners of the rose windows in the transepts at Westminster. The rippling lushness which brings the Angel choir to the verge of the Decorated style reaches a peak in the lavish clerestory, constructed according to the traditional Anglo-Norman pattern of a thick-walled gallery. It is a measure of the new-found passion for tracery and, indeed, for constructing whole walls of tracery, that the extravagant designer of the Angel choir clerestory could not resist duplicating on either side of his wall passage the whole set of mullions and traceried lights, glazed on the outside wall and open on the internal wall looking into the choir. This translucent double screen, part glazed, part open tracery, is doubtless inspired by the double tracery in the triforium at Westminster. This was itself an echo of the glazed triforia linked to the clerestory which, beginning at St Denis in the 1230s, were a feature of the French Court style.

At the Augustinian houses of Newstead Priory, Nottinghamshire, and Thornton Abbey, Lincolnshire, the influence of Lincoln predominates. The west front of Newstead (1280–90) is a particularly satisfying tripartite composition dominated by three traceried windows of immense size. Interestingly, the whole right-hand third of the façade is an early example of a 'sham' since it does not terminate an aisle but merely conceals some of the monastic buildings. At Thornton we can see the ruins of a fine octagonal chapter house begun in 1282 in a

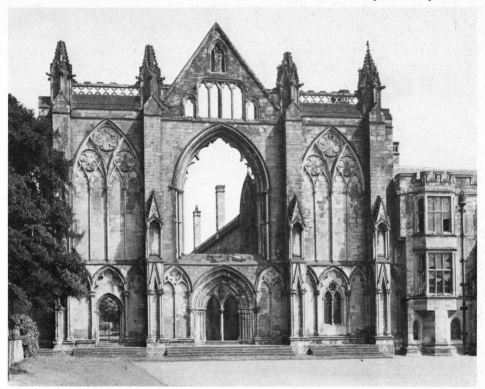

Newstead Priory, Notts., the west front

style derived from Westminster and Lincoln. The surviving chapter house at Southwell Minster, Nottinghamshire (*c.* 1290), with tracery deriving from the east window at Lincoln, is architecturally similar to that at Thornton but is chiefly memorable for its outstanding display of naturalistic foliage-capitals. Drawing on the realist sculptural style introduced at Reims and the Sainte-Chapelle in the middle years of the century, the Southwell masons created a fresh, bright interior delightfully ornamented with crisp carvings of English flowers and leaves.

Exeter and Wells

The rich style of the Lincoln Angel choir found particular favour with the builders of the new nave at Exeter who began work shortly before 1280 at about the time of the

Southwell Minster, Notts., detail of capitals from the entrance to the chapter house

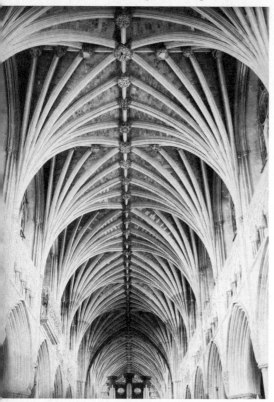

Exeter Cathedral, the nave looking east

rather than soars. Everywhere there is colour and surface decoration to charm the eye: the naturalistically carved foliage-corbels and bosses are set off against the grey Purbeck marble piers, yellow sandstone arches and white Caen stone above. Behind and around one there is always the great web of stone window tracery in the Geometrical style of Westminster and Lincoln, though with a few individual twists in the choir which point forward to the Decorated future.

Even more important and more sophisticated work was done at Wells Cathedral from *c.* 1285 into the third decade of the fourteenth century. A charmingly irregular and complex staircase of *c.* 1270 leads up to the chapter house (*c.* 1290–1307) with a breathtaking vault which owes much to the celebrated palm-tree effects of the Exeter vaults. From the central pillar, enriched with sixteen marble shafts, no less

completion of Lincoln. Breadth and multiplicity are the keynotes of Exeter, beginning with the diamond-shaped piers in the presbytery, set about with as many as sixteen shafts and supporting arches with equally complex mouldings. The elaborate tierceron vault continues this theme, and its surface is so richly adorned with ribs that we hardly notice the cells between them. Its weighty surface and duplicated ribs obscure the clerestory windows so that, rising from piers which are unduly short by French standards, it helps to ensure that the church spreads

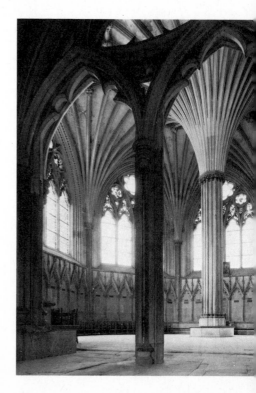

Wells Cathedral, the chapter house

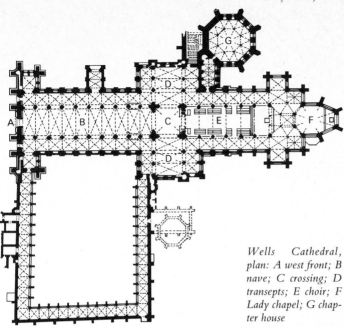

Wells Cathedral, plan: A west front; B nave; C crossing; D transepts; E choir; F Lady chapel; G chapter house

than thirty-two ribs (as compared with only sixteen in the Westminster chapter house) spring lithely upwards and outwards to meet the ribs that radiate from the corners of the octagonal room. This lively movement is echoed in the complex wall arcade running right round below the large windows, which have tracery verging on the Decorated.

The chapter-house theme was repeated with variations in the new Lady chapel and retrochoir that were added at this time at the east end of Wells. The complex vistas created here are easier to experience than to describe. To put it in the simplest terms, the Lady chapel is an irregular elongated octagon with three sides projecting at the east to form an apse, and the three corresponding sides at the west are left open in the form of arches so as to allow the space to flow into the retrochoir, which is considerably lower than the Lady

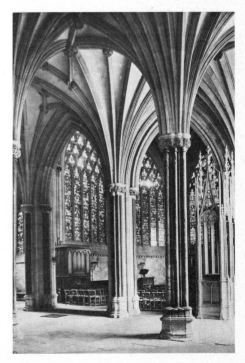

Wells Cathedral, the Lady chapel

57

chapel. The design of the retrochoir is still more complicated, since its piers tend to suggest that it is an elongated hexagon at right angles to the Lady chapel. However, the vaults do not really bear this out and the principal impression is one of cones of ribs juxtaposed in pleasing confusion. Before leaving the Lady chapel, we should note early examples of two features that were to be of central importance in the Decorated style: the nodding or three-dimensional ogee arch in the sedilia, and the lierne vault. These are key examples of that diagonal pattern-making in space which, as we have seen, characterized the Wells chapter house and east end. A lierne vault can be defined as containing minor ribs that do not spring from either the main springers or from the central boss. The significance of this is that the ribs lose their functional purpose and the vault becomes purely decorative.

The Decorated style

The Norman church of the Augustinian abbey at Bristol, made a cathedral by Henry VIII in 1542, was given a new five-bay aisled chancel with side chapels and an eastern Lady chapel under Abbot Knowle between 1298 and *c*. 1330. The new work is basically a hall church with aisles the same height as the nave, but the designer has deliberately introduced complexities into the construction of the aisles so as to suggest, among other things, that they are lower. These picturesque complexities have their origin in a structural system in which the weight of the choir vault is carried to buttresses in the outer aisle walls by means of curious horizontal stone beams spanning the aisles. These may be inspired by the similar beams in the lower chapel of the Sainte-Chapelle, that *locus classicus* of the Court style. At Bristol the beams are themselves carried by arches of which the spandrels are left open, so that we can see through from bay to bay. Even above the level of the beams we are encouraged to look through in a series of piquant vistas because in each aisle bay the

cells of the vault immediately over the beam are omitted. The lines of spatial flow are further accentuated by the remarkable design of the piers, which are really continuous mouldings rather than shafts. Thus most of the members are not surmounted by capitals but flow uninterruptedly from the base up to the apex of the arcade and down again to the base. This is extremely unusual as early as the end of the thirteenth century and becomes an important feature of Late Gothic, particularly in Germany.

The way that ingenious spatial play especially appealed to the Bristol masons can also be seen in the ante-room vault of the Berkeley Chapel (*c*. 1305–10), which opens off the south aisle. This interior is a kind of joke with a flat ceiling supported by the whole paraphernalia of ribs, transverse arches and bosses in which all the cells are simply omitted: a stone version of the emperor's new clothes!

There are further innovations of greater seriousness in the chancel vault, which is one of the earliest lierne vaults. To emphasize the novelty of the liernes, the designer used them to create down the centre of the vault a series of kite-shaped areas which he further emphasized with cusping. The whole forms an unstructural pattern of considerable decorative charm, which had an immediate impact on the design of the even more fanciful choir vaults at Wells (*c*. 1330) and Tewkesbury (*c*. 1340) and the south aisle at St Mary Redcliffe, Bristol (*c*. 1330).

At St Mary Redcliffe, which is one of the most sumptuous parish churches in the country, the north porch of *c*. 1325 is a design of spectacular originality, not to say eccentricity. It has a highly unusual hexagonal plan and a complex doorway surrounded by three bands of the intricate, knobbly and not especially naturalistic foliage-carving, which came in at the beginning of the fourteenth century. This lush decoration is so profuse as to have a positively Indian quality. The actual frame of the door consists of six linked concave arches with an upwards-swinging effect

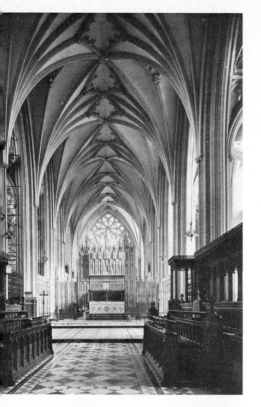

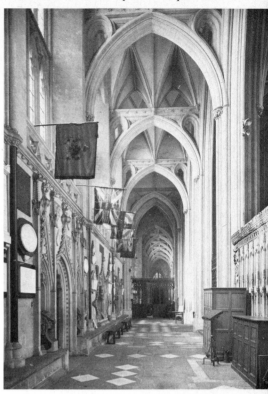

Bristol Cathedral, the choir looking east (above left), the south choir aisle (above), and the vestibule to the Berkeley Chapel (left)

based on the tomb recesses in the presbytery of Bristol Cathedral. The only other hexagonal porch in England is at St Laurence's church, Ludlow, Salop, but something of the overloaded and luxurious profusion of St Mary Redcliffe's porch can be seen in the south aisle of the parish church at Gaddesby, Leicestershire.

When the central tower of Wells needed strengthening in the 1330s it was decided to insert strainer arches into the crossing to help to carry the weight. The design of these powerful inverted arches of gigantic size and extraordinarily arresting impact

59

St Mary Redcliffe, Bristol, the north porch

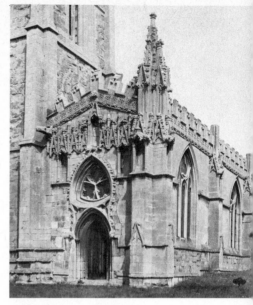

Gaddesby, Leics., the south aisle

echoes certain details at Bristol Cathedral in the sedilia and aisle bridges.

On a smaller scale, the following exquisite monuments and fittings are characterized by spatial complexity and delicacy with prominent use of the nodding ogee arch: the wooden bishop's throne (1313–c. 1317) and stone sedilia of c. 1320 in the presbytery at Exeter Cathedral, Edward II's tomb at Gloucester (1329–34) and the Percy tomb at Beverley (c. 1339).

At Ely Cathedral there is further indication of the interest in spatial surprise which can be detected in the hexagonal planning of the porch at St Mary Redcliffe or in the astonishing vault of the monastic kitchen at Durham (1366–71), with its central octagonal opening. The Norman crossing tower of Ely Cathedral collapsed in February 1322 and in its place rose the unique and lovely octagon which can be seen as the culmination of what had been learnt in the design of the chapter house at Wells. Light floods in not only from the

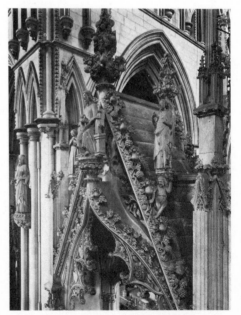

Beverley, Yorks., detail of the Percy tomb

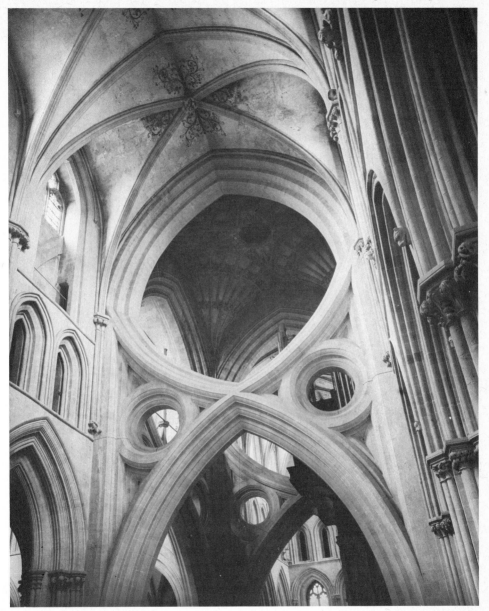

Wells Cathedral, strainer arches in the crossing

great diagonally placed windows in the side walls but also downwards from the lantern placed above the dramatically cut-away vault. To construct the lantern in stone would have posed so many problems that the Ely masons called from London the king's master-carpenter, William Hurley, to devise a solution in timber. His lantern does not rest, as it appears to, on the vault beneath (which is also, deceptively, of wood), but on a cantilevered timber frame entirely concealed from view. The whole construction forms one of the most daring and imaginative pieces of architecture in England. The blind tracery inside the timber lantern is proto-Perpendicular in character. It was erected in the 1340s at the same time as the timber roof of St Stephen's Chapel, Westminster, which was also designed by William Hurley. The work at Ely and Westminster reflects a Court taste which we shall shortly investigate in more detail.

In falling, the Ely tower had damaged the Norman choir so that in *c.* 1328–35 the first three bays of the choir were rebuilt. Taking as his starting point the calmer and more classic design of the Early English retrochoir to the east, the designer of the new choir produced a glittering and graceful structure in which the delicately ornamental gallery tracery contrasts tellingly with that in the retrochoir. Above floats one of the loveliest and earliest of lierne vaults, with the central ribs forming a series of six-pointed stars.

With work on the new choir complete, the masons immediately turned their attention to the vast new Lady chapel. This was begun as early as 1321, but work was interrupted when the crossing tower fell a year later. The interest in movement and diagonality which we have observed at Wells, Bristol and the Ely octagon is demonstrated here in the remarkable arcading of three-dimensional or nodding ogee arches that runs round the sides of the chapel. This Curvilinear complexity is echoed in the tracery of the great windows and in the broad lierne vault with star patterns dissolving the distinction between

bays. The wall niches are richly decorated with sculpture, now much damaged, depicting the life and miracles of Our Lady. The architectural details were originally richly coloured. The loss of this polychromy, as well as most of the stained glass, has made the chapel far lighter and cooler in effect than its designers intended.

The gatehouse at the Augustinian priory of Butley in Suffolk is one of the more enchantingly festive minor buildings in the Decorated style. The gaiety of the flushwork decoration, which was to become an East Anglian feature, the elegant sham tracery and the great chequer-board of coats of arms alternating with fleurs de lis set in flint, combine to

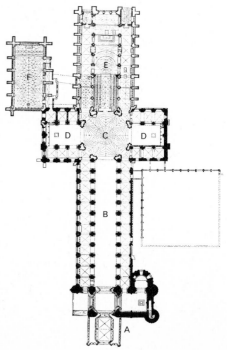

Ely Cathedral, plan: A west front, with galilee porch; B nave; C crossing, with octagon over; D transepts; E choir; F Lady chapel

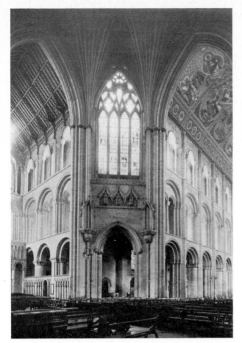

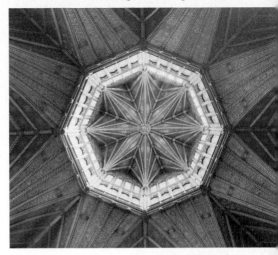

Ely Cathedral, the octagon; the crossing (left) was made octagonal by adding a diagonal bay across each corner and covered by a wooden vault with a lantern (above)

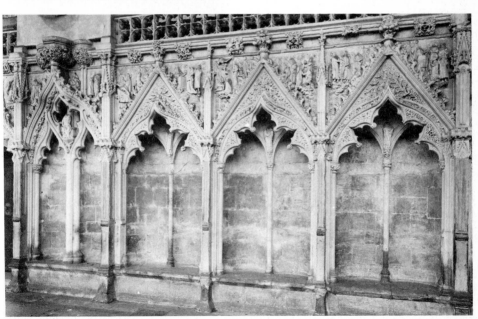

Ely Cathedral, detail of wall niches in the Lady chapel

Butley Priory, Suffolk, the gatehouse

produce a classic example of what De-corated Gothic means as an architectural term.

The Court style and the origins of Perpendicular

We have become accustomed to fairly rapid stylistic change in the development of English mediaeval architecture. How-ever, from about 1350 to 1550 the dominant style was what is now known as Perpendicular. This is an essentially recti-linear system of design based on the repetition of cusped panels. It has some claim to be regarded as 'the national style of England', since it is not found on the Continent. As we shall see, it grew out of the English Court style, first in the Decorated context of St Stephen's Chapel, Westminster, and then in the more austere and more strictly French form of St Paul's chapter house and the eastern parts of Gloucester Cathedral. But it should be emphasized at this point that the origins of the Court style were themselves French.

King Edward I is perhaps best known architecturally for his magnificent Welsh castles, but the finest and possibly most important building that he commissioned has unfortunately largely disappeared. This was the immensely richly-decorated two-storey St Stephen's Chapel in the Palace of Westminster, begun in 1292 as

the English answer to the Sainte-Chapelle in Paris. Save for the clerestory and vault, which were added in 1330–47, it seems to have been complete by 1327. It was used as the House of Commons from 1547 until 1834 when it was burnt and subsequently demolished, save for the crypt which survives, heavily restored. What is parti-cularly important here is that it made architectural use of tracery patterns in a way that was evidently based on the French Court style of the second half of the thirteenth century and which contained within it the seeds of the Perpendicular style. Thus at St Stephen's Chapel we find that in the interior the arched windows were framed at the top in a rectangle, that their spandrels were panelled with vertical tracery patterns and their mullions were prolonged downwards through the dado arcade as at Mantes Cathedral and St Nazaire, Carcassonne, in the 1280s. It also seems likely that on the exterior the mullions of the main windows descended in a kind of curtain in front of the crypt windows and so to the ground. In other words, St Stephen's Chapel approached the essentials of the Perpendicular style, in which a building is conceived as a cage defined by a grid of vertical mullions and tracery, glazed, blind or open. Exactly this pattern had been anticipated in the thirteenth-century French Gothic style known as Rayonnant, where it was in

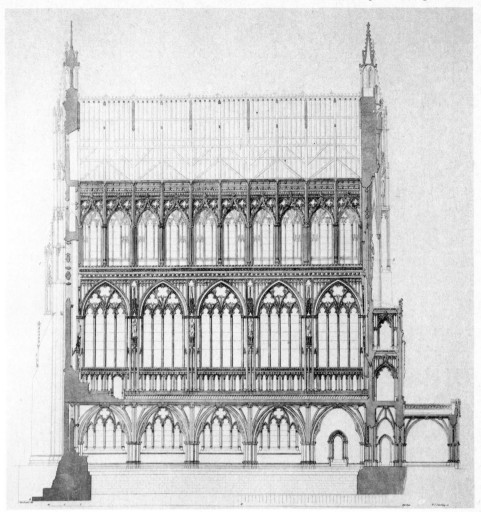

St Stephen's Chapel, Westminster, longitudinal section; only the undercroft now survives

some ways a natural consequence of the French avoidance of the thick-wall technique so dear to English designers.

This kind of autonomous tracery is particularly associated in France with the area of the triforium, for example, the St Denis choir (begun 1231), Troyes (c. 1235), the Tours choir (begun 1240), the Amiens south transept (1240s), the Notre Dame transepts (1258), the St Germer-de-Fly Lady chapel (c. 1259), the apse of St Urbain at Troyes (begun 1263), the Séez choir

(c. 1270), the apse lower windows at St Thibault-en-Auxois (c. 1290), the nave at La Trinité, Vendôme (begun 1306), and St Ouen, Rouen (begun 1318). The use of tracery in churches of this kind and in St Stephen's Chapel was reflected in the chapter house and cloisters of old St Paul's Cathedral. This is not surprising since they were designed in c. 1332 by William de

65

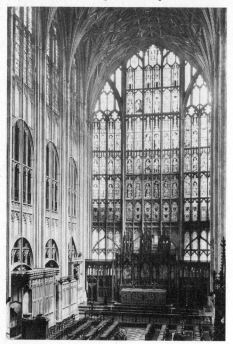

Gloucester Cathedral, the choir with east window

Ramsey who was a mason at St Stephen's in 1326 and who was in charge of work there from 1337.

The Perpendicular style is generally thought to have come of age at Gloucester Cathedral, where the south transept was remodelled in 1331–37 and the choir in *c.* 1337–*c.* 1350. It should now become clear that the reason why we have had to spend so long investigating buildings in London that no longer exist is that the work of Gloucester is close in both detail and overall conception to the Court style of St Stephen's Chapel and the chapter house and cloister of old St Paul's. So close that it has been assumed that William de Ramsey must have been involved in the design of Gloucester. Certainly, the Gloucester choir was a court building in that it was conceived as a shrine for the remains of King Edward II who was murdered in

1327 at nearby Berkeley Castle and who, it was hoped, would eventually become a royal saint like Edward the Confessor.

Gloucester is a fascinating example of the remodelling in an up-to-date style of an old building left largely intact beneath the fashionable veneer. Thus, in the Norman choir the arcaded aisles and tribunes over them survived, but were clad with an astonishing rectilinear grid of vertical tracery patterns, with the descending mullions of the French Court style running from top to bottom of the whole elevation. There are echoes here of St Thibault and of Narbonne, where the choir (begun in 1319) was already adorned with blind tracery of markedly proto-Perpendicular character. At the top of the Gloucester elevation a tall new clerestory was added. The other major structural change involved the replacement of the Norman apse and ambulatory with what is simply a vast wall of glass right across the east end. This is canted against wind pressure and is actually slightly wider than the choir. The tracery patterns of this great

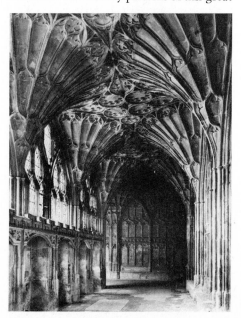

Gloucester Cathedral, the cloister

east window and of the side walls of the choir make prominent decorative use of the horizontal as well as the vertical mullions, an emphasis which was to be more typical of the coming Perpendicular than of the Court style. The stained glass of *c.* 1350 in the east window has survived intact as the first example with tiers of full-length figures, a type often repeated into the fifteenth century.

The lierne vault in the choir is of unparalleled complexity, chopped up into countless small compartments by the liernes and tiercerons which are everywhere punctuated by prominent bosses. As a *tour de force* it is an unquestionable triumph, but whether its particular kind of linear and textured complexity fits visually with the linear complexity of the traceried walls is less certain. The possible aesthetic conflict was sensed by masons at the time, who resolved it by inventing the fan vault either between 1360 and 1370 in the chapter house at Hereford (demolished 1769), or in the south-eastern bays of the cloister at Gloucester some time between 1351 and 1377. Most people associate Perpendicular particularly with the fan vault, which is reasonable since the fan vault is in part the result of the application to a vault of the tracery patterns that characterize the walls and windows of a Perpendicular building. Thus, the essence of the fan vault is structurally the solid concave-sided semi-cone to which is applied surface decoration of cusped panels giving the *appearance* of an elaborate rib vault.

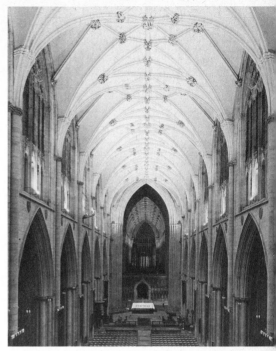

York Minster, the nave looking east

York, Canterbury and Winchester

Contemporary with St Stephen's Chapel was the nave at York Minster, begun in 1291, which, similarly, owed much to the French Court style and influenced later English cathedral design. If variety had been the keynote of the Decorated style, uniformity was to be that of the coming Perpendicular. We can see the beginnings of this calm rectilinear uniformity at York, where French-inspired descending mullions unite the clerestory with the triforium so as to suggest the two-storeyed elevation of Late Gothic.

How easily this style lent itself to Perpendicular treatment can be appreciated in the instructive contrast between the nave at York and the eastern parts, where the presbytery (or Lady chapel) of the 1360s and the choir (*c.* 1380–1400) continued in general outline the system of the earlier nave, but were adorned with blind arcading inspired by Gloucester. The immense Perpendicular east window is even larger than that at Gloucester. Extraordinary openwork grilles or screens of vertical mullions are placed dramatically in front of a number of windows at the east end of York: on the outside they appear before the windows of the retro-

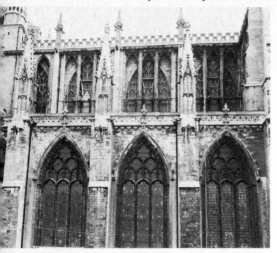

York Minster, detail of the choir clerestory showing double tracery

York Minster, the east front

choir and presbytery, and on the inside before some of the windows in the eastern transepts and also before the great east window itself up to the springing of the arch. This extravagant and somewhat Picturesque gesture, which was also echoed in the nave at Bridlington Priory, Humberside, must be an echo of the thirteenth-century French Court style as expressed in sophisticated buildings like Séez Cathedral and St Urbain at Troyes.

The magnificent east front at York is the grandest of that sequence of North-Country east fronts which includes Ripon, Guisborough, Selby and Howden. The powerful west front shows an interesting development from the relatively austere lower parts of *c.* 1291 to the sumptuous Decorated or Curvilinear tracery of the great central window (glazed 1338) and so to the elaborately Perpendicular towers dating from the middle decades of the fifteenth century. Elaborate Curvilinear tracery patterns became the hallmark of the Decorated style in Yorkshire and

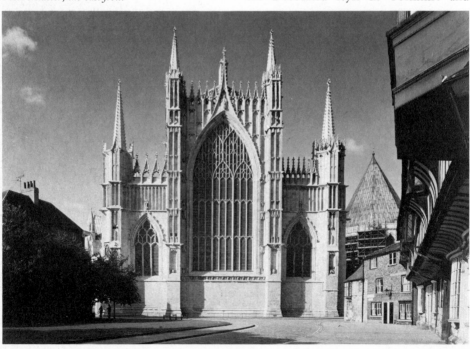

*Northleach church, Glos.,
the south porch*

elaborate timber roofs, and rich porches like that at Northleach, Gloucestershire. The towers are a reflection of the much larger steeples added to the major cathedral and monastic churches from the crossing tower at Lincoln, designed and built by Richard of Stow in 1307–11, to Hereford, Pershore, Salisbury, Lichfield and Norwich; and so to the great Perpendicular towers of Durham, Worcester, York, Beverley and Canterbury.

Somerset is particularly rich in towers, and one of them, Taunton (built between 1488 and 1514), will have to stand as an example of many. In fact it has many peculiarities of detail, including a set of pinnacles below the battlements as well as above them. On the other side of the country, St Botolph's church in the prosperous port of Boston, Lincolnshire, was given a colossal tower, 292 feet (89 metres) high, making it the tallest parish church tower in England. It was begun in 1309 but was built slowly so that most of it

Taunton church, Somerset, the west tower, accurately reconstructed in the mid-nineteenth century by Sir George Gilbert Scott

75

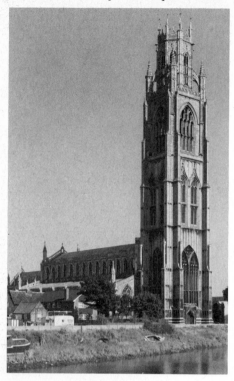

is Perpendicular rather than Decorated. The crowning feature, the openwork octagonal lantern, was not reached until 1515.

Some of the finest 'wool churches' are in Suffolk, for example the late-fifteenth-century church at Long Melford, with its huge Lady chapel almost detached from the body of the church, and Lavenham, with characteristic East Anglian flushwork and elaborate woodwork screens to the Spring chantry and the Oxford chantry. These churches owed their existence to donations from successful and pious clothiers among whom the Clopton family were predominant at Long Melford and the Spring family at Lavenham. Suffolk is also especially rich in examples of the Perpendicular timber roof, of which the most complicated and astonishing is that at Needham Market of *c.* 1470. The

St Botolph, Boston, Lincs.

Long Melford church, Suffolk, from the south-east, with the Lady chapel in the foreground; the tower is a nineteenth-century addition by G.F. Bodley

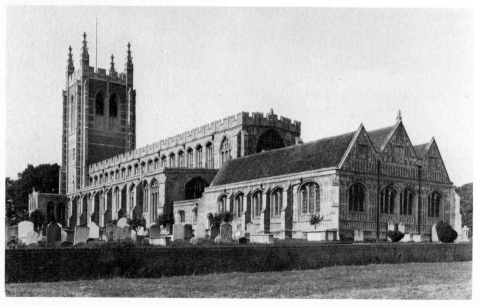

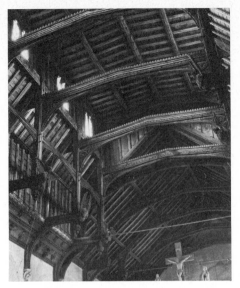

Needham Market church, Suffolk, detail of the roof

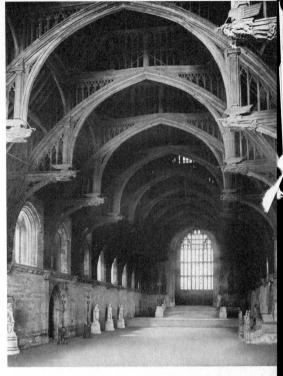

Westminster Hall, London

imaginative fantasy of its designer has turned a hammerbeam construction into an image of a whole church with nave, aisles and clerestory suspended in mid-air. The earliest large-scale hammerbeam roof is that inserted into Westminster Hall by the master carpenter Hugh Herland when the hall was rebuilt in 1394–1401 by Henry Yevele. The earlier aisled hall would have had timber or stone piers, and the hammerbeam roof was adopted partly because it did not require that kind of support.

Secular architecture

The last secular buildings we looked at were the keeps of the twelfth-century castles built for William the Conqueror and his associates. In the late thirteenth century Edward I built or remodelled more than twenty castles in Wales and on the border as part of his campaigns against Llewellyn and the Welsh. The noble symmetrical castle such as Harlech (c. 1285), inspired by early-thirteenth-century French and Italian precedent, lies rather outside the general development of mediaeval domestic architecture. It was, however, imitated at Bodiam Castle in East Sussex, built as a defence against the French in 1385, one of the last major castles erected in England. The plan of Bodiam has moved a long way from Harlech in that the notion of an outer fortified wall is less predominant than that of a fortified house consisting of four ranges surrounding a courtyard. The keep at Warkworth Castle, Northumberland, was built in c. 1400 by the first Earl Percy in a similarly sophisticated way so as to combine practical defence with elaborate living quarters and a beautiful symmetrical plan

77

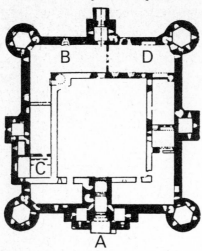

Bodiam Castle, Sussex, plan: A entrance via bridge over the moat; B Lord's hall; C chapel; D Lord's kitchen

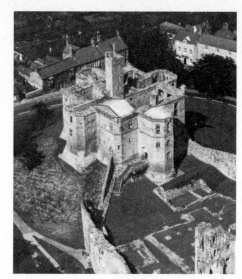

Warkworth Castle, Northumberland, the keep

formed by overlaying a Greek cross with canted edges on a similarly canted square.

The castle at Caister, Norfolk, built in the 1430s, is important as the first to be built in brick. This material, which was introduced into eastern England from the Low Countries and Germany in the fourteenth century, quickly revolutionized English domestic architecture. Caister was soon followed by other brick castles, such as Tattershall, Lincolnshire, begun in 1434 for Ralph Cromwell, Lord Treasurer under Henry VI, and Herstmonceux, East Sussex, licensed in 1440. These were evidently designed with a conscious aesthetic effect in mind at a time when castles were beginning to become an anachronism: indeed brick is perhaps not the best defence against cannon. Castles such as Herstmonceux are generally symmetrical in form whereas the immediate future lay in an empirical if Picturesque asymmetry. This asymmetry is well exemplified in the bishop's palace at Wells, particularly in the hall and chapel added in the 1280s and 1290s by Edward I's famous chancellor, Bishop Burnell. The random spreading plan is dominated by

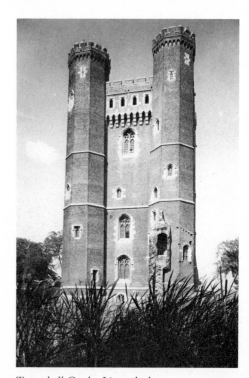

Tattershall Castle, Linc., the keep

two halls which remind us that mediaeval life was lived in common in a great hall and that what mediaeval men understood by a house or even a palace was precisely a hall. This normally had at one end a dais lit by a bow window, where the lord's table was placed, and at the other a screen with two doors leading via a cross-passage to the kitchen and pantry. In the later Middle Ages, the lord had a private apartment, or solar, at an upper level, accessible from the dais end of the hall. To enlarge a palace you would add another hall. At Oxford and Cambridge the rapid growth from the thirteenth century of small colleges, often on adjacent sites, is another instance of the social and architectural importance attached to the hall.

Markenfield Hall, North Yorkshire, built by a prosperous courtier in 1310, is an L-shaped house dominated by a fine hall. The great hall at Penshurst, Kent, was built in 1341 by John de Poultney, four times Lord Mayor of London. The same Lord Cromwell who had built Tattershall Castle also built himself a stone manor-house at South Wingfield, Derbyshire, in *c.* 1441. It is planned round two asymmetrical courtyards, the first containing servants' quarters, the second the lord's apartments comprising a hall with a great bay window, private rooms also with bay windows, the great chamber and a chapel (now destroyed).

Other manor-houses, particularly in Kent and Sussex, were built of timber-frame construction. An exceptionally well preserved example is Ockwells, Berkshire, built in the 1460s for Sir John Norreys, Master of the Royal Wardrobe. The house has no features connected with defence and is, by contrast, memorable for its tremendous extent of windows, allowing sunlight to pour in through elegant heraldic glass.

A close parallel to manor-house design is afforded by the colleges of Oxford and Cambridge. William of Wykeham, Chancellor of England and a great architectural patron, founded New College, Oxford, in 1379. The college buildings, which were

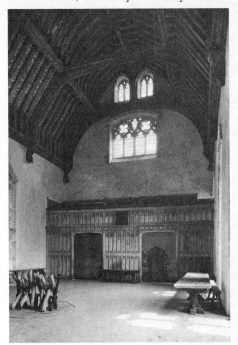

Penshurst, Kent, the hall

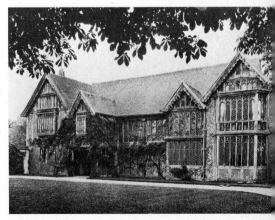

Ockwells, Berks.

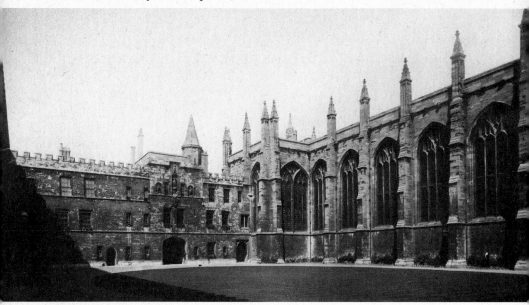

Oxford, New College, Great Quad, with chapel on the right

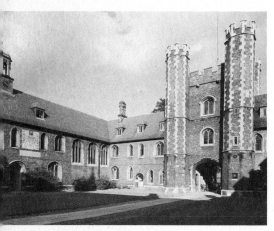

Cambridge, Queens' College, Principal Court (above) and plan (right)

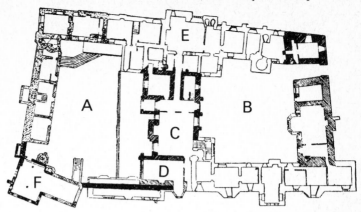

Haddon Hall, Derbyshire, plan: A upper courtyard; B lower courtyard; C hall; D dining room; E kitchen; F chapel

put up in the next decade by William Wynford, a royal master-mason, combined in a single, formal quadrangle all the essential elements of a college: chapel, hall, library, warden's lodging, treasury, and residential chambers for fellows and undergraduates. This influential plan was

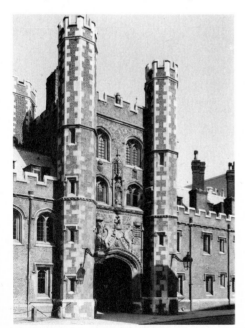

Cambridge, St John's College, gate-tower

followed at Oxford in, for example, the fifteenth-century colleges of All Souls, Queen's and Magdalen. At Cambridge the standard collegiate plan was not established until the building of Queens' College in 1448–49, where the master-mason may have been Reginald Ely, the first architect of King's College Chapel. The plan of Queens' has sometimes been seen as a reflection of fifteenth-century manor-house design as, for example, at Haddon Hall, Derbyshire. The use of brick is characteristic of Cambridge, as is the great gatehouse, a type which found its fulfilment in the heraldically decorated gate-tower of St John's College (1511).

We have now reached the eve of the Reformation, a cataclysmic event that turned England upside down. The shattering effect of the dissolution and destruction of the monasteries must in some ways have been greater than the impact in later centuries of the French and Russian revolutions. The fate of the colleges of Oxford and Cambridge also hung in the balance, but they were unexpectedly spared dissolution, though only by a hair's breadth. The severance of England from the Roman Catholic Church and from the whole of European culture associated with it had an irrevocable effect on her art and architecture and on the kind and extent of artistic patronage available.

Later Tudor and Jacobean Country Houses

The arrival of the Renaissance

WE ENDED THE LAST CHAPTER on a certain note of alarm at the change in patronage effected by the Reformation in England. Thus, after the break with Rome we find little architectural patronage by Henry VIII, less by Elizabeth and virtually none by the Anglican Church. This, indeed, is the first chapter which not only does not have ecclesiastical buildings as its main theme but in which there is no need to mention a single church at all! The position of the ruling élite when Elizabeth came to the throne was by no means secure: their Protestant religion was not widely shared by the people as a whole, which also made the country especially vulnerable to invasion and attack by the Catholic countries of Europe. There was a constant fear that the queen's death would lead to the overthrow of the government and the class that supported it. The great country houses at which we shall be looking in this chapter may have arisen partly from a desire to glorify and hence to stabilize the position of the queen and the governing class.

Architecturally, England's isolation from Rome meant that from henceforth she was to receive knowledge of the Italian Renaissance only at second hand from northern European sources which tended to lack the grace and purity of the Italian originals. Things had been very different right up to the Reformation, with the Renaissance making its impact in a most distinguished and sophisticated way in two works for Henry VIII. These are the tomb of Henry VII and Elizabeth of York in Henry VII's Chapel at Westminster Abbey, and the screen at King's College Chapel, Cambridge. The tomb was carved in 1512–18 by the Florentine sculptor Pietro Torrigiano (1472–1528) in black-and-white marble with figures of bronze gilt. The magnificent yet delicately carved oak screen of c. 1533–36 at King's College Chapel is possibly the work of Benedetto da Rovezzano (1474–1552), another Florentine sculptor, whom Cardinal Wolsey had brought to England to design his own tomb at Windsor. Incidentally, the sober black marble sarcophagus of this tomb, carved in 1524–29, can be seen today in the crypt of St Paul's Cathedral where it was incorporated into the tomb of Nelson in 1806.

At Wolsey's palace of Hampton Court, begun in 1514 as the largest house in England, Ann Boleyn's gateway was adorned in 1521 with terra-cotta roundels of Roman emperors by Giovanni da Maiano. A room known as Wolsey's Cabinet also contains beautiful Renaissance ornament in its frieze and coffered ceiling. The palace as a whole, however, is conceived within the old-fashioned tradition of brick courtyards and gatehouses which we saw developing at Cambridge in the fifteenth century. Given by Wolsey to Henry VIII in 1529 in an unsuccessful attempt to stave off his downfall, Hampton Court was enlarged by the king during the 1530s. Wolsey's Great Hall was now remodelled with a

Layer Marney Towers, Essex

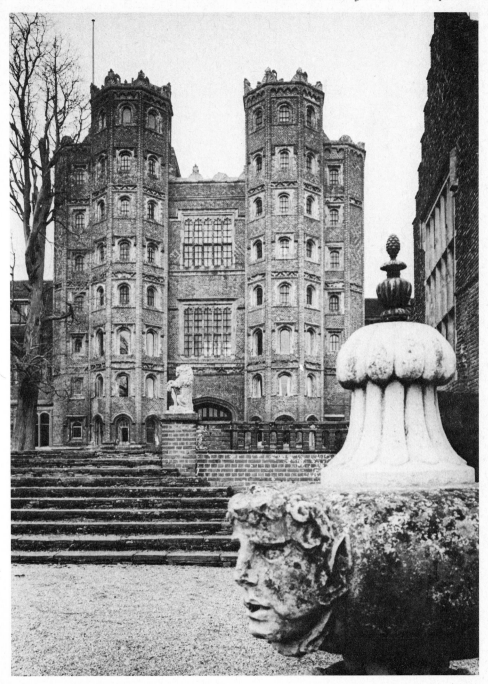

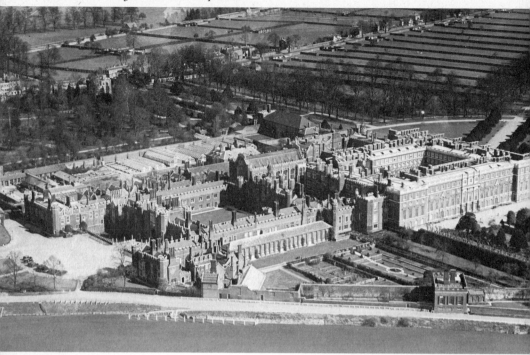

Hampton Court; the Tudor Palace is on the left, the later ranges, built by Wren for William and Mary, on the right

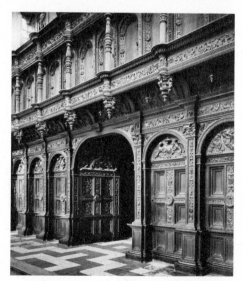

Cambridge, King's College Chapel, the screen

superb hammerbeam roof tricked out with Renaissance ornament.

One of Henry's principal courtiers, Sir Richard Weston, built Sutton Place, Surrey, in the early 1520s, a house which is adorned with small panels of elegant Italian decoration cast in terra cotta, a material introduced into England by Torrigiano. The brick-built house forms a courtyard entered by a gatehouse, now demolished, of the traditional English pattern, but the hall range is selfconsciously symmetrical in the Italian or French way so that the great hall is entered, rather inconveniently, from its centre rather than from the customary screens passage. At the same time Lord Marney, another of the king's courtiers, began a spectacular house in Essex, Layer Marney

Towers (*c.* 1520–23), of which only the gatehouse was completed. Though there is nothing Italianate about the plan or form of the building, it boasts even more terra-cotta Renaissance decoration, and of more varied pattern, than Sutton Place.

Henry VIII's own palace of Nonsuch, begun in 1538 and demolished in the 1680s, was renowned for its fantastical skyline and elaborate stucco decoration, inspired by the palaces of François I at Chambord and at Fontainebleau where the Italian Mannerists, Rosso and Prima-ticcio, had been at work since about 1530.

After Henry's death in 1547 the country was run for two years by Lord Protector Somerset who, to judge from his London house in the Strand, was a more discerning architectural patron than the king. Built from 1547 to 1552 and demolished in the eighteenth century, old Somerset House, or at least its Strand façade, was the first classical building in England. It was a completely symmetrical composition crowned by a straight balustraded skyline broken in the centre by the higher entrance gateway with a triumphal-arch motif on the ground floor. Much of this is evidently based on contemporary French work such as the château of Ecouen by Jean Bullant who, with Philibert de l'Orme and Pierre Lescot, had developed by the mid-sixteenth century a mature and recogniz-ably French version of Italian Renaissance architecture.

From the remarkable Somerset House and the circle surrounding its patron there flowed influences and ideas that were to change the face of English architecture. Somerset's steward, Sir John Thynne, was to build Longleat; his secretary, William Cecil, was to build Burghley House; his brother's confidant, Sir William Sharing-ton, had already added exquisite Re-naissance features in the 1540s to the monastic property of Lacock, Wiltshire, which he had acquired in 1540; and finally his successor as Protector, the Duke of Northumberland, sent a member of his household called John Shute to Italy in 1550 to study antique and modern ar-chitecture. In 1563 Shute published the first English book on the classical orders, *The First and Chief Groundes of Architecture*. With its engravings of the five orders it depends less on first-hand observation of

Old Somerset House, London, front towards the Strand

Burghley House, Northants., courtyard and tower

Stonyhurst, Lancs., entrance front

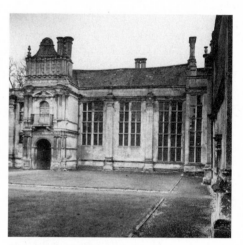

Kirby Hall, Northants., courtyard

Italian architecture than on Serlio's influential *Regole generali di architettura*, which appeared in six parts between 1540 and 1551, with a seventh volume published posthumously in 1575.

The immense Burghley House was built from the 1550s to the 1580s for William Cecil, who was Chief Secretary of State from 1558, first Lord Burghley from 1571, and Lord High Treasurer from the following year. The great courtyard boasted an open Italianate colonnade and a spectacular three-storey tower dated 1585, displaying the orders on different storeys. This monumental composition culminated in a huge pyramid-like obelisk flanked lower down by two smaller ones. It looks back not only to the Somerset House frontispiece but to Philibert de l'Orme's work of *c.* 1550 at the château of Anet, including the celebrated gateway and the pyramidally-capped chapel towers. The frontispiece adorned with the orders became a particularly popular type, of which a characteristic if comparatively little-known example is the four-storey gate-tower built for Sir Richard Shireburn at Stonyhurst, Lancashire, in *c.* 1592–95.

With its giant pilasters and the rather French planning of its courtyard, Kirby Hall, Northamptonshire (1570–73), is a very striking and unusual example of direct decorative influence from Shute and Serlio. However, designers increasingly turned for decorative inspiration to the more fancifully patterned ornament, including strapwork, to be found in

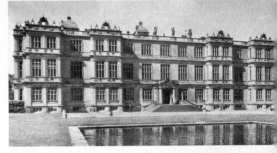

Flemish and German publications such as J. Vredeman de Vries's *Architectura* (1563) and *Compertimenta* (1566), and Wendel Dietterlin's *De Quinque Columnarum* (1593) and his even more extravagant *Architectura* (1598).

Robert Smythson (*c.* 1536–1614) and the Elizabethan prodigy house

Longleat, Wiltshire, is the first monument in the group of giant buildings aptly christened 'prodigy houses' by Sir John Summerson. Longleat has an extremely complicated building history since its façades, probably designed by Allen Maynard and Robert Smythson, were erected in 1572–80 round a house built in 1568 after a fire the previous year in which a yet earlier house was burnt. Compared with previous houses, and many later Elizabethan ones, Longleat is memorable for its compactness, horizontality, reticent silhouette, and undeniably classic *gravitas*. The other characteristic features are the tremendous extent of glass and the bay-window units which are obviously derived from old Somerset House.

Robert Smythson's next major work after Longleat was Wollaton Hall in Nottinghamshire. This was built in 1580–88 for Sir Francis Willoughby who wanted a grand setting in which to entertain the queen. Wollaton is like a far more dramatic version of Longleat with the corners vigorously pulled out to form towers. Apart from Longleat, its sources include English Gothic as well as plates in the third book of Serlio's *Architettura* (1540), in de Vries's *Variae Architectae Formae* and *Tombs* (both of 1563) and in his undated *Caryatidae*. Many exterior details such as the banded pilasters, cartouches and strap-work gables derive from de Vries as do details of the screen in the great hall; the design of the chimney-piece in the hall is based on Serlio. The plan of the whole building seems to have been inspired by Serlio's design for Poggio Reale, which consists of a rectangle with four squares attached to its corners and containing a hall

Longleat, Wilts., entrance front, probably by Maynard and Smythson; the doorway is a later addition

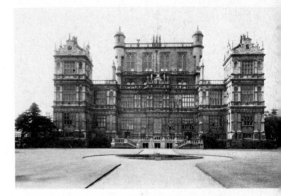

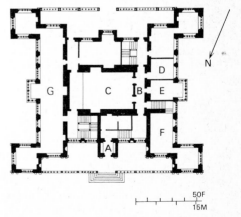

Wollaton Hall, Notts., by Robert Smythson, entrance front (above) and plan (below): A entrance; B screens passage; C hall; D pantry; E buttery; F kitchen; G long gallery (on upper floor)

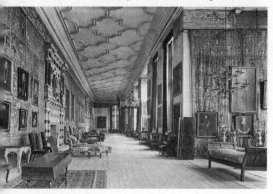

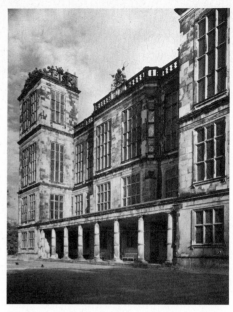

at its centre. To gain light, the central hall at Wollaton has to rely on a clerestory which rises high above the main body of the building. Amazingly, another room of the same length and breadth as the hall stands on top of it, where it helps to create the fairy-castle skyline of Arthurian or Spenserian romance.

It seems almost certain that Robert Smythson was also the designer of Hardwick Hall (1590–96), the great Derbyshire seat of the wealthy and eccentric Elizabeth, Countess of Shrewsbury, 'Bess of Hardwick'. As at Wollaton the many-windowed rectangularity of Longleat has been the starting point for a composition of more animation and

Hardwick Hall, Derbyshire, probably by Robert Smythson, entrance front; long gallery and plan: A entrance vestibule; B hall; C main staircase; D pantry; E buttery; F kitchen; G chapel

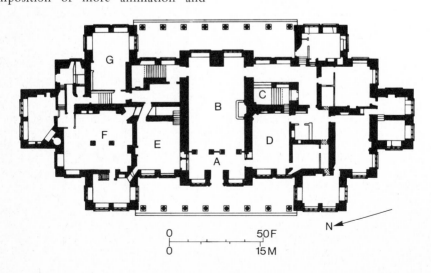

0 50 F
0 15 M

N

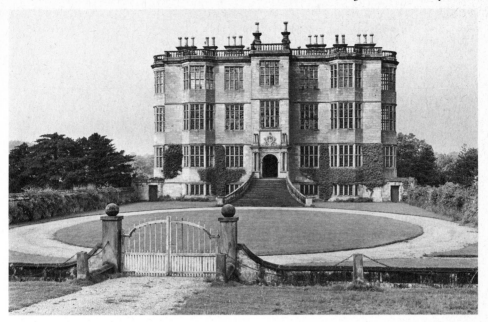

verticality. The most remarkable and influential feature of the extremely complex plan is the two-storey great hall with its long axis running at right angles to the main body of the house. Among the advantages of this novel disposition was that it enabled the hall, which had essentially been an asymmetrical feature in the mediaeval house, to be incorporated symmetrically into the centre of the plan.

Hardwick has been less altered internally than either Longleat or Wollaton and survives with much of its original tapestries, plasterwork, paintings and fittings to give an eloquent impression of late-Elizabethan life on the grand scale. By this time the great hall had ceased to be used for meals by the owner and his family, so that at Hardwick there was a first-floor dining room as well as the ground-floor hall. It was also becoming customary in large houses to have two suites of apartments, state and private, on different floors. Thus Bess's private rooms were on the first floor while the state rooms, including a great chamber and the

Wootton Lodge, Staffs., perhaps by Robert Smythson, entrance front

inevitable long gallery, were on the top or second floor, where they commanded spectacular views.

The last in this sequence of Smythsonian houses at which we shall look is Wootton Lodge, Staffordshire, built in *c.* 1607–11 for Sir Richard Fleetwood as a hunting lodge. It is only attributable to Smythson on stylistic grounds, but its entrance façade has a classic serenity that one can well imagine as the last work of an old and distinguished designer. Other North-Country houses that fit into this particular school are Heath Hall (1585), West Yorkshire, Burton Agnes (1601–10), Humberside, Barlborough (1584–85), Derbyshire, and Gawthorpe (*c.* 1600), Lancashire.

A good example of the less spectacular type of large late-Elizabethan house is afforded by Condover Hall, Salop. This was built in *c.* 1598 by a talented local

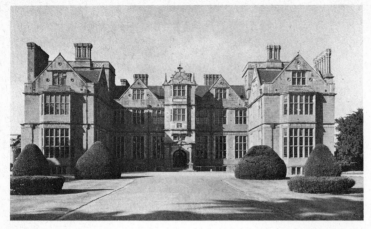

Condover Hall, Salop,
entrance front

mason, Walter Hancock, for Judge Thomas Owen, Justic of Common Pleas. With its familiar E-shaped plan and big comfortable gables it has an easy symmetrical dignity.

There is undoubtedly a materialist glamour about the prodigious architecture of the Elizabethans, but this should not blind us to their love of symbolism and conceit. Nowhere is this better exemplified than in the small but highly eccentric Triangular Lodge built by Sir Thomas Tresham in 1594–97 in the grounds of his Northamptonshire seat, Rushton Hall. He had been brought up in the new Protestant religion, but was received into the Catholic Church in 1580, for which he was imprisoned intermittently for eighteen of the last twenty-five years of his life. The Triangular Lodge was evidently built to symbolize the Blessed Trinity and the Holy Sacrifice of the Mass for which he had suffered so much. Raised on a triangular plan with three triangular gables on each side, it is profusely adorned with religious emblems and inscriptions.

At Longford Castle, Wiltshire (completed 1591), a whole house was built on a triangular plan with massive, mediaevalizing round towers at the corners. The north-west façade, restored by Salvin in the 1870s after extensive alterations in the

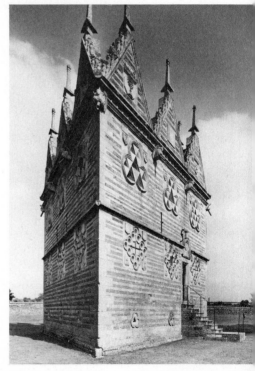

The Triangular Lodge, Rushton, Northants.

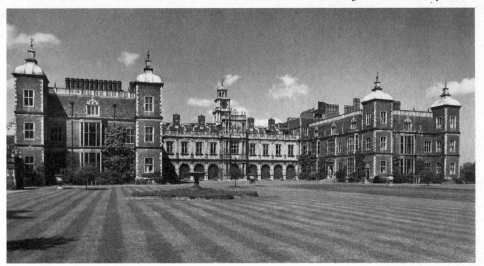

Hatfield House, Herts., the south (originally entrance) front

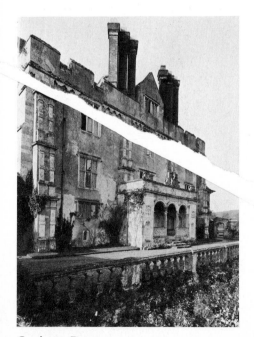

Cranborne, Dorset

in 1612 by Sir Charles Cavendish, son of Bess of Hardwick, from whom he doubtless inherited his passion for building. With John Smythson, son of Robert, as his designer, Cavendish created what is perhaps the first link in the long and colourful chain of 'sham' castles, which was to continue for three centuries. Indeed the last is probably Lutyens's Castle Drogo in Devon, built exactly three hundred years after Bolsover.

Bolsover has been linked by modern historians to the rich, fantastic world of Jacobean pageantry and tournaments and to Spenser's *Faerie Queene* (1590). It also stood on the site of a twelfth-century castle which it was presumably intended to recall in its design. The new keep is approached ~~tically through a fortified forecourt, scenically arranged in a manner~~ ren... ...the sham castles often erected ...rounds to masques and pageants. ... keep rises austere and unadorned ...line, military manner, its fashio... ...etry unexpectedly brokenorner tower. The real poetry isor the interior where there are ...erately archaic rib vaults in the hall and Pillar Parlour, and a remarkable series of ornate

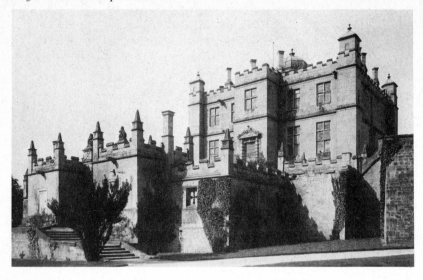

Bolsover Castle, Derbys., by John Smythson, the keep

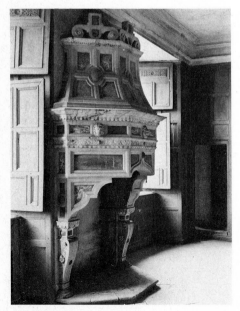

Bolsover Castle, chimney-piece

hooded chimney-pieces, which combine classic and Gothic features but are based in general terms on plates in Serlio's fourth book of architecture. Most of these were inserted by Sir Charles Cavendish's son William, subsequently Duke of Newcastle, who completed the keep after his father's death in 1617.

Artisan Mannerism

William Cavendish sent his architect, John Smythson, on an important journey to London in 1618–19. Here he recorded a number of up-to-date buildings including some in the style particularly favoured by rich City merchants, which Sir John Summerson has christened 'Artisan Mannerism'. On his return Smythson added to the keep at Bolsover a number of features inspired by this style such as pedimented balcony windows, and in 1629–34 he also added a detached wing containing an immense long gallery. The terrace façade of this gallery range is conceived in a bizarre Mannerist style sprouting into a series of attached columnar shafts corbelled out from the wall and adorned with banded and vermiculated rustication. They are like nothing else on earth.

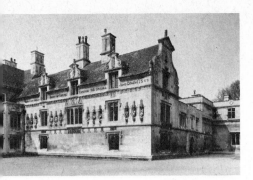

Stapleford Park, Leics., Lady Abigail's Range

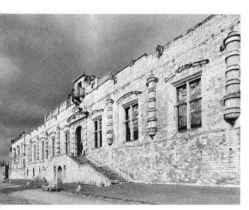

Bolsover Castle, by John Smythson, the terrace façade

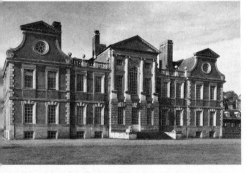

Raynham Hall, Norfolk, by Sir Roger Townshend, the east front

Later Tudor and Jacobean Country House

The two different traditions reflected in the gallery and the keep at Bolsover – Artisan Mannerism and a romantic attitude to the past – coalesce in an admittedly eccentric building of 1633 at Stapleford Park, Leicestershire, known after its builder as Lady Abigail's Range. A number of Gothic features, possibly brought from other buildings, have been selfconsciously applied to a building capped conspicuously by shaped and pedimented gables in the current Dutch fashion. These had arrived in London from Amsterdam by 1619, when they were recorded on a pair of houses in Holborn in a drawing by John Smythson of Bolsover.

Though of Jacobean origin, Artisan Mannerism quickly became established as a country-house style in the early years of Charles I's reign. It thus forms a fitting end to this chapter although it is really a parallel to the work of Inigo Jones at which we shall be looking in the next chapter. Eminently characteristic are Swakeleys, London (1629–38), and, less exuberant, the Dutch House at Kew, built in 1631 by Samuel Fortrey, a London merchant of Dutch descent. Like the Dutch House, Raynham Hall, Norfolk, is another regular building crowned by three Dutch gables. It was built some time between 1622 and 1632 by Sir Roger Townshend, a country squire and architectural amateur. Stylistically it is a curious combination of progressive, i.e. Jonesian, and old-fashioned, i.e. Artisan Mannerist, features such as the 'Holborn' or Dutch gables. On the west entrance-front there were originally two side entrances leading into screens passages at either end of the great hall, but other features of the plan recall the disposition of rooms in a Palladian villa. The east front has been altered even more than the west but it is still dominated by a remarkable temple portico of four attached columns surmounted by a pediment. This is based on one of Inigo Jones's designs for the Prince's Lodging at Newmarket of *c.* 1619; clearly we should delay our investigation of that great architect no longer.

5

From Inigo Jones to James Gibbs

The formation of Inigo Jones

THE REVOLUTION effected in English architecture by Inigo Jones (1573–1652) was important not merely for establishing a change of style but also a change in the intellectual and social status of the designer of buildings. Thus, from now on it would often give the wrong impression to say that a certain patron built a particular house with the assistance of a certain surveyor or mason, for increasingly we can, and indeed must, credit every major building with the name of its architect. The architect is now often a man of refined intellect who may have studied and travelled on the Continent and who can live on terms approaching equality with his patron; he is also often equipped with artistic gifts that enable him to draw and sketch his architectural ideas fluently on paper. In possessing all these attributes Jones stands out conspicuously from both his predecessors and his contemporaries.

Where did all this come from? The answer, of course, is Renaissance Italy. We have seen how in the course of the sixteenth century Renaissance features were applied to English architecture in an essentially *decorative* way, even when on a large scale, such as in the frontispieces of superimposed orders. In retrospect, it is amazing that no one seems to have grasped that the Renaissance implied a wholly new way of thinking about architecture in the round, and about the proportional relationship of all the parts. Now we know from his pupil, John Webb, that as a young man before *c.* 1603 Jones had spent 'many years' in Italy where he acquired a considerable artistic reputation. It seems likely that he had also studied the art of masque design at the Medici court in Florence, for, after his return, he was employed from 1605 as a masque designer by James I's queen, Anne of Denmark. It was at this time that he produced his first recorded architectural designs which were for a New Exchange in the Strand and for the completion of the central tower of old St Paul's Cathedral, which had lost its spire. His drawings for these projects, both dating from *c.* 1608, mark a complete break with Jacobean tradition in their not especially felicitous combination of elements from Palladio, Antonio da Sangallo and Serlio. In 1610 he was given his first architectural appointment as surveyor to Prince Henry, heir to the throne. Before his premature death two years later, Prince Henry was already acting the role of enlightened Renaissance prince by forming an important collection of Italian Renaissance paintings, bronzes and classical antiquities. As one of the few men in England with an informed first-hand knowledge of Italian art and architecture, Jones must have been welcomed into the circle surrounding Prince Henry, despite his rather graceless manner. This son of a Smithfield clothworker of Welsh extraction had travelled far!

Prominent in this courtly circle was the young Thomas Howard, fourteenth Earl of Arundel (1586–1646), a nobleman of exceptional artistic discernment who was to become one of the most important collectors and patrons in the history of English art. In 1613 Arundel was among those invited to escort the king's daughter,

Princess Elizabeth, to Heidelberg after her marriage to the Elector Palatine. Arundel chose to take Inigo Jones in his suite with a view, it seems, to benefiting from his knowledge on the travels in Italy which he proposed to undertake once his official duties were over. Thus in 1613–14 Arundel and Inigo Jones made an extensive artistic tour of Italian cities in which Jones was able to consolidate and deepen his already considerable understanding of classical architecture and Renaissance theory.

What is striking and unusual about Jones's interests is that they were *not* in the Italian architecture of the day, which was about to move from Mannerism to Baroque. Thus, once more, Jones is very different from the pattern we have seen in previous chapters in which Englishmen looked anxiously across the Channel in order to emulate *contemporary fashions*, whether it be Henry III admiring Reims in the thirteenth century or Henry VIII Fontainebleau in the sixteenth. What Jones was interested in was the principles of design in antique architecture as enshrined in the work of Palladio and of Palladio's heir, Vincenzo Scamozzi (1552–1616), whom he met in Venice in 1614. Palladio's *I Quattro Libri dell'architettura*, published in Venice in 1570, is perhaps the most influential architectural book of all time. The first of its four books is concerned with the orders and with technical matters of construction; the second with domestic architecture, mainly Palladio's own; the third with public and urban buildings; and the fourth with temples, almost entirely those of ancient Rome. Part of the special appeal of the book, which is addressed to practising architects, lies in the instructive relationship between the presentation of antique architecture and the reflection of it in Palladio's own very attractive buildings as described in book two. From Palladio's buildings Jones derived an interest in the various harmonic proportions which could be used to govern the length, breadth and height of rooms as well as the relationship of one room to another.

Jones's copy of the *Quattro Libri*, in an edition of 1601, which survives in the library of Worcester College, Oxford, contains the annotations he made in it while inspecting the antique remains illustrated in its fourth book. Jones was also fortunate enough to acquire at this time the corpus of Palladio's drawings for public and private architecture, a purchase fraught with consequences for the future of English architecture.

A Roman sketchbook has also survived from this period in which Jones states clearly his opposition to what he calls the 'composed ornaments which proceed out of the abundance of designers and were brought in by Michelangelo and his followers'. He thought these were inappropriate to 'solid architecture' and should therefore be confined to garden architecture and interiors. In his opinion, architecture 'ought to be solid, proportionable according to the rules, masculine and unaffected'. It is a clearly stated ambition of a man who knows exactly what he wants. As we shall see shortly, it is surely exactly what his buildings achieved.

We have devoted some time to Jones's formation not only because it was totally different from any other in the previous history of English architecture, but because it set a pattern that survived well into the nineteenth century. During this period it became almost a necessity for the successful architect to undertake a Grand Tour in which he would study both antique architecture and that of the Italian Renaissance. We still find the greatest classical architect of the nineteenth century, C.R. Cockerell, using Palladio's buildings to illustrate the principles of antique architecture in the brilliant lectures he delivered to architectural students at the Royal Academy in the 1840s and 1850s.

The buildings of Inigo Jones

It would not be entirely surprising if, after such an introduction, the actual buildings of Inigo Jones were to come as something of a disappointment: for one thing, out of

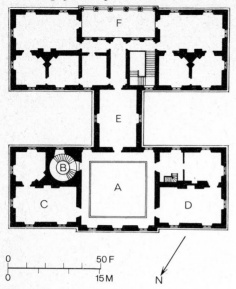

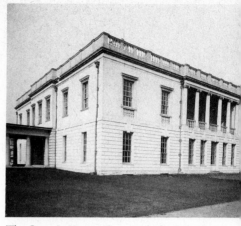

The Queen's House, Greenwich, by Inigo Jones,
the south front (above) and plan (left): A hall; B
'Tulip Staircase'; C drawing room; D bedroom; E
bridge; F loggia

his many recorded architectural works as few as four fully authenticated buildings, and a gateway at Chiswick, survive today. Moreover, despite his arrogant ambition to reform English architecture, they had extraordinarily little influence in his lifetime. As can be inferred from the concluding section of the previous chapter, they were regarded as an alien court taste by the majority of patrons and designers who continued to exploit versions of Artisan Mannerism until well into the second half of the seventeenth century. Thus, just as it is one of the oddities of architectural fashion that on his visit to Italy with Arundel, Jones should have been inspired by a style that was already half a century out of date, so no one could have supposed that his own style, which was so little understood outside court circles in his lifetime, would have swept the country in the way it did in the eighteenth century.

In September 1615 Inigo Jones succeeded Simon Basil as Surveyor-General of the King's Works, a post he held until 1642. All his major works were done for the Crown, and in James I and Charles I he found ideal and enthusiastic patrons. His first work as surveyor was the Queen's House at Greenwich, begun in 1616 for Queen Anne of Denmark as a stark affront to the Picturesque Jacobean style of the day. The grounds of the old Tudor palace at Greenwich running down to the Thames were separated from the park to the north by a public road. By an odd conceit the house was built half in the palace gardens, half in the park, with the two parts connected by a covered bridge over the road. This inconvenient arrangement was altered in 1661 by Jones's pupil, Webb, who added two further bridges so as to convert the H-plan into something more nearly rectangular. The original dual plan may owe something to Giuliano da Sangallo's villa of the 1480s for Lorenzo de' Medici at Poggio a Caiano, but the inspiration for the open loggia on the south front is ultimately from Palladio although we know that Jones's immediate source was Scamozzi's Villa Molini, near Padua, of the 1590s. The inside of the north block facing the river is dominated by a superb hall. Unlike that in any previous English house, this is a single 40-foot (12-metre) cube rising through two storeys with a cantilevered balcony running round the edge at first-floor level so as

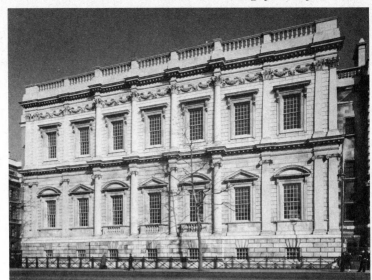

The Banqueting House, Whitehall, London, by Inigo Jones

to connect it with the other first-floor rooms.

Work on the Queen's House stopped after three years with Anne of Denmark's death in 1619. It was resumed in 1630 for Charles I's wife, Henrietta Maria, and was completed five years later. Thus, the work of Jones that would have had most impact during the 1620s was the Banqueting House built between 1619 and 1622 in startling contrast to the Tudor Palace of Whitehall, of which it formed a conspicuous part. The two-storey exterior is developed from Palladio's designs for town-palaces, and is modelled with a subtle pattern of engaged columns and single and coupled pilasters in an extremely sophisticated classical way, quite without any precedent in England. The interior is an immense double cube, 110 by 55 by 55 ft (33·5 by 16·7 by 16·7 m), which has slightly lost its original sense of direction by the removal of the large coffered apse that dominated its southern end. This was based on Palladio's reconstruction of the Temple of Venus and Rome in Rome. The design of the ceiling was also revolutionary and influential, being divided into nine large panels which,

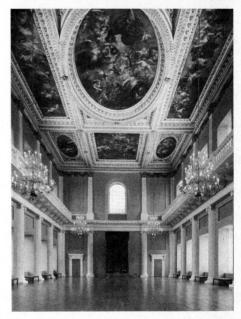

The Banqueting House, Whitehall, interior with ceiling by Rubens

99

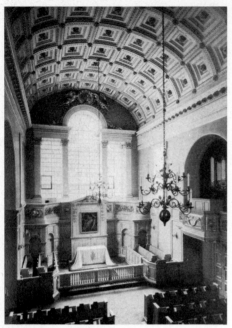

The Queen's Chapel, London, by Inigo Jones

Jones's Protestant church of St Paul, Covent Garden (1631–33), has also fortunately survived, though rebuilt and altered in the eighteenth and nineteenth centuries. None of the houses which Jones and the French designer, Isaac de Caux, provided in the elegant arcaded piazza in front of the church, has survived. Jones's piazza, inspired by recent town planning in Paris and Leghorn, was built in 1631–37 as an exercise in property development by the fourth Earl of Bedford. Since Bedford was anxious to spend as little money as possible on the church, Jones produced an austere design in the primitive or vernacular Tuscan order. This anticipates certain aspects of eighteenth-century Neo-Classicism, as does the gigantic unpedimented portico with which Jones transformed the west front of old St Paul's Cathedral in 1634–40. Inspired by Palladio's reconstruction of the portico of the Temple of Venus and Rome, it was unquestionably the largest portico north of the Alps until its demolition after the Great Fire of London in which the cathedral was gutted. Jones was a perfec-

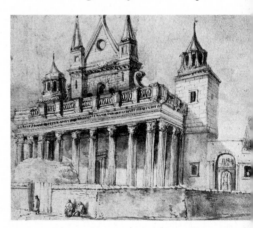

Portico added to old St Paul's Cathedral by Inigo Jones

like the whole building, have a breadth and balance in marked contrast to the crowded, small-scale compartments of previous English ceilings. This feature of the ceiling is likely to pass unnoticed in view of the surging Baroque paintings by Rubens depicting the apotheosis of James I which were inserted into the panels in 1635.

The Banqueting House was immediately followed by another single-chamber building of double-cube proportions, the Queen's Chapel at St James's Palace. This was designed for Catholic worship in 1623 and was ready for Queen Henrietta Maria four years later. The west entrance-front was based on the Prince's Lodging built by Jones at Newmarket in c. 1619. The interior is dominated by a beautiful Venetian window derived from Scamozzi and an elliptical coffered ceiling based on that in the Temple of Venus and Rome as reconstructed by Palladio.

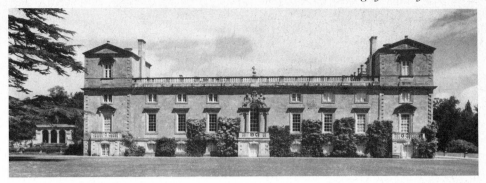

Wilton House, Wilts., by Inigo Jones and Isaac de Caux

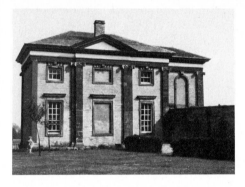

Stoke Bruerne, Northants., pavilion, by Inigo Jones

tionist. Full-scale experimental models in timber of all the cornices, window ornaments and even the entire entablature of the portico were erected *in situ* to ensure before any stone was cut that the ornamental details would relate proportionately to the scale of the architecture. Surrounded by blocks of offices and flats which totally lack visual finesse, we may find almost unbelievable the care which more civilized ages took over the effect their buildings would produce.

Enormous scale was again characteristic of the designs that Jones prepared in the 1630s for a new Whitehall Palace on the site of St James's Park and of the old palace. This would have been twice the size of Philip II of Spain's Escorial and, like it, would have contained eleven courtyards. Not surprisingly, Jones had not quite the large vision to design on so overwhelmingly vast a canvas. The small units of design that had been satisfactory at the

Banqueting House simply did not build up into a coherent picture when repeated *ad infinitum* in the way he proposed. The more sweeping stylistic language of the Baroque, which was being inaugurated in Rome at just this moment, would be needed before statements on the scale of Jones's Whitehall could be successfully expressed.

We know of no country house that can be regarded unquestionably as the independent work of Inigo Jones, though his direct influence is found in a number, particularly at Stoke Bruerne and at Wilton. What survives of Stoke Park, Northamptonshire (*c.* 1630), is a pair of elegant pavilions and colonnades, inspired in plan by Vignola and in elevation by Michelangelo. At Wilton House, Wiltshire, the celebrated south front was built in 1636 for the fourth Earl of Pembroke at the suggestion of his friend, King Charles I. Since Jones was too busy, the designs

The followers of Inigo Jones: Pratt, May and Webb

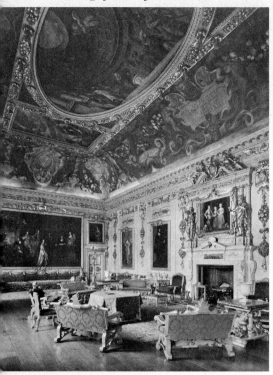

Wilton House, the double-cube room, by Inigo Jones and John Webb

Jones's position as a successful court architect established a pattern which made possible the subsequent careers of Webb, Pratt and May. Though they all depended on the revolution that Jones had effected, they moved stylistically towards the Baroque, and thus form the link between the two giants of the seventeenth century, Jones and Wren.

Sir Roger Pratt (1620–85) was an educated gentleman and lawyer who, taking to architecture, designed two houses, both now demolished, which were to be exceptionally influential in the second half of the seventeenth century. At Coleshill House, Berkshire, built for his cousin, Sir George Pratt, he established in c. 1650 a dignified but relaxed and comfortable type of house with two storeys of nearly equal height, big dormers and chimneys, with a 'double pile' plan containing a convenient corridor running down the middle. A touch of drama was provided by the great double-flight staircase which, most unexpectedly, dominated the entrance-hall. Stairs of this type are essentially a Baroque development and are not found in the kind of Renaissance building admired by Jones. Pratt produced a variant of the elevational treatment of Coleshill at Clarendon House in Piccadilly, built in 1664 for the Lord Chancellor, Edward Hyde, as one of the very first great classical houses in London. The type proved popular, perhaps because it was obviously such a *sensible* way of building, in contrast to the rather intense scholarship that characterized Jones's precise and learned architecture.

At Eltham Lodge, near London, of 1664, Hugh May (1621–84) blended the Pratt style with a certain influence from the Dutch Palladianism which he had seen during his stay in Holland with the exiled court of Charles II. In 1668 the king appointed him Comptroller of the Works, and five years later architect to Windsor Castle, where he provided new interiors in

were made by Isaac de Caux, though with Jones's 'advice and approbation'. The façade is Jonesian in its general proportions, its Scamozzi-inspired central window, and its Italianate pedimented corner-towers, which were to be extremely influential in the eighteenth century. Behind the central arched window lies one of the most magnificent rooms in England, a double-cube chamber. The interior of the house was gutted by fire in 1647 or 1648 and remodelled in 1649–50 by John Webb, again with advice from Inigo Jones. The sumptuous decoration of the double-cube room, carried out after the fire, with its architecturally framed Van Dyck portraits and lavish painted cove by Edward Pierce, echoes the Baroque spirit of contemporary interiors in France.

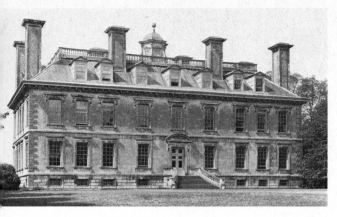

Coleshill, Berks., by Sir Roger Pratt (demolished), exterior (left) and plan (below): A hall; B saloon; C drawing room; D parlour

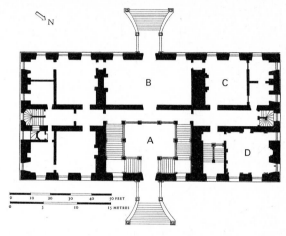

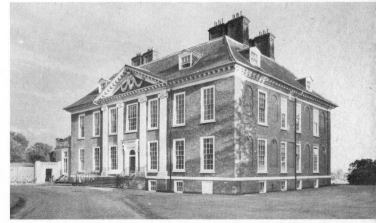

Eltham Lodge, Kent, by Hugh May

103

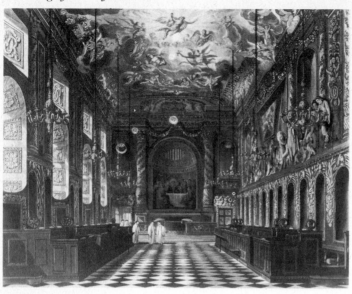

The King's Chapel, Windsor Castle, by Hugh May

1675–84 enriched with painting and carving by Verrio and Grinling Gibbons. The King's Chapel, St George's Hall and the two state staircases, perhaps the most fully Baroque interiors ever created in England, have been destroyed, but the less important Queen's Audience Chamber, Queen's Presence Chamber and King's Dining Room still give some impression of this Restoration richness.

Jones's pupil, John Webb (1611–72), added a great portico to The Vyne, Hampshire, in 1654, the first in the long line of temple porticos to adorn English country houses. His attractively rusticated new wing at Lamport Hall, Northampton-shire, of the following year, also survives, but unfortunately, what was probably his most important house, Amesbury, Wilt-shire, of *c.* 1660, has been completely rebuilt. It was a development on the theme of Palladio's first villa, the Villa Godi at Lonedo of the late 1530s, and boasted a circular staircase carried up in the core of a larger rectangular staircase. C.R. Cockerell wrote of the house in the 1820s that 'it has an uncommon grandeur which fills and occupies the mind'.

Uncommon grandeur is undoubtedly the hallmark of the King Charles II block built by Webb at Greenwich Palace (now Hospital) in 1664–69 as one side of a new palace that was never completed to his designs. Though he took as his starting point Inigo Jones's not entirely successful designs for Whitehall Palace, Webb showed that he could think on a big scale with large elements and could unite his masses satisfactorily by the use of Baroque devices such as the giant order. It is nothing like as impressive or har-monious as the effects that Wren would shortly be achieving but it was nonetheless remarkable for its date and must have encouraged Wren to set about developing its latent grandeur.

Wren's early years

Until his early thirties the greatest English architect was not an architect at all but a scientist of such distinction that his work was admired by Newton himself in his *Principia* of 1687. Born in 1632, Christo-pher Wren was educated at Westminster School and Wadham College, Oxford,

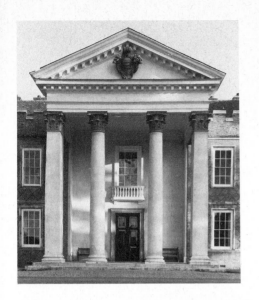

The Vyne, Hants., the portico added by John Webb

Lamport Hall, Northants., by John Webb

The King Charles II block, Greenwich Palace (later Greenwich Hospital), by John Webb

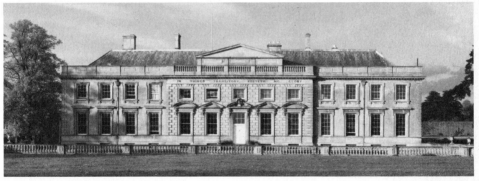

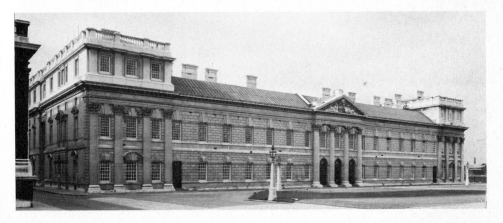

which he entered in 1649, the year of the king's execution. His father, who was Rector of East Knoyle in Wiltshire, and his uncle, Matthew Wren, Bishop of Ely, were prominent in the High Church and Royalist cause. Indeed Matthew Wren was imprisoned for eighteen years in the Tower of London by the Puritans, a fact which may have encouraged Charles II to afford valuable early patronage to his nephew. In 1653 Christopher Wren was elected a fellow of All Souls College, Oxford, and four years later was appointed Professor of Astronomy at Gresham College, London, where he would have seen the celebrations at Charles II's Restoration in 1660. At Gresham College he was one of a group of scientists, formed at Oxford, who met regularly to discuss their work. Gaining the king's interest, the group was granted a royal charter in 1661 and became the Royal Society. Wren himself is known to have presented the king with a large-scale model of the moon and a set of drawings of insects seen through a microscope. He returned to Oxford in 1661 as Savilian Professor of Astronomy, and it is clear that he was already turning his attention to architecture, which at that date was still considered as an intellectual diversion for the educated gentleman rather than as a full-time profession.

His first commission came in 1663 from his uncle, the Bishop of Ely, for whom Wren provided at Pembroke College, Cambridge, a simple classical chapel, the first in Oxford or Cambridge with no Gothic detail at all. More important was his design of the same year for the Sheldonian Theatre at Oxford, the building in which university ceremonies are held. It must be remembered that no major public building had been erected in England since the start of the civil war more than twenty years earlier. This lack of an accepted current tradition, coupled with Wren's exceptionally inventive scientific mind, helps to make the new theatre a building of unique originality. It is significant that in April 1663 he chose to

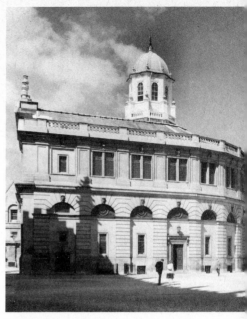

The Sheldonian Theatre, Oxford, by Christopher Wren

display a model of it at a meeting of the Royal Society as an example of structural ingenuity. The particular feature of interest was the roof: in order to span an area of 70 by 80 ft (21 by 24 m) without visible supports, the timber ceiling was suspended from a series of concealed triangular trusses. In an attempt to recall the roofless theatres of the ancient world, the ceiling was adorned by a rather florid painting representing, among other things, the sky.

Wren was not content, as so many would have been, to base the plan of the Sheldonian on the Banqueting House, but chose instead an antique source, the D-shaped plan of the Theatre of Marcellus in Rome as recorded by Serlio. This offered him no suggestion for the treatment of the façade of the polygonal north end. He thus disposed this part of the building in an original if uneasy manner with an arched,

rusticated podium supporting not a principal storey adorned with the orders but merely an enlarged attic.

The building is, then, a learned if rather cranky tribute to the world of experimental philosophy in which Wren moved. Science and art, classical learning and modern technology were combined here in a rather strained manner, whereas in his later works they were to be combined with increasingly miraculous fluency.

The Sheldonian is the product of the moment when Wren's primary interests were beginning to shift from science to architecture, though he did not resign from the chair of astronomy until 1673. As if to consolidate his new enthusiasms he paid a prolonged visit to France, partly to study architecture in and around Paris, from the summer of 1665 to the following March. The climax of this important visit was his meeting with the greatest European architect of the day, Gianlorenzo Bernini (1598–1680), of whose monumental designs for the Louvre he had all too brief a glimpse. So far as we know, Wren never travelled abroad again, though it seems scarcely conceivable that he could have produced his great classical and Baroque masterpieces without ever having visited Italy.

Wren's City churches

In September 1666, the year of his return from France, the Great Fire of London damaged or destroyed old St Paul's Cathedral and eighty-seven parish churches, as well as more than thirteen thousand houses in the City. The magnitude of the disaster prompted Wren to produce his monumental scheme of 11 September for rebuilding the City on a totally new plan based on Roman and French urban design in which straight, wide streets radiated from major public buildings or piazzas. This utopian scheme was dropped partly because merchants and shopkeepers found unacceptable the compulsory purchase which would have been needed to carry it into execution. How-

ever, it was partly on the strength of his imaginative scheme that Wren was appointed Surveyor-General of the King's Works in 1669. The next year saw the passing of the Rebuilding Act which meant that work on the building of fifty-two new City churches could now begin in earnest under Wren's supervision. Most were designed between 1670 and 1686, though a number of the steeples, often the most brilliant parts of them, were added later. Many of these steeples are breathtaking virtuoso performances in stone like St Mary-le-Bow (1680) and St Bride, Fleet Street (1701–03), which seem to depend on Antonio da Sangallo's model for St Peter's. Other notable examples include

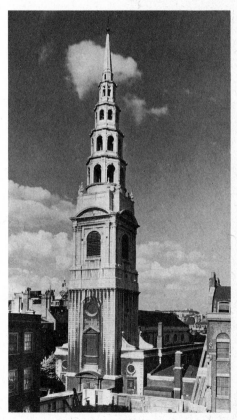

St Bride, Fleet Street, London, by Wren, the west tower

St Vedast, Foster Lane (1694–97), with swinging concave curves in a Baroque taste inspired by Borromini, and St Dunstan-in-the-East (1697), which is pure Gothic Revival. The plans and steeples were invariably designed by Wren himself, but the ornate fittings in wood and plaster were usually the independent work of the craftsmen in which the City was now so rich.

We are so accustomed to the brilliant variety of plan and rich decorative detail of these Anglican churches that it is easy to forget that there was no precedent whatever for the design of classical churches in England, save marginally in the work of Inigo Jones. In fact, since they were generally built on the cramped irregular sites of mediaeval churches hemmed in by other buildings, impressive façades were often unnecessary. What was required was a centralized space which was lucidly organized along classical lines and was dominated not by an altar but by a centrally placed pulpit. As Wren eloquently put it in 1711, 'in our reformed Religion, it should seem vain to make a Parish church larger, than that all who are present can both hear and see. The Romanists, indeed, may build larger Churches, it is enough if they hear the murmur of the Mass, and see the Elevation of the Host, but ours are to be fitted for Auditories.' In fact, this rather bleak and materialist approach is contradicted by the poetic variety of the actual churches, of which, incidentally, roughly half of the original fifty-two survive today. Some of them have the traditional nave and aisles like St Bride, Fleet Street (1671–78), which may be inspired by Vitruvius's description of his basilica at Fano as reconstructed in Perrault's edition of Vitruvius of 1673. St Clement Danes in the Strand (1680–82) is a uniquely beautiful variant in that its aisles are carried round in the form of an ambulatory in front of an apsed east end. Wren's gifts as a geometer were never used to better effect than in the group of centralized churches, some of which deploy a real or suggested dome: St

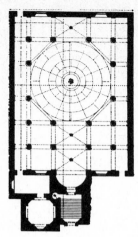

St Stephen Walbrook, London, by Wren, plan

Mary Abchurch, St Mildred, Bread Street (demolished), and St Swithin, Cannon Street (demolished), are basically domed squares; contemporary Dutch influence seems to account for the churches like St Anne and St Agnes, Gresham Street, and St Martin, Ludgate, both begun in 1677, in which a Greek-cross plan is inscribed within a square surmounted by intersecting barrel vaults. St Benet Fink (begun in 1670) and St Antholin (begun in 1678), both alas demolished, enjoyed an especially complex articulation in which a longitudinal plan was treated as though it were centralized with an oval dome rising from a decagon or an elongated octagon. Fortunately, St Stephen Walbrook (1672–79), the most complex and expensive of this group of churches, has survived. Its diaphanous interior space in which a dome floats on eight arches and eight columns is a miraculous combination of two planning types, the aisled nave and the centralized plan.

St Paul's Cathedral

In the summer of 1666, just before the fire, Wren had prepared a design for remodelling old St Paul's Cathedral with a dome

and lantern resting on a colonnaded drum. The inspiration for this, including the separate inner dome, probably came from Lemercier's Val-de-Grâce (1646), which he had just seen in Paris. Thus Wren had already envisaged the most memorable feature of the cathedral as we know it today, before it became clear in 1669 that the burnt-out ruins could not be shored up and that a wholly new building would be necessary.

What is called Wren's First Model, consisting simply of a rectangular choir with a large domed vestibule at its western end, was ready in 1670 and received the king's approval. This design was soon regarded as inadequate, so that in 1673 Wren produced the Great Model design, named after the 18-foot (5·4-metre) model which is still preserved in the cathedral. In that year, incidentally, Wren was knighted. The Great Model design, which is partly based on Michelangelo's unexecuted project for St Peter's, is believed to have been Wren's own favourite scheme. Certainly it is considerably more unified as an architectural conception than the plan finally adopted, but it was rejected precisely because it *was* an architectural

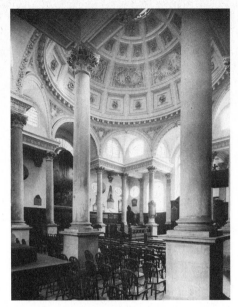

St Stephen Walbrook, interior

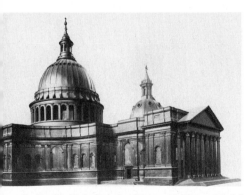

St Paul's Cathedral, by Wren, the Great Model (above), and plan of the Great Model design (right)

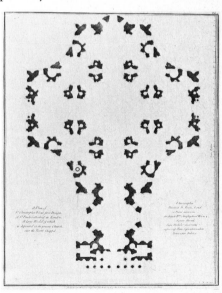

rather than a functional or liturgical conception. That is to say, it was a centralized plan under a dome without a traditional choir or nave. It was also unpopular because it could not be erected in stages as funds became available. Thus in 1675 Wren prepared yet a third plan, known as the Warrant Design. This is important for establishing the cruciform mediaeval plan with projecting transepts which satisfied the dean and chapter and which was very close to that eventually executed. It has sometimes been thought that its octagonal crossing, as wide as the nave and aisles together, may be an echo of Ely Cathedral, where Wren's uncle was bishop.

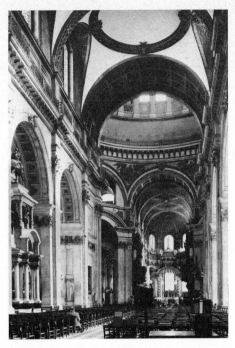

St Paul's Cathedral, by Wren, interior looking east

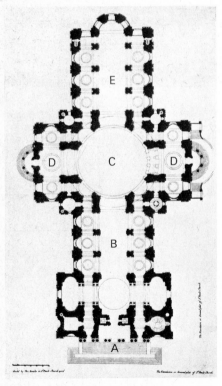

St Paul's Cathedral by Wren, plan of final design: A west front; B nave; C crossing, with dome over; D transepts; E choir

The foundation stone was laid on 21 June 1675 and the cathedral was in the course of erection for the next thirty-five years, during which period Wren made many significant alterations to its design. The most important were made right at the start in 1675 and involved the decision to abandon the extraordinary spire of the Warrant Design in favour of a dome of the magnitude of that in the Great Model. To provide a visually adequate substructure for a dome of this height, Wren adopted the unique expedient of doubling the apparent height of the building by raising false screen walls on top of the aisle walls all round the cathedral. These were also functionally useful for carrying and controlling thrusts, particularly those of the dome, and for concealing the flying buttresses which helped to support the vault of the choir. The new two-storey

elevation can be seen as an enriched version of Jones's Banqueting House conceived in the freer spirit of French and Italian Baroque. The transept elevations recall Mansart's designs for the Louvre, but beautiful curved porticos radiate from them which are directly inspired by that at Pietro da Cortona's Sta Maria della Pace in Rome of 1656. The Baroque touches reach their climax in the western towers designed after 1700 and vigorously modelled with curves and counter-curves based on Borromini's S. Agnese in Piazza Navona, Rome, of the 1650s. Wren was not able to build the gigantic portico he would have liked between the towers and so produced a two-storey elevation with coupled columns inspired by those at the east front of the Louvre by Perrault of the 1660s.

The great dome, regarded by many as the most beautiful in the world, was built between 1698 and 1710. The problem that confronted Wren was that a dome which looks right from the restricted space *inside* a church will be inadequate as a landmark when viewed from the unlimited space *outside*. Michelangelo had solved the problem more than a century earlier at St Peter's by creating two separate domes, one inside the other, while in the seventeenth century the scenic or Baroque imagination of the two Mansarts had led to the design of church interiors in which one can look through from the inner dome to the outer. Wren developed this theme in an astonishing way by introducing yet a third feature in the form of an immense brick cone between the two domes in order to carry the weight (580 tons) of the masonry lantern which surmounts the whole composition and from which light percolates mysteriously down through a small opening into the cone and so through a larger opening into the inner semi-circular dome. Thus the outer dome

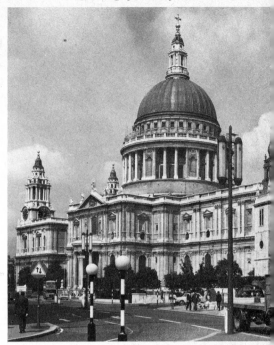

St Paul's Cathedral from the south-east

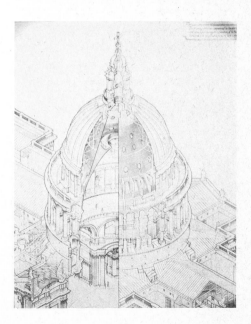

St Paul's Cathedral, diagram showing the construction of the dome

is a mere decoration consisting of a lead-covered timber framework designed solely with a view to aesthetic effect. It is the combination in one person of this brilliant technical ingenuity and these supreme artistic gifts that makes Wren one of the greatest of Englishmen.

Wren's secular buildings

Despite what might have proved the all-absorbing task of the design and construction of St Paul's Cathedral, Wren found time to produce a great range of important secular buildings in London and the ancient universities. At Christ Church, Oxford, he completed Wolsey's Tudor quadrangle with a great Gothic gatehouse

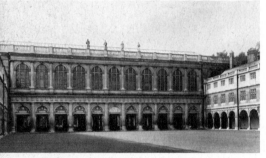

Trinity College Library, Cambridge, by Wren

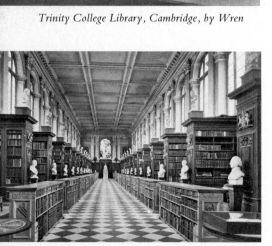

Trinity College Library, Cambridge, interior

in 1681–82; and at Trinity College, Cambridge, he built in 1676–84 one of the most magnificent classical libraries in the country. To gain sufficient height for the great first-floor library he brought its floor-level down to the height of the springing of the arches in the ground-floor arcade. These 'arches' are thus false since their tympana are solid. He echoed this Baroque device in the Fountain Court at Hampton Court Palace where he added the south and east wings in 1689–94 for the new king and queen, William and Mary. He had originally planned a much grander rebuilding of the whole palace in a style modelled on Le Vau's work at the Louvre. In 1683–85 he had prepared a similarly grandiose scheme, inspired by Versailles, for a new palace for Charles II at Winchester, but the portions that were built were later turned into a barracks and were destroyed by fire in the nineteenth century. Much more impressive was his scheme for a new Palace of Whitehall prepared in 1698 in a mature Baroque style. Though this remained unexecuted its power and quality are reflected in what is his finest work after St Paul's, the Royal Hospital for Seamen at Greenwich, where he continued Webb's work on a much extended scale between 1696 and 1716. Wren's twin colonnaded vistas terminating in the great Baroque domes over the

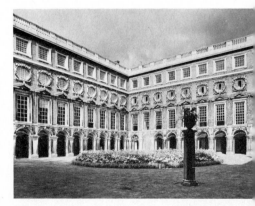

Fountain Court, Hampton Court Palace, by Wren

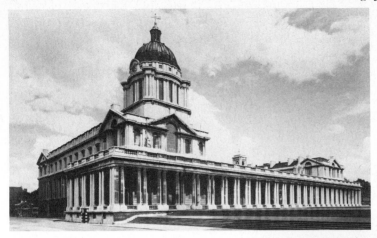

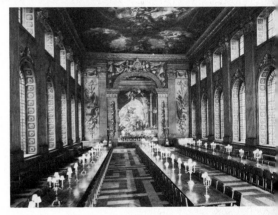

Greenwich Hospital, chapel wing added by Wren (left) and the Painted Hall (below), with paintings by Thornhill

chapel and the Painted Hall are among the most splendid things of their kind in Europe. The Painted Hall is a triumphant extravaganza divided into three parts, doomed vestibule, hall and upper hall, on three different levels, which are theatrically divided from each other by great arched openings. The architecture flows over exuberantly into elaborate carved detail by Hawksmoor and magnificent Baroque paintings by Thornhill.

English Baroque:
Talman, Vanbrugh and Hawksmoor

Wren's employment as Surveyor-General of the King's Works by three successive monarchs, Charles II, James II and, after the revolution of 1688, William III, meant that he worked little for private patrons and therefore designed virtually no country houses. The first Baroque country-house architect is William Talman (1650–1719) whose finest work is at Chatsworth House, Derbyshire, where he rebuilt the south and east fronts in 1687–96 for the first Duke of Devonshire. The great south front was inspired by Bernini's project for the Louvre and by Le Vau's château of Vaux-le-Vicomte (1657), while the splendid interiors were lavishly adorned with painted and carved decoration by Verrio, Laguerre, Cibber and

Tijou. Here for the first time the architecture and ornament associated with the Stuart court appeared in the residence of a Whig nobleman. It is perhaps surprising to find work of so pronouncedly Baroque a character being commissioned by a patron known for his hatred of autocratic monarchy and the Catholic Church, and who was prominent among those responsible for bringing the Protestant William of Orange to the English throne.

A smaller but especially attractive example of Talman's style can be seen in his courtyard façade of 1702 at Drayton House, Leicestershire, one of the most beautiful country houses in England. But

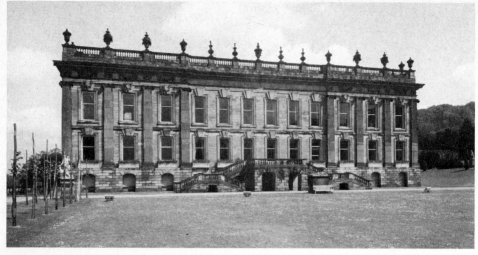

Chatsworth, Derbyshire, the south front (above) and chapel (below) by William Talman

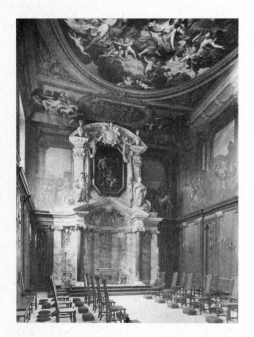

Drayton House, Northants, by William Talman

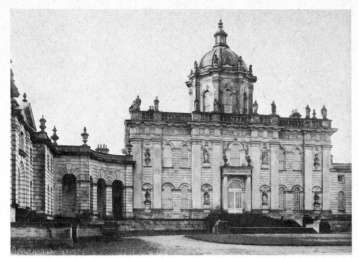

for his exceptionally unpleasant personality Talman's architectural practice would doubtless have been more extensive. As it was, he lost the post of Comptroller of His Majesty's Works to Vanbrugh in 1702 and the important commission for Castle Howard to the same architect in the following year.

Sir John Vanbrugh (1664–1726) began his colourful and varied career as a regular soldier; he was arrested in 1688 as a spy in France where he was imprisoned for four years. After his return to England he turned to writing plays and produced *The Relapse, or Virtue in Danger* in 1696, the equally successful comedy, *The Provok'd Wife*, in the following year, and a further eight plays by 1705. In the meantime, for reasons that are far from clear, he decided to become an architect and designed Castle Howard, North Yorkshire, for the third Earl of Carlisle in 1699. Work on putting his astonishing designs into effect began in 1700 with the professional assistance of Nicholas Hawksmoor (1661–1736), who had worked in Wren's office for about twenty years.

English Baroque came of age overnight with Castle Howard since it drew together the threads of monumental design which had so far appeared in isolated works such

Castle Howard, Yorks., by John Vanbrugh, the entrance front (above) and hall (below)

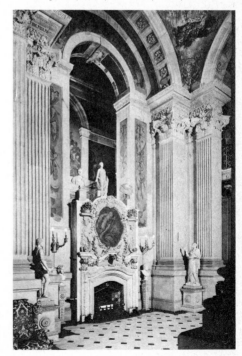

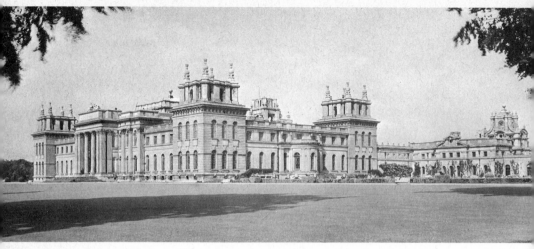

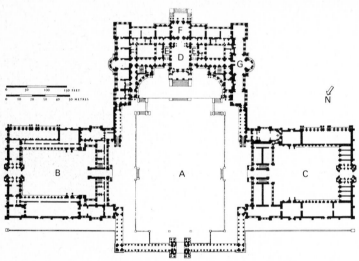

as Webb's Charles II block at Greenwich, Talman's Chatsworth and Wren's un-executed designs for Greenwich which centred, like Castle Howard, on a domed building approached through a quadrant forecourt. There are also echoes at Castle Howard of the French seventeenth-century Baroque of Vaux-le-Vicomte and J.H. Mansart's Marly, though the brilliant domed hall which opens through arches to the flying staircases is a scenic device with no French precedent.

Blenheim Palace, Oxfordshire, by John Vanbrugh, the garden front (top) and plan (below): A Great Court; B Kitchen Court; C Stable Court; D hall; E staircase; F saloon; G gallery

At Castle Howard and even more at Blenheim Palace, Oxfordshire (1705–16), Vanbrugh and Hawksmoor were thinking grandly in terms of masses, planes and volume in a way that Inigo Jones had never done, and Wren only rarely. There is a monumental sculptural quality about

Blenheim which is partly due to the fact that it was conceived primarily as a monument rather than a home, paid for by the Crown as a reward to the first Duke of Marlborough for having checked Louis XIV's attempts to dominate Europe. The four corners of the building consist of prominent towers capped by extraordinary belvederes which combine antique and Baroque sources. The antique source is the arched upper parts of a demolished Roman temple at Bordeaux as recorded in Perrault's influential edition of Vitruvius of 1673; while the bizarre finials that surmount the belvederes recall the tortured sculptural effects of Borromini. The whole dramatic skyline is dominated by a high clerestoried hall which is a little reminiscent of the Jacobean Wollaton. Vanbrugh's dynamic style certainly looks back to the heroic age of England's prodigy houses, and we know that he was determined to give to his houses what he called 'something of the Castle Air'. He developed this theme in his powerful later houses, designed without the aid of Hawksmoor, such as Eastbury Park, Dorset (begun in 1718, largely demolished in 1755), and Seaton Delaval, Northumberland (1720–28, gutted by fire in 1822). He undoubtedly had a keen appreciation of the romantic associations of the English past, as shown by his attempts to save from demolition the Tudor 'Holbein' gate in Whitehall and also the old Woodstock Manor in the park at Blenheim. His plan for retaining the ruins of Woodstock Manor as a romantic feature in the landscape, as well as the part he is presumed to have played in the development of the irregular Arcadian park of Castle Howard, make him the father-figure of the English Picturesque tradition which we shall investigate in the next chapter.

Vanbrugh's sometime colleague, Hawksmoor, is in some ways a more complicated, enigmatic and varied architect, and certainly more difficult to sum up. His Easton Neston, Northamptonshire, begun in the 1680s with façades

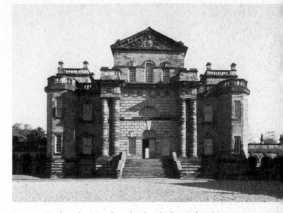

Seaton Delaval, Northumberland, by John Vanbrugh

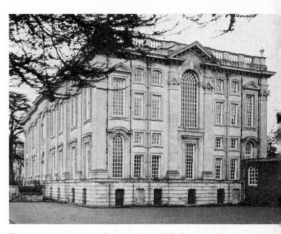

Easton Neston, Northants., by Nicholas Hawksmoor, north and east fronts

remodelled in *c.* 1700–02, has an unusual and dramatic plan and complex elevations in a manner derived from Talman. But his powerful and idiosyncratic style is best appreciated in the six London churches he designed in 1712–16 as a consequence of the Act for Building Fifty New Churches passed by the Tory Government in 1711. Immense blocks of dazzling Portland stone clash in the air with poetic dynamism in a wondrous demonstration of Hawksmoor's passions for archaeology, for

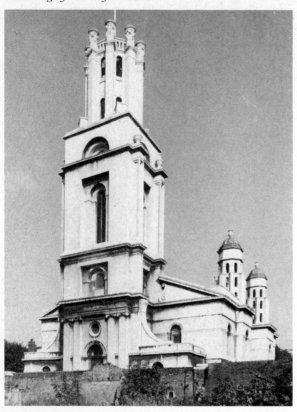

St George-in-the-East, London, by Nicholas Hawksmoor

Gothic, for Baroque, and for what one can only describe as abstract sculpture. The first church, St Alphege, Greenwich, has an eastern portico dominated by the late Roman motif of an arch rising into the pediment; while the stepped pyramidal steeple of St George, Bloomsbury, is based on Pliny's account of the mausoleum at Halicarnassus. On the other hand, the eccentric towers of St Anne, Limehouse, and St George-in-the-East seem to be the result of an attempt to create Gothic effects with antique elements. St Mary Woolnoth is a highly original Baroque composition which was perhaps the basis of Vanbrugh's Seaton Delaval, but the noblest and most satisfying of Hawksmoor's churches is Christ Church, Spitalfields, with its long basilical nave and extraordinarily grandiloquent tower.

Like Vanbrugh, Hawksmoor was moved by the venerable associations of the Gothic past and, unlike Vanbrugh, actually designed in Gothic, for example at Beverley Minster in *c.* 1716–20, a building he much admired, at All Souls College, Oxford (1716–35), and at Westminster Abbey, where he designed the present western towers in 1734. The only European parallel at this moment for such historical sensitivity is the west front of Orléans Cathedral, designed in 1733 by Jacques Gabriel. Orléans, however, might more correctly be related to the sixteenth- and seventeenth-century debate about the proper way to complete unfinished mediaeval churches, which resulted in eighteenth-century Gothic designs for the west fronts of Milan Cathedral and S. Petronio, Bologna.

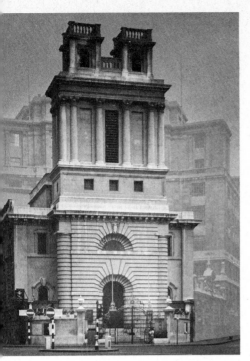

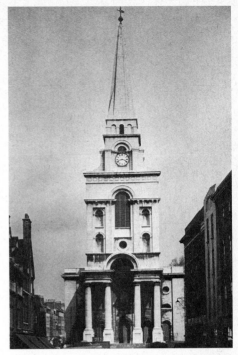

St Mary Woolnoth, London, by Nicholas Hawksmoor

Christ Church, Spitalfields, London, by Nicholas Hawksmoor, west tower (above) and interior looking east (below)

English Baroque: Archer, Thornhill and Gibbs

Whereas Vanbrugh and Hawksmoor, neither of whom had visited Italy, created an essentially English or insular Baroque, Thomas Archer (*c.* 1668–1743) travelled in Holland, Italy, and probably Germany and Austria, and evolved a style with more direct echoes of Bernini and Borromini than that of any other English architect. His two London churches, both of 1713, St Paul, Deptford, and St John, Smith Square, are in some ways close to Hawksmoor, though the Deptford church has a centralized plan, possibly inspired by S. Agnese in Piazza Navona in Rome. His country-house design is no less remarkable. At Chatsworth he built the curious bowed north front in 1704 and also

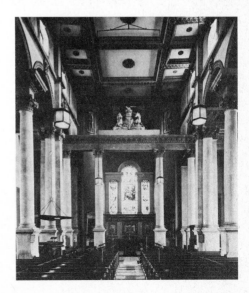

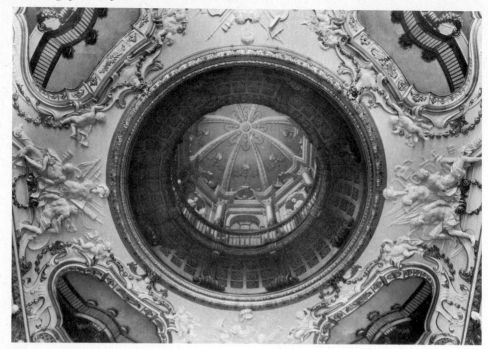

the domed Cascade House in the garden. His Heythrop House, Oxfordshire (1707–10, now largely rebuilt), drew heavily on Bernini, while Borromini's S. Ivo may have sparked off his astonishingly ecclesiastical-looking domed garden-pavilion at Wrest Park, Bedfordshire (1709–10).

The decorative paintings of Sir James Thornhill (1675–1734) in the illusionistic style that was brought to this country by Verrio and Laguerre, are the essential Baroque accompaniment to many of the buildings we have been looking at in this chapter. Thornhill was employed on Wren's Hampton Court, Painted Hall at Greenwich and dome of St Paul's, on Talman's (now demolished) Kiveton Park, on Chatsworth, on Vanbrugh's Blenheim, Eastbury and Grimsthorpe, on Hawksmoor's Easton Neston and church of St Alphege, and on Gibbs's Cannons House (now demolished) and chapel at Wimpole Hall. Though Thornhill is

Moor Park, Herts., ceiling by Thornhill, Amigoni and Sleter

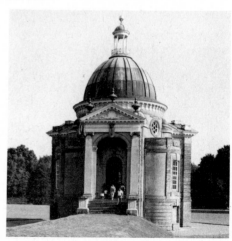

Wrest Park, Beds., pavilion by Thomas Archer

120

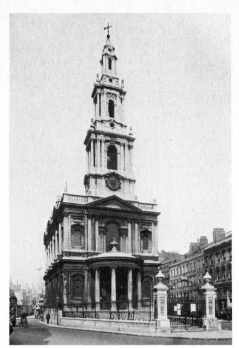

St Mary-le-Strand, London, by James Gibbs

thought of primarily, and rightly, as a decorative painter, he also turned his hand to architecture. In 1720 he responded to an invitation to submit designs for St Martin-in-the-Fields, and in the same year work was begun on the rebuilding to his designs of Moor Park, Hertfordshire, where the magnificent hall is a triumph of *trompe l'œil* paintings and exuberant stucco work.

The last important inheritor of the Baroque style that had been established with Hawksmoor's help in Wren's office at the end of the seventeenth century, was James Gibbs (1682–1754). He was brought up as a Catholic in Scotland and in 1703 went to the Scots College in Rome to train for the priesthood. He abandoned his studies after about a year to become a pupil of Carlo Fontana (1638–1714), the leading Baroque architect in Rome. On his return to England in 1709, he was equipped with an up-to-date, professional, Continental

training in architecture such as none of his contemporaries enjoyed. Thus in 1713 at the age of 31 he was appointed to join Hawkesmoor as one of the two surveyors to the Commissioners for building Fifty New Churches in London. It was in this capacity that he designed his first important work, St Mary-le-Strand, built in 1714–17. One of the most exquisite small churches in London, it is an extremely personal statement in a language that derives from Wren and even Jones, for example its two-storey elevation, but spoken with a markedly Italian accent. Like many of Gibbs's works, it entirely avoids the large, massing characteristic of Vanbrugh and Hawksmoor, and returns to the smaller-scale surface patterning more typical of Jones, which is a recurrent feature of English architecture. The exceptionally delicate Wrenian tower was an afterthought added when the original scheme for a monumental column to Queen Anne, standing in front of the church, was abandoned on her death in 1714.

As a Catholic, a Tory, a Scot, and probably a Jacobite, Gibbs had survived happily enough in the days of the Stuart and Tory Queen Anne, but with the importation of the alien Hanoverian dynasty and the defeat of the 1715 rising, the days in which he could hope to hold public office were numbered. It is one of the ironies of architectural history that although Vanbrugh and most of the clients for his Baroque houses were Whigs, it was the Whigs who were now instrumental in promoting Palladianism, so that poor Gibbs became the victim of a needless confusion between architecture and politics. In January 1716 he was dismissed by the Whigs from his surveyorship to the church-building commission and was thereafter employed mainly by the ancient universities and by Tory peers and squires, for whom he designed a large number of country houses. Though the exteriors of these were generally in a fairly conservative style, the interior decoration, which was often undertaken by the Italian

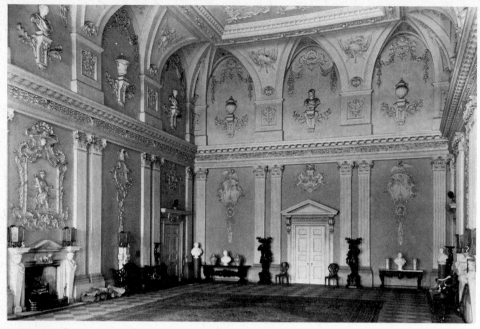

Ragley Hall, Warks., the saloon, by James Gibbs

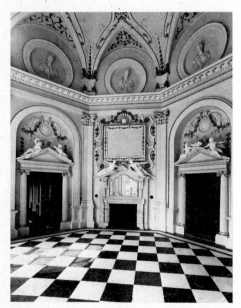

Orleans House, Twickenham, the octagon room by James Gibbs

plasterworkers Artari and Bagutti, was more exuberant, as for example at the octagon room at Orleans House, Twickenham, of 1720, or the sensational saloon at Ragley Hall, Warwickshire, of *c.* 1750–58.

However, he did build one more London church for a predominantly Whig committee, St Martin-in-the-Fields (1720–26), a design of signal importance. His first scheme was for a church with an astonishing circular nave, apparently based on a design published in 1693 by the master of Baroque illusionistic painting Andrea Pozzo. The more sober executed design has a wide nave, without a clerestory, covered by a segmental tunnel vault carried on free-standing columns. This is a development from the type established by Wren at St Andrew, Holborn, and St James, Piccadilly, and is sumptuously decorated by Artari and Bagutti. The striking west front is quite a

new departure with its giant temple-portico of which the pediment supports, rather incongruously, a fine steeple in an attempt to recreate the effect of a Gothic spire in classical terms. Incongruous or not, the combination was repeatedly echoed in Anglican churches for the next century and, through the medium of the plates depicting it in Gibbs's extremely influential *Book of Architecture* (first edition 1728), enjoyed a wide popularity in the American colonies and the West Indies.

Perhaps Gibbs's finest work is his magnificent library at Oxford of 1737–48, known as the Radcliffe Camera. This circular, domed building, beautifully sited in an open piazza, is based on designs for the library prepared by Hawksmoor in 1712–15 and 1733–34 which were themselves inspired by Wren's project of 1687 for a mausoleum for Charles I at Windsor. Gibbs has enhanced this tradition with his own unique blend of Mannerist complexity and Baroque allusion. The outline

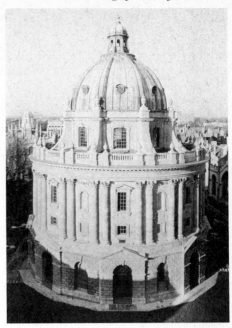

The Radcliffe Camera, Oxford, by James Gibbs

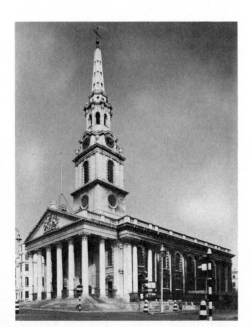

St Martin-in-the-Fields, London, by James Gibbs

of the dome has the aspiring verticality of Michelangelo's St Peter's, and its drum is supported on curved buttresses recalling those at Longhena's Sta Maria della Salute, Venice, begun in 1630.

Debarred by his religion and his politics from public office and also from inclusion in Campbell's important *Vitruvius Britannicus*, Gibbs sought successfully to achieve recognition through his own publications: his *Book of Architecture*, illustrated with 150 plates of his own designs, was followed in 1732 by the first edition of his influential *Rules for Drawing the Several Parts of Architecture*, and in 1747 by *Bibliotheca Radcliviana*, a beautiful record of his Oxford library. In the next chapter we must investigate the kind of opposition from the Palladians that might have crushed a less spirited and less talented architect than Gibbs, as it crushed the native Baroque whose efflorescence has been outlined in this chapter.

6
The Classical Revival

Campbell, Burlington and Kent

ARCHITECTURAL HISTORY, like any other history involving human beings, is full of paradoxes and surprises. Who could have predicted that in 1715 a movement would have arisen with the firm ambition of overthrowing the whole Baroque style which was apparently so firmly established in the varied work of brilliant architects like Hawksmoor, Archer and Gibbs? Yet at this moment a group led by Colen Campbell (1676–1729) and Lord Burlington (1694–1753) made clear its intention of putting the clock back exactly a hundred years by purifying English architecture of all Baroque extravagance in an act of homage to Vitruvius, Palladio and Inigo Jones.

No other country in Europe, with the possible exception of France, could show at this time a comparable attempt to dethrone the essentially visual and sensuous basis of Baroque architecture in favour of an intellectual search for first principles in the antique or, at any rate, in the antique as codified and illuminated by Palladio. The establishment by learned connoisseurs of a Rule of Taste which could only be acquired from books, travel and archaeology, constitutes the essence of the Classical Revival referred to in the title of this chapter. It continued to colour the development of English architecture into the early years of the nineteenth century. The fact that it was principally Whigs who, in the early eighteenth century, implied that the new pure style was somehow 'natural', as opposed to the 'false' artificiality of the Baroque, gave birth to a confused political parallel between the supposed advantages of the new style and those of the new Whig oligarchy as against the old Stuart monarchy. The emphasis on 'naturalness' also carried with it useful implications for those who wished to design gardens in the new irregular manner.

The new movement was ushered in by two books, both published in 1715 and both dedicated, significantly, to the new Hanoverian king, George I. They are Leoni's edition of Palladio's *I Quattro Libri*, translated by Nicholas Dubois, and Colen Campbell's *Vitruvius Britannicus*, which surveyed in a series of stately plates English architecture from Jones onwards, culminating in Campbell's own Wanstead House, near London (c. 1714–20, demolished 1824).

Wanstead was impressive for its external austerity, unusual in so large a mansion; for its anti-Baroque horizontality, of Jonesian inspiration; and for its giant hexastyle portico, the first on any English country house. This portico was derived from the antique via Palladio, who wrongly thought that ancient houses must have had porticos of this kind. Wanstead influenced a chain of houses such as Flitcroft's Wentworth Woodhouse, South Yorkshire, Paine's Nostell Priory, West Yorkshire, and the elder John Wood's Prior Park, near Bath. Even more influential, however, was Campbell's establishment of a more modest Palladian villa type in two houses, both begun in 1720: Newby (now Baldersby) Park, North Yorkshire, and Stourhead, Wiltshire. In 1722–25 he produced a yet closer echo of a

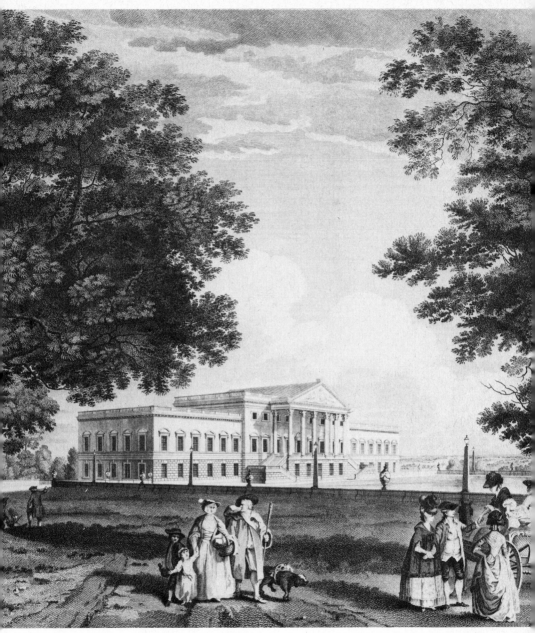

Wanstead House, near London, by Colen Campbell

specific Palladian source with the building of the domed Mereworth Castle, Kent, inspired by Palladio's Villa Rotunda outside Vicenza.

At this stage Richard Boyle, third Earl of Burlington and fourth Earl of Cork, arrived on the scene of English Palladianism. A subscriber to Campbell's *Vitruvius Britannicus*, he invited Campbell in 1719 to take over from Gibbs the remodelling of his town house, Burlington House, Piccadilly. In the same year Burlington spent some months at Vicenza studying Palladio's architecture, returning from Italy with a large collection of Palladio's drawings and also with the English painter William Kent (*c.* 1685–1748), with whom he was to remain in close association for nearly thirty years.

In *c.* 1723–29 Burlington designed and built for himself an enchanting villa at Chiswick inspired by Palladio's domed Villa Rotunda and Scamozzi's Villa Pisani and Villa Molin as reflected in Campbell's Mereworth. The sequence of three apsed and interlocking rooms along the garden front is inspired by Palladio's Palazzo Thiene in Vicenza, which had been designed to create an especially antique

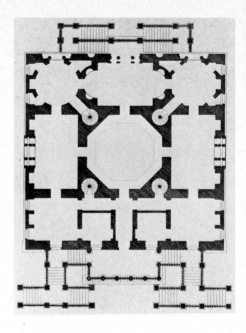

Chiswick House, near London, by Lord Burlington, entrance front (below) and plan (above)

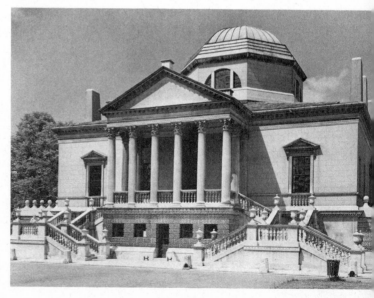

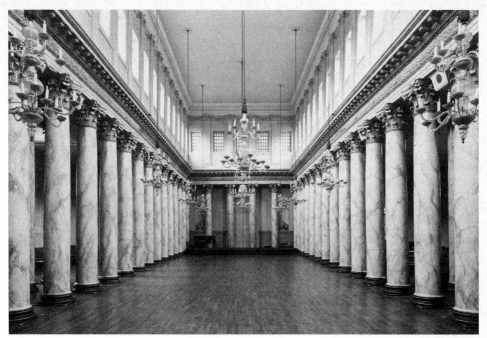

The Assembly Rooms, York, by Lord Burlington

effect. The plan of these rooms had considerable influence on later English architecture, particularly on the work of Adam.

In the Assembly Rooms at York (1731–32), Burlington attempted an archaeological reconstruction of the so-called Egyptian Hall of Vitruvius as interpreted by Palladio. Its original entrance front (replaced 1828) deployed themes from the baths of ancient Rome, again as seen through the eyes of Palladio, whose drawings of the baths Burlington had purchased and subsequently published as *Fabbriche Antiche disegnate da Andrea Palladio* (1730).

In 1720–21 Burlington had bought from John Talman a large collection of drawings by Jones and Webb as part of his ambition to return English architecture to the state of purity he believed it had enjoyed under Inigo Jones. He assigned the task of editing these for publication to William Kent and they appeared in two volumes in 1727 as *Designs of Inigo Jones*.

However, it was not until the 1730s that Kent emerged as a fully fledged architect nurtured in the tradition of Palladio, Jones, Campbell and Burlington. His most striking early work is undoubtedly Holkham Hall, Norfolk, designed in 1734 as the result of an august collaboration between Kent, his patron Lord Leicester, and Lord Burlington. Its episodic or staccato composition in which each section of the design is an autonomous unit, is the classic example of Burlington's assault on the fluid sweep of Baroque architecture. The interiors, which are more varied and colourful than the exteriors, are a good demonstration of the problem that faced someone like Lord Leicester who, on his return from the Grand Tour, wanted an antique house in which to display his collection of paintings and classical sculpture. The problem, which had already

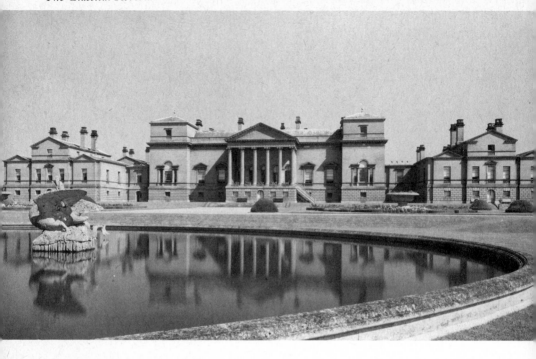

Holkham Hall, Norfolk, by William Kent, the south front (above) and plan (below): A hall; B courtyards; C saloon; D drawing rooms; E dining room; F gallery; G state bedroom; H chapel wing; J library wing; K kitchen wing; L guest wing

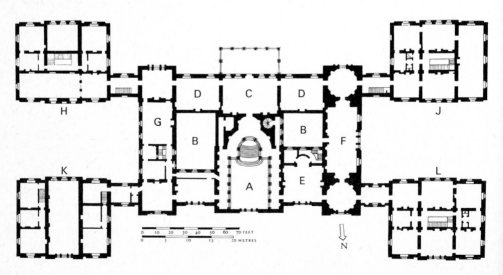

appointment in 1726, through Burlington's patronage, to a seat on the Board of Works and to the post of Master-Mason and Deputy Surveyor in 1735, ensured that Burlingtonian Palladianism ousted Baroque in the royal and public buildings associated with the Office of Works. The most important buildings that Kent designed in this capacity are the Royal Mews, Charing Cross (1731–33, demolished 1830), the Treasury buildings, Whitehall (1733–37), and the Horse Guards, Whitehall (1748–59).

Kent was a far more varied and complex designer than either Campbell or Burlington. His staircase at 44 Berkeley Square, London, of 1742–44, is a spectacularly Baroque and theatrical composition. He was also important as a furniture designer, producing monumental architectural pieces which in some ways anticipate the early neo-classical furniture of Lalive de Jully in France and James Stuart in England. In his additions of *c.* 1733 to the Tudor gatehouse at Esher Place, Surrey, he invented the 'Gothick' style which became so fashionable later in the century. In this sensitivity to the past he can be seen as the heir to Vanbrugh. Like Vanbrugh, he is also a significant figure in the development of landscape design. He was involved in the layout of gardens in the new irregular style and in the design of Arcadian classical buildings to adorn them, at Stowe, Buckinghamshire, from *c.* 1730 to 1736, at Claremont, Surrey, from *c.* 1734, and at Rousham, Oxfordshire, from 1738 to 1741. The mingling of landscape and architecture in the Elysian Fields at Stowe, where Kent's Temple of Ancient Virtue is modelled on the Temple of Vesta at Tivoli, may owe something to the landscape paintings of Claude and Poussin. It should not be forgotten, however, that Kent had lived in Rome from 1709 to 1719 and that there was precedent for this type of 'natural' garden in Italian Renaissance and Baroque gardens, such as that of the Villa Borghese in Rome, which often contained parts deliberately laid out as 'wildernesses'.

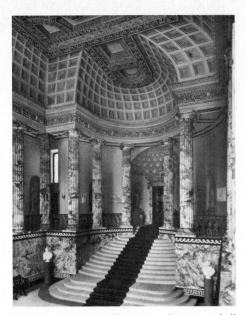

Holkham Hall, by William Kent, the entrance hall

faced Palladio, was simply that there was no information as to what the interiors of antique houses were actually like. The solution was either to reflect contemporary fashions which might well be neither neo-antique nor neo-Palladian – as Jones and Webb had done in their rather Baroque interiors at Wilton – or, as Kent did in the entrance hall at Holkham, to devise an astonishingly original interior combining elements from Vitruvius's Egyptian Hall, the colonnaded basilicas of ancient Rome, the screen inside Palladio's S. Giorgio Maggiore, Venice, and the frieze from the Temple of Fortuna Virilis in Rome. The result was a *tour de force* that represented the Classical Revival of early-eighteenth-century England at its most imaginative and grandiose, but could scarcely be described as in any way domestic in tone.

Though Kent built no other country house on the scale of Holkham, his

Stowe, Bucks., the Temple of Ancient Virtue

Neo–Palladian architecture quickly spread across the face of England. Among the most talented of the many architects involved were Sir Robert Taylor (1714–88) and James Paine (1717–89), both practising in London; John Carr (1723–1807) in York; and the two Woods of Bath, John Wood the Elder (1704–54) and his son John (1728–81). Carr's comparatively little-known Constable Burton, North Yorkshire (*c.* 1762–68), with its impressive portico *in antis*, is a fine example of a house fairly closely modelled on one of Palladio's most satisfying designs, the Villa Emo at Fanzolo of the later 1550s. The Woods are well known for their remarkable transformation of Bath, which began with the elder Wood's Queen Square (1729 onwards) and Circus (1754 onwards), which has been described as resembling the Colosseum turned inside out. This fashionably antique note was coupled with the novel and influential device of incorporating the façades of separate terrace-houses into a unified palatial composition. The younger Wood

Constable Burton Hall, Yorks., by John Carr

The new impact of archaeology begins in the 1750s. Robert Wood carried out explorations in Syria and published measured drawings of late Roman architecture in his *The Ruins of Palmyra* (1753) and *The Ruins of Balbec* (1757); Robert Adam published a similar folio volume on *The Ruins of the Palace of the Emperor Diocletian at Spalato* in 1764. In the meantime, however, the Society of Dilettanti had been founded in 1733–34 by a group of rich young noblemen and gentlemen in the process of making their Grand Tours. The aim of the society was to promote 'Greek taste and Roman spirit', and for the next century its members did exactly this by acting as patrons of designers and architects and by financing archaeologists and scholars. Among the first to benefit from the society's patronage were James Stuart (1713–88) and Nicholas Revett (1720–1804), who issued their revolutionary 'Proposals for publishing an Accurate Description of the Antiquities of Athens' in 1748. In 1751–55 they prepared the first measured drawings ever made of these then little-known buildings and published the first volume of their *Antiquities of Athens* in 1762. The actual buildings designed by Stuart and Revett are too minor to detain us in a broad survey of this kind, and the full impact of the Greek Revival was not felt until much later.

The Circus, Bath, by John Wood the Elder

continued this tradition in the Royal Crescent of the 1760s and also built the New Assembly Rooms.

Stuart, Chambers and Adam

In Burlington's lifetime the Classical Revival got as close to the antique as Palladio would allow, perhaps sometimes a little closer. It is not surprising that a new generation of architects, fired by Burlington's enthusiasm for authenticity and purity, was not content to see the antique through the eyes of Palladio and Jones but wanted to see it at first hand. In reacting even more strongly than the Burlingtonians against the compositional methods and surface decoration of Baroque architecture, they produced the style known today as Neo-Classicism.

The doctrinaire, purist and archaeological approach to architecture implicit in the pro-Greek propaganda of Stuart and Revett in England, Caylus, Laugier and Le Roy in France, and Winckelmann in Germany, naturally provoked a major European controversy. Two of the principal opponents of the Greek cause were Giambattista Piranesi (1720–78), the influential engraver of the monuments of ancient and modern Rome, and Sir William Chambers (1723–96), head of the royal works in architecture in England and instrumental in founding the Royal Academy in 1768. Though Robert Adam kept out of the controversy, it was abundantly clear from his own works that

Project for a mausoleum for the Prince of Wales, by William Chambers

he was no Greek purist. What such designers understandably resented was the drastic reduction in the range of available architectural sources that would be the inevitable consequence of a full-scale Greek Revival.

William Chambers was born in Sweden in 1723, the son of a Scottish merchant who had settled there. He was educated in England and from the age of about 17 to 26 followed a mercantile profession in the Swedish East India Company. Turning to architecture he became a pupil of J.–F. Blondel in 1749–50 in his celebrated Ecole des Arts in Paris. Here he established contacts with architects like Peyre, De Wailly and Soufflot, who were establishing the new anti-Rococo classical style that was. to dominate French architecture for the rest of the century. Chambers left Paris to study in Rome from 1750 to 1755 where he would have met a similar group of architects at the French Academy there. He also met two extremely influential figures who moved in this world, Piranesi and Clérisseau. It was Piranesi whose dramatic vision of the decaying remains of the ancient world fired the imagination of this group of architects; and it was Charles-Louis Clérisseau (1722–1820) whose drawing technique enabled architects, especially Chambers and Adam, to express this romantic vision of the antique.

Chambers's first known architectural project, a mausoleum for Frederick, Prince of Wales, was designed in Rome in 1751. A powerful and monumental design based on antique buildings such as the Tomb of Cecilia Metella and the Pantheon, it is conceived in an up-to-date French style. Most interestingly, he also submitted a view of the mausoleum drawn in the manner of Clérisseau so as to show it in a landscape and reduced to romantic decay by the lapse of centuries. This reminds us how closely the Classical Revival of the

eighteenth century was bound up, at any rate in England, with the Picturesque movement, which emphasized architecture as part of the natural setting and as part of an historical process.

Chambers's first executed work was the quintessentially Picturesque layout of the gardens at Kew in 1757–63 for the Dowager Princess of Wales. Though many of his garden buildings such as the House of Confucius, the Alhambra and the Mosque have been destroyed, the famous Pagoda, Ruined Arch and rebuilt temples to Bellona and Pan, happily survive. In 1758–76 came the exceptionally elegant Casino at Marino House, near Dublin, for the first Earl Charlemont. Like Chambers's major work, Somerset House, London (1776–96), the Casino is designed in the crisp understated style of contemporary France as seen in the work of Gabriel, Soufflot and Antoine. While this was eminently suitable for the small-scale Casino it was less appropriate, at least

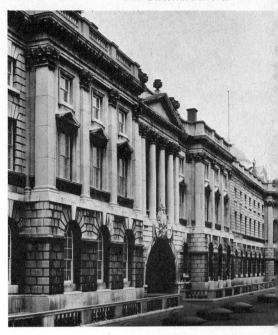

Somerset House, London, river façade by William Chambers

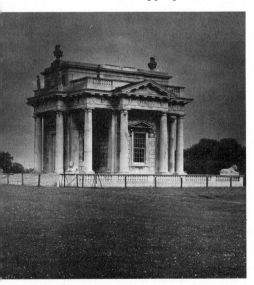

Casino at Marino House, Dublin, by William Chambers

as used by Chambers, for a vast public building like Somerset House which had to house parts of the civil service as well as the learned societies under royal patronage.

In 1759 Chambers published the first edition of his *Treatise on Civil Architecture*. This sober work codified the use of the orders on the basis of examples from sixteenth- and seventeenth-century Italian masters as much as from antique architecture. It contrasts strikingly with the major publication of his rival, Robert Adam, which was a glossy piece of lavishly illustrated self-advertisement called *Works in Architecture of Robert and James Adam* (vol. I 1773, II 1779, III 1822).

Robert Adam (1728–92) had set out from his native Scotland on his Grand Tour in 1754 and spent most of the next three years studying antique and

Renaissance architecture in Italy, especially in Rome. Though he learnt much from Piranesi and Clérisseau, he does not seem to have shared Chambers's interests in the principles and practice of contemporary French classicism. His *Works in Architecture* contains no rigid, doctrinaire set of principles but rather a strong desire to *please* by replacing the four-square Palladian solemnity with an architecture of movement, variety and gaiety. For the Picturesque movement which he was so anxious to achieve he specifically points to the work of Vanbrugh. He felt that in previous classical revivals attention had been concentrated on public and sacred rather than on domestic architecture. This is why he chose to publish measured drawings of the palace of the Emperor Diocletian at Spalato. In his concern to enlarge the repertoire of antique decorative motives available to the modern designer he looked for inspiration to the 'Grotesque' stucco decorations in

the Etruscan or Pompeiian style of Renaissance decorators such as Raphael and Giovanni da Udine in the Vatican loggias or the Villa Madama. He enlivens these with newly discovered motifs such as the Greek Ionic of the Erectheion in Athens or the elongated leaf capitals from Spalato. He is especially anxious to create spatial drama and complexity in his interiors by juxtaposing rooms of contrasting shapes and sizes, often made mysterious by columned screens, semi-domes and apses inspired by the baths of ancient Rome.

So eclectic and colourful a range of sources could have been a recipe for indigestion and disaster in the hands of a lesser designer, but after his return to England in January 1758 Adam achieved a mature personal style of enchanting decorative perfection in the space of about five years. The pattern of development can well be appreciated from Syron House (1762–69) and Osterley Park (1763–80),

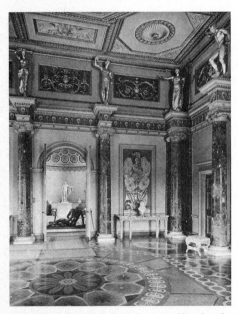

Syon House, near London, the Ante-Chamber, by Robert Adam

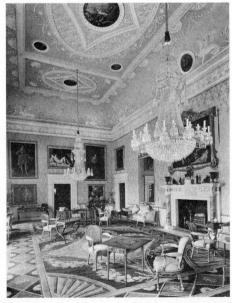

Saltram House, Devon, the saloon, by Robert Adam

No. 20 St James's Square, London, ceiling of a room on the first floor, by Robert Adam

both near London, Nostell Priory, West Yorkshire (1765–75), and Saltram House, Devon (1768–69); and also in his later London town-houses, Northumberland House, Strand (1770–75, demolished 1874, though the Glass Drawing-Room survives in the Victoria and Albert Museum), 20 St James's Square (1771–74), Derby House, Grosvenor Square (1773–74, demolished 1862), and Home House, Portman Square (1773–76).

Many of his country houses were fashionable remodellings of existing buildings, since the greatest days of house-building by the newly established Whig families were over by the time Adam started on his career. At Syron, for the first Duke of Northumberland, and at Osterley, for the banker Robert Child, Adam was faced with the problem of modernizing an old-fashioned red-brick Tudor house built round a courtyard. Magnificent though his remodelling of Syon is, it would have been even more spectacular had his daring proposal to fill the courtyard with a giant Pantheon been executed. At Osterley, however, he carried into execution a similarly dramatic proposal by which one side of the courtyard was replaced with an open double portico based on the monumental Portico of Octavia in the Campus Martius in Rome. At Harewood House, West Yorkshire, by Catt of York, Nostell Priory by Paine, and Kedleston Hall, Derbyshire, Adam was called in during the 1760s to complete Palladian houses by other architects. Kedleston is particularly interesting for showing quite how far a late (Palladian mansion, as begun by Brettingham and Paine from *c.* 1758–60, had already proceeded in the direction of antique Roman splendour. In Paine's proposals a reconstruction of Vitruvius's colonnaded Egyptian Hall leads to a pair of domed staircases and so to a circular

drawing-room projecting on the garden front like the Temple of Vesta at Tivoli. Adam de-Palladianized the interior decoration of the drawing-room and turned it into a Pantheon-like saloon. It no longer projected as a colonnaded bow, but instead the centrepiece of the garden front was a no less grandiose statement of the Roman triumphal-arch theme.

It must not be thought that the splendid interiors we have seen in late seventeenth- and eighteenth-century country houses were intended for everyday living. We know that for the greater part of the year many of them were closed and shuttered with protective coverings over the furniture and fittings, while the family lived in more modest rooms. As late as the 1770s Adam provided in the south wing at Osterley a version of the seventeenth-century 'appartement', in which a grand self-contained suite contained drawing-room, tapestry (or ante-) room, state bedroom and dressing-room. In the Victorian and Edwardian periods an

apartment of this kind tended to be furnished as a series of drawing-rooms crowded with chairs and sofas, giving a wrong impression of eighteenth-century life. In the age of Adam large rooms intended for the reception of company were often very bare by nineteenth-century standards, sometimes without a carpet and with furniture kept round the edge of the room. The interiors of Osterley have recently been restored to give something of this effect.

Though the scope of this book is limited to England, it is not possible to appreciate Adam fully without reference to his public and private buildings in Scotland. In Edinburgh his Register House (1774–92) and university (1789–93), both completed

Kedleston Hall, Derbyshire, by James Paine and Robert Adam. The two south wings were never built. A saloon; B hall; C music room; D drawing room; E library; F ante-rooms; G bedroom; H dining room; I kitchen; J laundry; K private wing

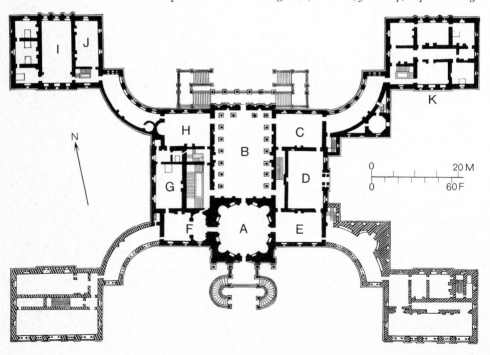

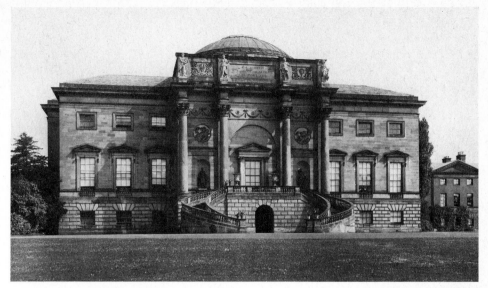

Kedleston Hall, the garden front, by Robert Adam

Kedleston Hall, the hall, by Robert Adam

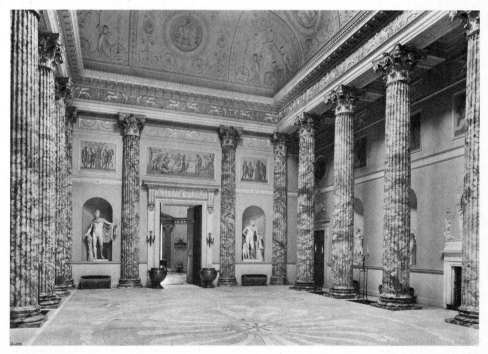

by other hands in the nineteenth century, demonstrate his very considerable gifts for animated composition on a monumental scale in a late-Palladian style. He also built in Scotland a group of about ten castellated country houses in his 'castle style', of which the finest are Culzean Castle, Strathclyde (1777–92), and the much smaller Seton Castle, Lothian (1790–91). These express his romantic sensitivity to Scottish traditions, to Vanbrugh and to the dramatic landscapes painted by Salvator Rosa.

Finally, we should not overlook the extraordinary sense of completeness which an Adam interior gives us. This is the result of the meticulous attention to detail of a man who, even more than William Kent, was determined to set his mark on everything down to carpets, furniture, candlesticks and lock-plates. The immense output of his architectural office, which he ran in conjunction with his brother James, would not have been possible without a large number of skilled draughtsmen like George Richardson, Joseph Bonomi and Antonio Zucchi. Mention must also be made of his brilliant plasterworkers, led by Joseph Rose junior (1745–99), who went round from house to house translating his drawings into plasterwork ceilings and wall-decorations of exceptional complexity and delicacy.

Wyatt, Steuart and Holland

Adam's success at establishing his fashionable and personal style in the 1760s naturally encouraged imitators, a process in which the firm of Joseph Rose & Co. played an important part. A startling example of their work is the library at Sledmere House, Humberside, which was designed with Rose's help in 1788–90 by its owner, Sir Christopher Sykes. Based on the baths of ancient Rome, it has an antique Roman grandeur resembling the library of some great college or monastery rather than that of a country gentleman.

It was James Wyatt (1746–1813) who was the principal and most successful

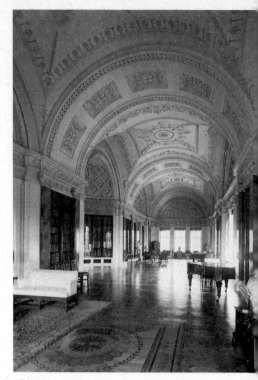

Sledmere House, Humberside, the library; the plasterwork was reconstructed from the original moulds after a fire in 1911

imitator of Robert Adam. He sprang to fame with his Pantheon in Oxford Street, London, of 1769–72, a superlatively beautiful domed space with plasterwork by Joseph Rose. Wyatt had an extraordinarily prolific and successful career in the field of both public and private architecture, culminating in his appointment as Surveyor-General and Comptroller of the Office of Works in 1796. However, he has not found much favour with modern architectural historians, perhaps because of his lack of stylistic consistency and intellectual seriousness. Yet he produced some extremely elegant classical houses such as Heaton House, Greater Manchester (c. 1772), with its fine Etruscan Room, the interiors at Heveningham Hall, Suffolk

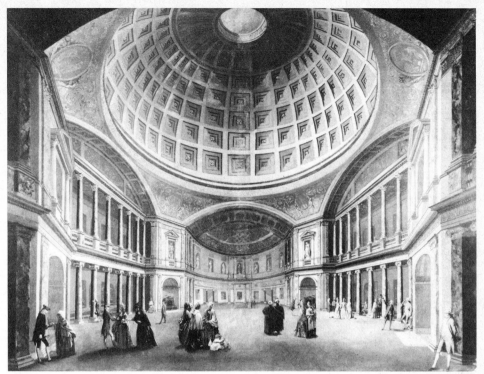

The Pantheon, London, by James Wyatt (demolished)

(*c.* 1780–84), Castle Coole, co. Fermanagh (1790–97), with Joseph Rose plasterwork, and Dodington Park, Avon (1798–1813), an eclectic Regency amalgam of Roman, Chambersian, Picturesque and Greek Revival elements, beautifully disposed in a fine Capability Brown park of the 1760s.

We have already seen in other classical architects of the eighteenth century a romantic appreciation of England's Gothic past. In Wyatt this expressed itself in a chain of houses in the Gothic or castle styles which won him much popularity in his life, though less today. Examples of his Gothic work of the 1770s and 1780s can be seen at Sheffield Place, East Sussex, Sandleford Priory, Berkshire, and the Strawberry Room from Lee Priory, Kent, which survives in the Victoria and Albert Museum. The importance of these houses for the future of domestic architecture, especially in the nineteenth century, is that, unlike Adam's castellated houses, they are generally asymmetrical. This Picturesque irregularity was also continued in his castle-style houses, built about 1800, such as Norris Castle, Isle of Wight, Pennsylvania Castle, Dorset, Belvoir Castle, Leicestershire, and Ashridge Park, Hertfordshire.

Despite the mediaevalizing side of his vast output, Wyatt's restoration of many English cathedrals earned him in his lifetime the nickname of 'Wyatt the destroyer'. So far as his brutal treatment of Lichfield, Salisbury, Hereford and Durham cathedrals is concerned, the criticism is more than justified.

James Wyatt was one of a large tribe of Staffordshire-born architects and builders.

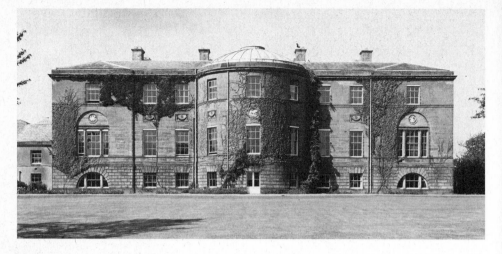

Doddington Hall, Cheshire, by Samuel Wyatt

We ought at least to glance at one more of them, James's brother, Samuel Wyatt (1737–1807), who for the most part confined himself to spare classical houses of chaste, astylar lines relieved only by smooth, bowed projections, sometimes domed. Doddington Hall, Cheshire (1777–98), is one of the finest, but there are others of similar refinement such as Herstmonceux Place, East Sussex, Delamere House, Cheshire (demolished), Tatton Park, Cheshire, Belmont Park, Kent, and Dropmore, Buckinghamshire.

One especially interesting minor architect is George Steuart (*c.* 1738–1806). His Attingham Park, Salop (1783–85), dominated by a portico with columns of abnormal attenuation, contains an enchanting circular boudoir painted in an Etruscan style probably by A.-L. Delabrière, who had decorated the interiors of Belanger's Bagatelle in Paris (1777), that *locus classicus* of the Louis XVI style. Delabrière also worked for Henry Holland at Carlton House and Southill. At St Chad's, Shrewsbury, Steuart takes delight in the violent and unexpected juxtaposition of different geometrical shapes in a powerful attempt to avoid the smooth compositions of Renaissance or Baroque architecture which tend to build up to an easy and predictable climax.

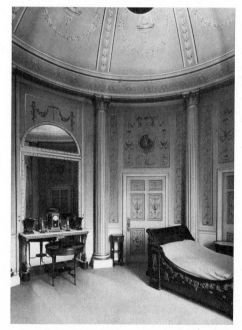

Attingham Park, Salop, by George Steuart, boudoir with paintings by A.-L. Delabrière

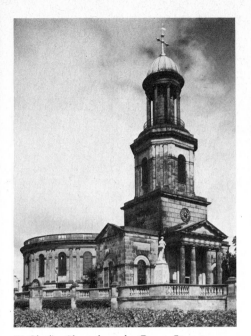

St Chad's, Shrewsbury, by George Steuart

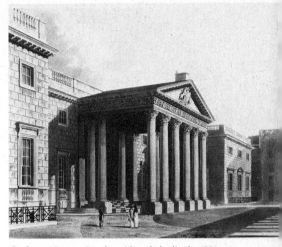

Carlton House, London (demolished), by Henry Holland, the entrance front

Henry Holland (1745–1806) was a very different architect from his contemporary, James Wyatt. He pursued more consistently an alternative to the Adam style, based partly on the publications of the mid-eighteenth-century French classicists which had already appealed to Chambers, such as M.-J. Peyre's *Oeuvres d'architecture* (1765), Jacques Gondoin's *Description des écoles de Chirurgie* (1780), J.-F. de Neufforge's *Recueil élémentaire d'architecture* (nine vols., 1757–72), and the numerous books by Pierre Patte.

Holland's most important early commission came in 1776 for Brooks's Club in St James's Street, London. This brought him into contact with the representatives of the Whig aristocracy who composed its members and for whom he was to work for the rest of his career. The Prince of Wales, later George IV, was also a member, and it was for him that Holland rebuilt Carlton House in Pall Mall

between 1783 and 1796. Approached through a rather French open screen of Greek Ionic columns and then through a Corinthian *porte-cochère*, its complicated network of exquisitely decorated interiors formed a setting of such distinction that Horace Walpole could describe it in 1785 as 'the most perfect in Europe'. Even if that praise is a little over-keyed, there can be no doubt that its replacement by George IV in 1827–33 with Carlton House Terrace to bring in rent to help pay for Nash's coarser work at Buckingham Palace, was one of the tragedies of English architecture. We can appreciate its quality today in a series of early-nineteenth-century aquatints by Pyne, and also in the interiors of Holland's Berrington Hall, Hereford and Worcester (1778–81), particularly in the richly impressive top-lit staircase. There are further interiors of the 1780s by Holland in a rather more chaste style at Woburn Abbey, Bedfordshire, for the fifth Duke of

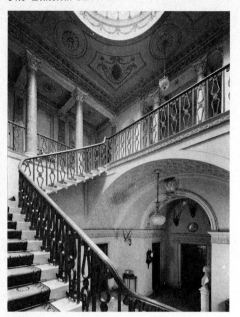

Berrington Hall, Hereford and Worcester, the staircase by Henry Holland

Bedford, at Althorp, Northamptonshire, for the second Earl Spencer, and at Broadlands, Hampshire, for the second Viscount Palmerston. His last major house, Southill Park, Bedfordshire (1796–1800), for the brewer Samuel Whitbread, achieves an amazingly understated elegance through the exercise of an iron self-control of exceptional rarity.

Like many eighteenth-century architects, Holland also turned to speculative building. He developed an estate of houses in Chelsea from 1770 which includes Sloane Street, Sloane Place and Cadogan Place.

The Picturesque: Dance, Soane and Nash

Although Holland was from 1771 the partner of the great landscape-architect, Capability Brown (1716–1783), and from 1773 his son-in-law, his architectural compositions remained uninfluenced by Picturesque or irregular techniques – except for his amusing Chinese dairy at Woburn. To see the full impact on eighteenth-century classicism of the Picturesque, whose origins we traced in Vanbrugh, we should turn to the work of Soane and Nash. To look at Sir John Soane (1753–1837) is also to look at his master, George Dance (1741–1825). Between them they introduced into the classical tradition what Soane called the 'poetry of architecture'. By this he primarily meant poetic and mysterious lighting effects produced by domes and top-lighting in an attempt to dissolve the traditional four-square room into a floating disembodied space. Like 'poetry of architecture', the term 'lumière mystérieuse', which Soane also uses, derives from the theories and visionary designs of Le Camus de Mézières, Boullée and Ledoux, which had dramatically interrupted the rational course of French classicism in the 1780s.

The thorough training in Franco-Italian classicism which Dance received during his long stay in Italy from 1759 to 1764 is reflected in his design for a public gallery of 1763. Its reticent skyline, stone domes and bleak, rusticated walls speak the language of the French Grand Prix students which Peyre was to encapsulate in his *Oeuvres d'architecture* of 1765. On his return to England Dance was fortunate enough to succeed his father as Clerk of the City Works, in which capacity he designed Newgate Prison in 1768–80 (demolished 1902). Echoing the classicism of his public gallery, Newgate Prison also contained some forceful reminders of Giulio Romano, Vanbrugh and Piranesi. With sinister dangling chains over its side entrances Newgate was intended to give sublime and poetic expression to the themes of justice and retribution.

In his council chamber at the Guildhall of 1777, now demolished, Dance broke away from the traditional conception of a domed space by making the dome and its pendentives part of the same sphere. This

emphasizes the protective tent-like aspect of the dome and minimizes the solid impact of the walls. His remarkable library at Lansdowne House, London (1788–91, since rebuilt), was mysteriously illuminated by light falling from concealed sources in sliced-off semi-domes, a technique perhaps borrowed from Piranesi. Fortunately, a number of his interiors from *c.* 1790 survive at Cranbury Park, Hampshire. Here the top-lit ballroom has a shallow cross-vault of a starfish pattern derived from the plasterwork in Etruscan or Roman tombs.

The minds of Dance and Soane were closely interlocked, so that we find the themes of Dance's interiors at the Guildhall and Cranbury constantly recurring in Soane's strange and romantic work. Born in 1753, Soane was in Holland's office from 1772 to 1778 and spent the next two years studying and travelling in Italy. His designs from this period show the characteristic preoccupations of international Neo-Classicism, inspired by Peyre and Piranesi, which had marked Dance's early work in the previous decade.

Soane's professional career began in earnest in 1788 with his appointment to the surveyorship of the Bank of England. Although major building projects in the period 1790–1815 were curtailed by the French Revolution and the Napoleonic Wars, the Bank of England expanded precisely because it was the headquarters from which William Pitt helped to finance the various European coalitions that fought against Napoleon. Very peculiar conditions governed Soane's rebuilding of the bank during the next thirty-six years: the work had to be done piecemeal and the building had to be surrounded by a solid, windowless wall. This meant that many interiors had to be top-lit. Fireproof construction was also essential, thereby rendering impossible any traditional ceilings of timber and plaster. In fact, the commission seemed calculated to bring out the very best in Soane's idiosyncratic genius. In the numerous domed halls like the stock office of 1792, the rotunda of

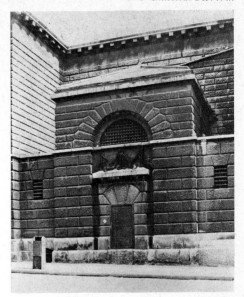

Part of Newgate Prison, London, by George Dance the Younger (demolished)

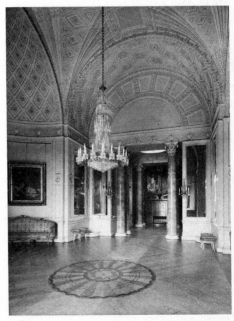

Cranbury Park, Hants, by George Dance the Younger, the ballroom

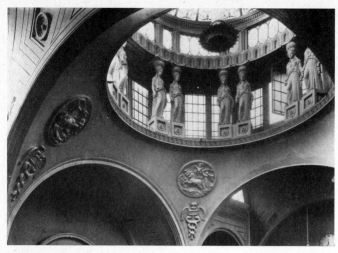

Bank of England, London, by Sir John Soane, the Dividend Office (demolished)

1796 and the consols office of 1798–99, Soane seemed to reduce classical architecture to its essentials by replacing the traditional members of the orders with curious grooves and incised lines. This reductionist approach may owe something to the French neo-classical theorist, the Abbé Laugier (1713–69), whom we know Soane admired, but it has been invested with a poetic eeriness which must have made these now demolished halls seem rather like the insides of strange, half-classical seashells. The old colonial and old dividend offices of 1818–23 add a more classical vocabulary to the language established in the 1790s, with the chorus of Greek caryatids in the lantern of the old dividend office adding a somewhat bizarre descant of its own.

Though Soane's interiors were all destroyed in the 1930s, the outer screen wall survives as well as the much mutilated Tivoli corner (1804–07), in which Soane deploys with rich effect his favourite Corinthian order from the Temple of Vesta at Tivoli. The Lothbury courtyard (1798–99) was flanked by two columnar screens, elevated on flights of steps, which led to an impressive triumphal arch. Soane also used the triumphal arch motif with striking effect on the entrance façade of his own house, Pitzhanger Manor (1800–03),

which survives today as Ealing Public Library.

Between 1792 and 1824 Soane remodelled his town house in Lincoln's Inn Fields in the same tortuous piecemeal fashion that had been forced on him at the bank. In 1812–13 he turned number 13 into an extraordinary private museum, adding parts of number 14 to it in 1823–24. He continued to live in his house-cum-museum until his death in 1837 when he left it to the nation as a museum 'for the study of Architecture and the Allied Arts'. His rich and varied collection of architectural drawings, models and casts, paintings, sculpture and miscellaneous antiquities, is scattered in deliberately Picturesque confusion through rooms of great spatial complexity, emphasized by numerous surprises such as mirrors, changing floor-levels and mysterious sources of light.

Despite the undoubted peculiarity of Soane's romantic interpretation of classicism, he gained many public appointments such as the professorship of architecture at the Royal Academy in 1806, and the post of attached architect to the Board of Works in 1814, in which capacity he rebuilt the House of Lords and the Law Courts (both since replaced). He was knighted in 1832 and, as a measure of the

Sir John Soane's house, Lincoln's Inn Fields, London, designed by himself, section (above) and breakfast room (below)

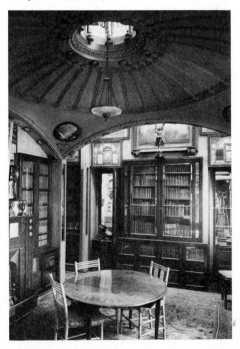

extent to which he was regarded as the father-figure of the newly emergent 'profession' of architecture, was offered the presidency of the Institute of British Architects on its foundation in 1834.

We have referred on several occasions to the Picturesque movement, noting its origins in the design of gardens and garden-buildings in the world of Vanbrugh and Kent. Although its emphasis on the relationship of architecture to its environment coloured the work of many eighteenth-century architects, few attempts to codify its principles in book form were made before the end of the century. The main exception was Thomas Whately's *Observations on Modern Gardening* which appeared in 1770 and was published in a French translation in the following year. The three best-known books all appeared in 1794–95: *The Landscape, a Didactic Poem* by Richard Payne Knight (1750–1824), *Essay on the Picturesque* by Sir Uvedale Price (1747–1829) and *Sketches and Hints on Landscape Gardening* by Capability Brown's heir as landscape-architect, Humphry Repton (1752–1818). From 1796 to 1802 Repton was in partnership with the architect, John Nash (1752–1835), and their beautifully sited, asymmetrical Luscombe Castle, Devon (1800), for the banker Charles

Cronkhill, Salop, by John Nash

Hoare, owes much to Downton Castle, Hereford and Worcester, which Payne Knight had built for himself as early as 1778. Luscombe was Gothic but at Cronkhill, Salop (*c.* 1802), Nash achieved similar effects on a smaller scale using an Italianate style based on vernacular buildings in the backgrounds of paintings by Claude – a source recommended by Payne Knight.

Between 1790 and 1815 Nash designed many similarly Picturesque houses in Gothic, castellated, Italianate and classical styles. Lacking in quality of detail or architectural scholarship, they are best seen from a distance, where they merge skilfully into settings of much beauty. What is remarkable in Nash's career is not so much these houses, but that in his mid-fifties, catching the attention of the Prince Regent, he suddenly became a town planner of great brilliance who achieved success by transporting to the centre of London the compositional techniques of the Picturesque which had previously been confined to the country. Nash's Regent's Park, conceived from 1811 to 1813 and built during the 1820s, was lined with grand terraces and dotted with Picturesque villas, all disposed in such a way as to

Cumberland Terrace, London, by John Nash

Panorama of west London from the north to show Nash's ceremonial route from Regent's Park in the foreground, via Park Crescent, Portland Place, Oxford Circus, Regent Street, Piccadilly Circus, Lower Regent Street and Waterloo Place to St James's Park and Carlton House Terrace

combine the rural amenities of a country gentleman's landscaped park with the advantages of urban living. This charming game of make-believe still finds expression in the twentieth century in the layout of the suburbs which make the umbrageous outskirts of English towns so different from those of Continental towns. In 1818 Nash drove his new Regent Street through the heart of London to connect the Prince Regent's Carlton House in Pall Mall with Regent's Park where he was to have a *guingette* or pleasure pavilion. The buildings in the new street were made deliberately irregular save for the central portion, the striking colonnaded Quadrant.

Though Regent Street has now been totally rebuilt, and the *guingette* never executed, the fantastic Royal Pavilion at Brighton, which Nash created for the Regent in 1815–21 out of a modest classical villa by Henry Holland, still delights us as a

The Royal Pavilion, Brighton, Sussex, by John Nash, the Banqueting Room

piece of wildly romantic stage-scenery miraculously transformed into real building.

The Greek Revival and nineteenth-century classicism

Nash, who came at the end of the eighteenth-century Picturesque tradition, was a discredited figure in his last years. This was due to the outcry at what was regarded as George IV's extravagant expenditure on Nash's transformation of Buckingham House into Buckingham Palace in 1825–30.

In general, English architects after 1815 followed a quieter mode than that favoured by Nash. In their search for a

sober style for public monuments, they developed some of the themes of the Greek Revival which had had a rather uncertain start in the later eighteenth century. The finest of those architects had been Thomas Harrison (1744–1829), who absorbed the monumental language of international Neo-Classicism while studying and working in Rome from the age of 25 to 32. His major executed work was Chester Castle, built between 1788 and 1822 to house county courts, a prison and barracks. The great forecourt is guarded by a version of the Propylaea on the Athenian Acropolis, as published by Le Roy in France and by Stuart and Revett in England. In fact this form had already been anticipated by C. G. Langhans at the Brandenburg Gate in Berlin of 1788–91.

Benjamin Latrobe (1764–1820) emigrated to North America in 1796, where his exquisite Catholic cathedral at Baltimore and his remodelling of the Capitol at Washington show us his debt to the English classical tradition and to Soane in particular. Before he left England, he designed Hammerwood Lodge, East Sussex, in *c.* 1790, which is one of the more successful Greek Revival houses. It is designed in a forceful style owing something to Ledoux. The same is true of the remarkable church at Great Packington, Warwickshire (1789–90), designed by the former assistant of Robert Adam, Joseph Bonomi (1739–1808).

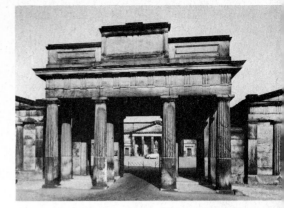

Chester Castle, the Propylaea by Thomas Harrison

Hammerwood Lodge, Sussex, by Benjamin Latrobe

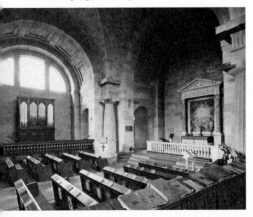

Great Packington church, Warks., by Joseph Bonomi

Grange Park, Hants., by
William Wilkins

Hammerwood makes an interesting contrast with Grange Park, Hampshire, which was designed in *c.* 1808 by William Wilkins (1778–1839), as the most complete Greek-temple house of all time. Wilkins received many commissions for public and private buildings, ranging from Downing College, Cambridge (1806–20), which owes much to the language established by Harrison at Chester Castle, to the National Gallery in London of 1833–38. Unfortunately, neither Wilkins nor his more prolific rival, Sir Robert Smirke (1780–1867), were architects of anything more than moderate ability, though the sheer scale of the Greek Ionic colonnade of Smirke's British Museum (1822–46), gives the building a certain grandeur.

The most distinguished opponent of the dullness of the Greek Revival was C. R. Cockerell (1788–1863). Like Wilkins and Smirke he went on an architectural Grand Tour which culminated in intensive study in Greece. On his return in 1817 he had become one of the leading archaeologists of the day, having made important discoveries, particularly of sculpture, at the temples of Aegina and Bassae. Cockerell revolutionized understanding of Greek architecture by his appreciation of the sculptural basis of Greek design. He was one of the first to record the use of entasis

on Greek temples, by which all major vertical and horizontal lines are slightly curved; he also noted that the temples were originally painted in bright colours.

The problem that confronted him as a practising architect was how to combine his knowledge of Greek architecture and sculpture with his desire for a rich and powerful architectural language at a time when the Greek Revival was characterized by the arid work of Smirke and Wilkins. Cockerell's diaries record his ceaseless search for perfection and his capacity for self-criticism: his early Greek Revival buildings, like the Hanover Chapel in Regent Street, London (1821–25, demolished 1896), did not satisfy him and he quickly developed a more plastic and eclectic classical language. This new monumental style was expressed in his masterly scheme for the Cambridge University Library, prepared between 1829 and 1836, of which only the north range was built. The combination of elements from Greek, Late Roman and English Baroque architecture with an austere handling of masonry that is essentially Greek, helped to create a personal style of much beauty, power and scholarship that was unique in Europe at that date. It can be appreciated more fully at Oxford in the Ashmolean Museum of

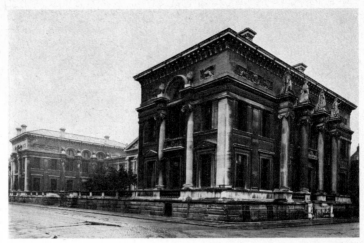

Taylorian Institute, Ashmolean Museum, Oxford, by C.R. Cockerell

Bank of England, Liverpool, by C.R. Cockerell

1839–45 where the St Giles's façade of the Taylorian Institute is one of the great masterpieces of English architecture. Of less sculptural animation but demonstrating the same sense of classic inevitability, is his branch Bank of England at Liverpool (1844–47). Cockerell was one of the first architects to design on a large scale for banks and insurance companies, and the impressive language he created was echoed in the design of banks right into the twentieth century.

Cockerell became the elder statesman of the architectural profession in England, being appointed Professor of Architecture at the Royal Academy in 1840 and first professional president of the Royal Institute of British Architects in 1860. He offered a powerful intellectual defence of the permanent validity of the classical tradition in his Royal Academy lectures, but his remoteness from the rising Gothic Revival ensured that he had little direct influence on his pupils.

One admirer was Soane's favourite pupil, George Basevi (1794–1845), whose Fitzwilliam Museum, Cambridge (1834–45), is one of the great classical museums of early-nineteenth-century Europe. The theme of the extended portico may be taken from the Roman Capitolium at Brescia, but it has been deployed in an

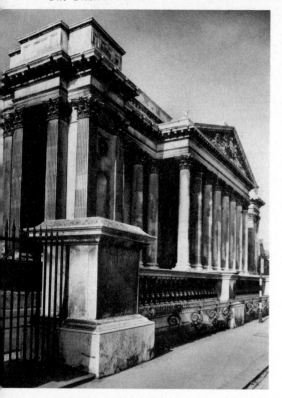

especially opulent manner so as to display the kind of sculptural richness that appealed to Cockerell. After Basevi's premature death it was Cockerell who continued work on the interiors of the museum. He did the same at the other great classical masterpiece of those years, St George's Hall, Liverpool, designed in 1839–40 by Harvey Lonsdale Elmes (1814–47). The planning and interior spaces of St George's Hall are a brilliant development of the theme of the baths of ancient Rome employed as a statement of the civic grandeur of a growing industrial city. With assistance from John Dobson (1787–1865), Newcastle was also developed as a classical city in the early nineteenth century. An able engineer and architect, Dobson also worked on as many as a hundred country houses in Greek Revival and Tudor Gothic styles.

The Fitzwilliam Museum, Cambridge, portico, by George Basevi

St George's Hall, Liverpool, by Harvey Lonsdale Elmes

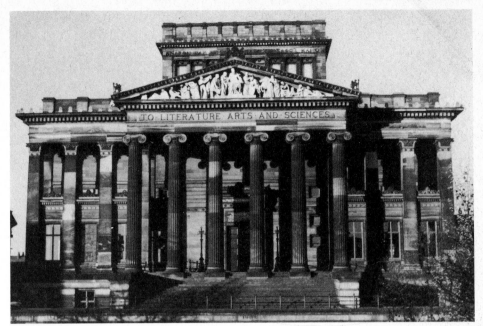

Harris Library and Museum, Preston, Lancs., by James Hibbert

The classical tradition survived longer in Scotland and the north of England than in southern England. The magnificent town hall at Leeds of 1853–58 by Cuthbert Brodrick (1822–1905) is a good example, as is the Harris Library and Museum of 1882–93 at Preston, Lancashire, by James Hibbert (c. 1833–1903). This is a late echo of the State Opera House in Berlin, designed in 1818–21 by the master of German Neo-Classicism, Karl Friedrich Schinkel (1781–1841). In Glasgow the idiosyncratic Alexander (or 'Greek') Thomson (1817–75) also worked extensively in a Schinkelesque manner, while Edinburgh assumed her role as the Athens of the North under the dominating influence of Thomas Hamilton (1784–1858) and W.H. Playfair (1790–1857).

There are a number of reasons for the survival of classicism in the north, one of which is that the Gothic Revival was particularly associated with an intellectual and religious triangle formed in the south of England by Oxford, Cambridge and London. Since most of the more interesting minds and finer architectural talents – with the dazzling exception of Cockerell – were drawn to the Gothic Revival from the 1830s, it is clearly time that we turned our attention to this extraordinary English phenomenon.

7

Victorian Architecture

As WE MOVE INTO the nineteenth century the problems of writing a general history of this kind become both different and more difficult, so that the selection of buildings becomes necessarily more personal. This, of course, is due to the vastly increased production of buildings needed for a rapidly expanding population, and to the variety of new building types and materials. To appreciate the impact of all this as well as the triumphant expressions of nineteenth-century engineering like the Crystal Palace and the great railway stations and bridges, it may be as well to turn to modern works of sociology and to the history of technology and transport. It is also important to remember that the presence of advanced technology within a building need not determine the visual appearance of the building. Great nineteenth-century buildings as different in appearance from each other as Elmes's St George's Hall, Liverpool, Barry's Reform Club and Houses of Parliament, and Paxton's Mentmore, were pioneers in the introduction of integral systems of heating and artificial ventilation. Aitchison's fine Italian Romanesque office building of 1864 at 59–61 Mark Lane, London, is largely of iron construction, as Mewès and Davis's Ritz Hotel, Piccadilly (1903–06), is an early pioneer of steel-frame construction – but in neither case can this be deduced from the exterior or, in the case of the Ritz, from the interior. Until recently architectural historians used to regret that there was a 'tragic division' between engineering and architecture in the nineteenth century. However, a new generation, less confident that it can point a reproving finger at the Victorians, has now learnt to appreciate Victorian architecture in its own right as one of the most fascinating and colourful periods in the entire history of English architecture.

Early Victorian Gothic

Salvin to Pugin
The Gothic Revival was one of the principal forces in shaping the face of Victorian England. Living in a collectivist

Nos 59–61 Mark Lane, London, by George Aitchison junior

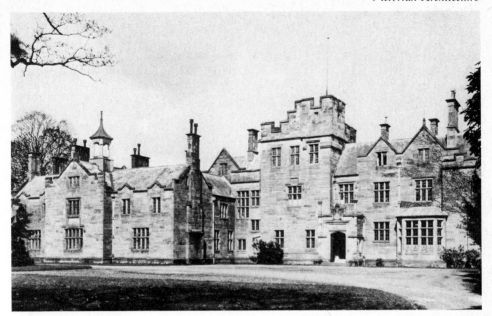

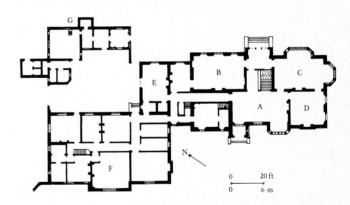

Scotney Castle, Kent, by Anthony Salvin, entrance front (above) and plan (below): A hall; B dining room; C library; D drawing room; E study; F kitchen and servants' quarters; G brew-house, dairy, etc.

notion that architecture could be true or false, morally good or bad, and that in the interest of 'honesty' it ought to reveal its structure and function and make use of 'natural' materials. This doctrine captured most of the architects of the day such as Carpenter, Street and Butterfield, as well as many of the clergy of the Church of England, and it thus bestowed on the Gothic Revival the peculiar intellectual force which it enjoyed in the nineteenth century. The doctrine has, of course, long outlived the Gothic Revival and was one of the principal arguments adopted by supporters of the Modern Movement in twentieth-century architecture. It is, on the whole, rare for the English to want their architecture to be governed by a set of intellectual principles or axioms, and it is perhaps no coincidence that Pugin was half-French by birth, for the French are particularly prone to produce architectural

157

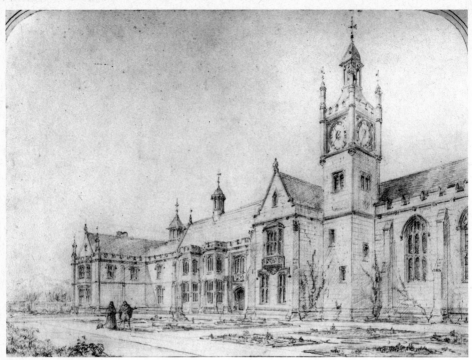

Scarisbrick Hall, Lancs., by A.W.N. Pugin, drawing of main front as originally proposed

treatises. Indeed Pugin's mechanistic approach in which architectural beauty was equated with structural honesty was the stock-in-trade of the neo-classical theorists of eighteenth-century France, though it seemed daringly new to Englishmen in the 1830s and 1840s.

Despite Pugin's ardent Catholicism his doctrines found wider acceptance in the Anglican than in the Catholic Church. The Catholic Revival in the Church of England was promoted from the 1830s by two powerful groups: the Oxford Movement which emphasized the sacraments and the spiritual role of the church, and the Cambridge Camden Society (known as the Ecclesiological Society from 1845), which emphasized correct, i.e. mediaeval, forms of church building and liturgy. The Cambridge Camden Society was probably the most influential undergraduate society of all time. Its ideal, like that of Pugin, was the English fourteenth century. Attempts to recreate this can be seen in

R.C. Carpenter's St Mary Magdalene, Munster Square, London (1849–52), in George Gilbert Scott's first major work, St Giles, Camberwell (begun 1842), and in his later All Souls, Haley Hill, Halifax (1855–59), paid for by Colonel Edward Akroyd, a prosperous local mill-owner.

To turn to Pugin's own architecture can come as a disappointment because the small Catholic community for which he worked was woefully short of funds. An exception was his early and lavishly decorated Scarisbrick Hall, Lancashire (1837–45), for the wealthy Charles Scarisbrick. This was an attempt to create a great house along mediaeval lines containing a great hall with a screens passage, minstrels' gallery and, rather eccentrically, *two* oriel windows side by side. Pugin was also

St Giles, Cheadle, Staffs., by A.W.N. Pugin, interior looking north-east

Lancing College chapel, Sussex, by R.H. Carpenter

fortunate in the patronage of the sixteenth Earl of Shrewsbury who paid for the richly adorned St Giles, Cheadle, Staffordshire (1840–46), though possibly his finest church is St Augustine, Ramsgate, Kent (1845–50). He built this entirely out of his own pocket at a cost of £20,000 and gave to the Catholic Bishop of Southwark. It stands a few yards away from his own much simpler brick house, the Grange of

[...] Lord Shrewsbury Pugin built the dramatic Alton Castle, Staffordshire (1[...]), and the associated Hospital of St [...] an elaborate alms-house with chapel, school and village-hall. At Alton, more than anywhere else, one can sense the social gospel that lay behind Pugin's architecture. The desire to create the ideal Christian community was one of the most powerful driving forces of the nineteenth century. Its perfect [...] an expression can be seen in the [...] of church, vicarage, school and [...] es built by George Edmund Street (–81) at All Saints, Boyne Hill, Maidenhead, Berkshire (1854–57). R.C. C[...]'s Lancing College, West Sussex (begun 1854–58), with its breathtaking [...] Gothic chapel begun by his son [...] 58, shows what electric effect the [...] e-making

power of this new vision could have on the appearance of a boys' boarding school.

Houses of Parliament, London, by Charles Barry and A. W. N. Pugin, exterior looking south-east, with the Victoria Tower on the right

The Palace of Westminster

Pugin's most elaborate interiors can be seen at the Palace of Westminster, and in particular in the House of Lords. Following the burning of the old palace in October 1834, it was stipulated in the competition for a new building in 1835 that only the Gothic or Elizabethan styles were appropriate for a great national monument. This indicates the strength of the tradition of associational architecture which we saw developing in the eighteenth century.

In 1835 the young Pugin helped Charles Barry (1795–1860) prepare the designs with which Barry won the competition for the new Houses of Parliament. The foundations of Barry's great building were begun in 1837, the first stone of the superstructure was laid in 1840, the House of Lords was opened in 1847, the clock tower was completed in 1858, the Victoria Tower in 1860, and work continued

during the 1860s under the direction of Barry's son, E. M. Barry. The whole building cost about two million pounds and though it had virtually no architectural influence in England it quickly became, and indeed has remained, one of the most potent of all national symbols.

Both the plan and the elevations are brilliant combinations of classical symmetry and Gothic drama. This is also true of the House of Lords, a double cube of the same proportions as Inigo Jones's classic Banqueting House in Whitehall, which is nonetheless sumptuously adorned in a rich polychromatic Gothic by Pugin, who claimed to have produced 2,000 drawings for this room alone. Pugin's ability to produce designs for metalwork, tiles, woodwork, furniture, wallpaper and even inkwells and calendars, reminds one of the decorative control of Robert Adam, though Adam never had to face the problem of design on this large scale. Indeed Pugin died partly from overwork and nervous strain in September 1852, aged only 40.

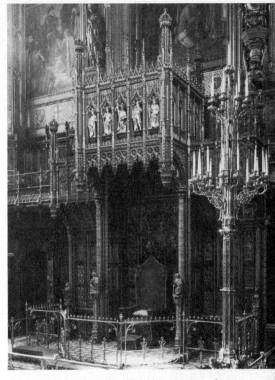

Houses of Parliament, detail of the House of Lords (above) and plan of whole complex (below): A entrance porch; B Westminster Hall (see p. 77); C central lobby; D House of Commons; E House of Lords; F Royal Gallery; G lobbies; H river front with libraries, committee rooms, etc.; J Big Ben; K Victoria Tower. (The shaded areas indicate open courtyards)

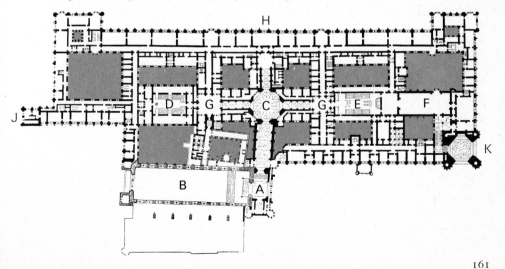

Italianate Revival

Barry

In our account of the Classical Revival in the previous chapter we noted the strength in the nineteenth century of Greek and Roman classicism in the North: Elmes, Dobson and Brodrick in England; Hamilton and Playfair in Edinburgh; and 'Greek' Thomson in Glasgow. Even in the South the Goths did not quite have things all their own way and there was much support for a secular architecture based on the forms of the Italian Renaissance. This allowed considerable richness of surface texture with large window-openings and was, above all, astylar, so that it did not involve the colonnades of neo-classical architecture which were now becoming unfashionable. The master of this movement was the same Charles Barry whose work we have admired at the Houses of Parliament: indeed he would have preferred to have designed the building in an Italianate style.

Barry's early career was set in a characteristically eighteenth-century classical mould: he went on a Grand Tour of France, Italy, Greece, Egypt and Syria in 1817–20 and on his return designed the Royal Institution of Fine Arts (now City Art Gallery) at Manchester in 1824 as a distinguished essay in the Greek Revival. Like Cockerell, he was soon to desire a more plastic style, but turned, unlike Cockerell, to an Italianate style which largely avoided the use of the orders. An important early example is the Travellers' Club, Pall Mall, London (1829–32), and, even more striking, the Reform Club next door of 1837–41. The Reform is inspired externally by the sixteenth-century Palazzo Farnese in Rome, but internally it is extremely novel and complex. It centres on a huge, top-lit, two-storey hall, surrounded by first-floor galleries, which is neither a conventional staircase hall nor a version of the mediaeval great hall.

Barry was extremely fortunate in his extensive patronage by the second Duke of Sutherland who enjoyed an enormous coal

The Reform Club, London, by Charles Barry, the central saloon

fortune. For him Barry rebuilt Trentham Hall, Staffordshire, from 1834 to 1849 (largely demolished 1910), as a giant High Renaissance palazzo grouped asymmetrically round a belvedere-capped tower. This Picturesque method of composition was derived from The Deepdene, Surrey, which Thomas Hope had remodelled for himself in 1818–23. For the Duke of Sutherland Barry also rebuilt Cliveden House, Buckinghamshire, in a magnificent Renaissance manner in 1850, and Dunrobin Castle, Highland (1844–48), in the Scottish Baronial style. The style of Barry's Trentham was adopted by Queen Victoria and Prince Albert for Osborne House, Isle of Wight (1845–51).

Barry's Reform Club and the stylistically related Bridgewater House, Green Park, London (1846–51), which he built for the Duke of Sutherland's brother, the Earl of Ellesmere, were a powerful influence on Lewis Vulliamy (1791–1871),

who built the immensely grand Dorchester House, Park Lane, in 1848–63 for the millionaire collector, R.S. Holford. Dorchester House was inspired externally by Peruzzi's Farnesina in Rome of 1509; inside, one of the most handsome rooms was the dining-room, designed by the finest of Victorian sculptors, Alfred Stevens (1817–75). Though the house was demolished in 1929, the great Michelangelesque chimney-piece from the dining-room survives at the Victoria and Albert Museum.

Gibson, Pennethorne and Scott
Barry's assistant, John Gibson (1817–92), set up as an independent architect in 1844 and had an extensive Italianate practice, largely in connection with the National Provincial Bank. His bank at Southampton of 1867 is a rich and animated composition, though it is exceeded in quality by his one-storey bank in Bishops-

Dorchester House, London, by Lewis Vulliamy, the dining room with sculpture by Alfred Stevens (demolished)

gate, London (1865). At Todmorden, West Yorkshire, he built the town hall from 1860 to 1875 as a sumptuous but crisply detailed temple with engaged columns. One of the most impressive of all examples of the classicism which was much favoured in northern cities is the Free Trade Hall in Manchester, designed by Edward Walters (1808–72) in a manner ultimately derived from Sansovino. Walters's other major work is his last, the ornate palazzo built for Williams Deacon's Bank in Mosley Street, Manchester, in 1860.

In London one of the major non-Gothic architects was Sir James Pennethorne (1801–71), a pupil of Nash who became a government architect and was appointed joint surveyor to the Land Revenue

The Free Trade Hall, Manchester, by Edward Walters

Department in 1840. Unfortunately, his most interesting building, the Museum of Economic Geology in Piccadilly (1844–51) was demolished in 1935, but his building for London University in Burlington Gardens of 1866 survives as the Museum of Mankind. This rather turgid composition, difficult to appreciate properly in its narrow street, was affected by the Battle of the Styles fought in the 1860s between Liberal politicians who favoured the Italianate style, and Conservative politicians who favoured Gothic. Thus Pennethorne was forced to present Gothic designs as an alternative to his Italianate project for this building in just the same way as Sir Gilbert Scott (1811–78) had been required to remodel his Gothic design for the Foreign Office more than once between 1857 and 1861 to suit the Renaissance tastes of the Liberal prime minister, Lord Palmerston. Seen from St James's Park, landscaped by Nash, Scott's Foreign Office as built between 1862 and 1873 is a particularly Picturesque composition, pivoting on an asymmetrically-placed loggia-topped tower in the Barry manner.

The Natural History Museum, London, by Alfred Waterhouse

The Foreign Office, London, by George Gilbert Scott, front facing St James's Park

South Kensington

The Battle of the Styles had no real political significance and in the mid-Victorian period a compromise Italianate style was favoured, particularly for the cultural buildings of South Kensington. The idea of this cultural centre was Prince Albert's, and its round-arched red-brick buildings may owe something to contemporary German fashions. With their extensive use of buff terra-cotta ornament they look not to Roman or Venetian Renaissance architecture but to north Italian Renaissance. The best examples are the quadrangle of the Victoria and Albert Museum, begun in 1859 by Captain Francis Fowke (1823–65) and the sculptor Godffrey Sykes (1824–66), and the Albert Hall and the Huxley Building, both of 1866–71 by Lieutenant-Colonel H. Y. D. Scott (1822–83). Near by is the Natural History Museum (1873–81) by Alfred

Waterhouse (1830–1905). This makes extensive use of structural steel-work, but is completely faced in a creamy-yellow terra-cotta blushed with mauve tints. Though the forms of this building are ultimately of Romanesque origin, they are handled with a regularity and symmetry that makes them blend extremely well with the Renaissance work around them.

High Victorian Gothic

The English fourteenth-century ideal of Pugin and his followers did not satisfy the restless, energetic Victorians for long. The period from 1850 to 1870 is characterized by an architecture of extraordinary sculptural violence, vigorous muscularity and strident polychromy. Oddly enough, what is called 'muscular Christianity', the cult of manliness and the obsession with compulsory games at boys' schools, did not dominate English education until the 1870s and 1880s, after its architectural equivalent was over. This movement is especially connected with the architects Butterfield, Lamb, Teulon, Burges, White, Brooks, and the early work of

Elvetham Hall, Hants., by S.S. Teulon

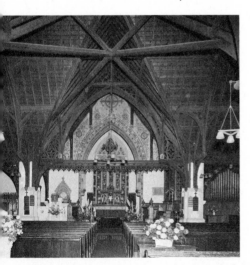

St Margaret, Leiston, by E.B. Lamb, interior looking east

Street, Bodley and Pearson. The emphatic constructional emphasis which those architects favoured can be appreciated in the carpentry roof of St Margaret, Leiston, Suffolk (1853), by Edward Buckton Lamb (1806–69); and their love of bizarre stripes and prickles in Elvetham Hall, Hampshire (1859), by Samuel Sanders Teulon (1812–73), a prolific country-house architect. Beneath the surface eccentricities lay a new appreciation of solid geometrical forms. This is immediately noticeable when we look at the cruciform St Peter, Daylesford, Gloucestershire (1859–61), or Christ Church, Appleton-le-Moors, North Yorkshire (1863–66), both by John Loughborough Pearson (1817–97). We can recognize it again in Bodley's All Saints, Selsley, Gloucestershire (1862), with its dynamic, German, saddle-back tower, its French plate-tracery and its external stone staircase; and in Street's aggressive St

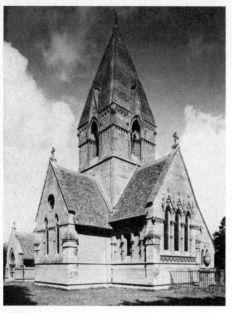

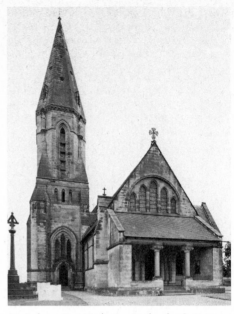

St Peter, Daylesford, Glos., by J. L. Pearson *St Andrew, East Heslerton, Yorks., by G. E. Street*

Andrew, East Heslerton, North Yorkshire, boasting a curious western porch like a massive stone verandah supported on twin columns of polished granite with Italian Gothic capitals. What High Victorian architects like Butterfield, Street and White tried to achieve was an un-sentimental reformed Gothic inspired by the massive forms of the thirteenth century, especially in France, and by the polychromatic effects of the Italian and German architecture which they daringly elaborated in brick.

Butterfield and Ruskin

William Butterfield (1814–1900) is perhaps the best-known, or most no-torious, of this group of architects. A devout Anglican from an Evangelical background who was elected a member of the Ecclesiological Society in 1844, he never married but devoted his life to reformed Christian architecture. Pugin's appeal for constructional honesty was

interpreted by Butterfield in terms of constructional polychromy, as can be seen in his All Saints, Margaret Street, London (1849–59), the model church of the Ecclesiological Society. Bands of vitrified bluish-black brick push their way up and down the red-brick walls, while inside the polychromatic decoration is much more varied and sumptuous with coloured tiles forming insistent patterns that completely cover the floors and walls.

It is at this stage that we should introduce John Ruskin (1819–1900), who lent immensely powerful support to the Gothic Revival by his vast and persuasive literary output, by his high moral tone and by the sheer beauty of his prose. The books which especially influenced architects were *The Seven Lamps of Architecture* (1849) and *The Stones of Venice* (1851–53). The Seven Lamps – Sacrifice, Truth, Power, Beauty, Life, Memory and Obed-ience – may seem to have little to do with architecture, but Ruskin was interested in

ornament, surface texture, colour and light; he was moved by the imprint of the human hand on the worked surface where he claimed to be able to read the joys, passions and beliefs of the individual craftsman and of the society that produced him. The romance and imprecision of Ruskin's approach to architecture made it especially popular. What was also influential, at any rate in the 1850s and 1860s, was his novel emphasis on Continental as opposed to English Gothic. Indeed Ruskin's attacks on English mediaeval architecture can still come as a surprise: in the 'Lamp of Power' he wrote, '. . . all that we do is small and mean, if not worse – thin, and wasted, and unsubstantial. It is not modern work only; we have built like frogs and mice since the thirteenth century (except only in our castles). What a contrast between the pitiful little pigeon-holes which stand for doors in the west front of Salisbury, looking like the entrances to a beehive or a wasp's nest, and

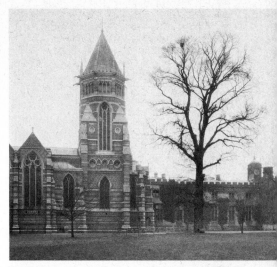

Rugby School, Warks., the chapel, by William Butterfield

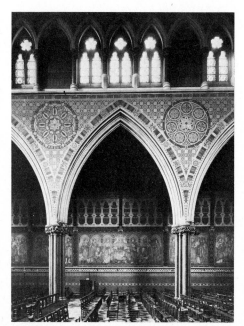

All Saints, Margaret Street, London, by William Butterfield, detail of the north arcade of the nave

the soaring arches and kingly crowning of the gates of Abbeville, Rouen, and Rheims, or the rock-hewn piers of Chartres, or the dark and vaulted porches and writhed pillars of Verona!'

Ruskin's emphasis on the pattern and colour of Italian Gothic and, especially in *The Stones of Venice*, on Venetian Gothic, was echoed in much of the secular and ecclesiastical work of Butterfield, Street, Scott, Waterhouse, and Deane and Woodward in whose Oxford Museum (1853–56) Ruskin took a close interest. It even percolated through to the design of the countless terraces of bay-windowed villas that grew up from the 1860s on the outskirts of almost every town in England. Butterfield developed his style consistently from All Saints, Margaret Street, onwards in a series of striking churches like St Alban, Holborn (1859–62), All Saints, Babbacombe, Devon (1865–74), and St Augustine, Queen's Gate, London (1870–77). He applied the technique equally relentlessly to the architecture of education at Keble College, Oxford (1867–83), and Rugby School, Warwickshire (1858–84; chapel 1870–72).

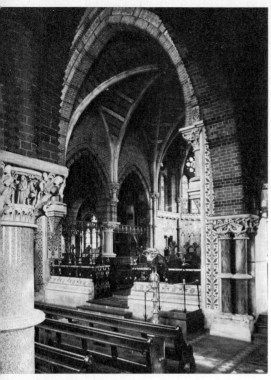

St James-the-Less, London, by G.E. Street, the chancel looking north-east

Cardiff Castle, by William Burges, the Summer Smoking Room

Street and Burges

In the meantime, George Edmund Street (1824–81) had published *Brick and Marble in the Middle Ages, Notes of a Tour in the North of Italy* (1855). His St James-the-Less, Westminster (1859), with its tall Ruskinian campanile is an electrically personal blend of English, early French and north Italian Gothic, with coloured brick, marble, tiles and mastic stirred together in fierce patterns. Towards the end of his extremely productive career Street built the Law Courts in the Strand, London (1874–82), as a late example of High Victorian vigour and determined asymmetry. One of the most powerful entries in the Law Courts competition of 1866 was by William Burges (1827–81), an architect who combined intense romance of spirit with wild exuberance of detail. His richest interiors, heavy with symbolism, were carried out for his millionaire patron, the Roman Catholic Marquess of Bute, and can be seen at Cardiff Castle (1868–81) and at Castell Coch near by (1875–81).

Scott and Waterhouse

We have noted in passing two Gothic churches by Scott and also his Italianate Foreign Office, but as one of the most prolific and successful of all Victorian architects he deserves separate notice of his own. It is difficult to be very attracted by his almost commercial approach to architectural production or by the incredibly self-satisfied tone of his unintentionally amusing *Personal and Professional Recollections* (1879). Apart from his numerous

cathedrals, churches and college chapels, generally in a sort of Anglo-French High Gothic, he also specialized in secular buildings, publishing *Remarks on Secular and Domestic Architecture, Present and Future* (1857) to prove that Gothic was perfectly adaptable for this purpose. The commonsense tone of the book, very different from the fire of Pugin, suggests that he had no special passion for Gothic but selected it with an eye to the main chance: 'I am no mediaevalist,' he wrote, 'I do not advocate the styles of the middle ages as such. If we had a distinctive architecture of our own day worthy of the greatness of our age, I should be content to follow it; but we have not; and the middle ages having been the latest period which possessed a style of its own . . . I strongly hold that it has greater *prima facie* claims to be used as the nucleus of our developments than those of ancient Greece or Rome.' His principal secular buildings are the grimly asymmetrical Kelham Hall, Nottinghamshire (1858–61), the Albert Memorial (1863–72) and, perhaps his most spectacular work, the Midland Grand Hotel, St Pancras (1868–74), considered by Scott to be 'possibly *too good* for its purpose'.

No account of Scott's career would be complete without reference to his numerous restorations of mediaeval churches. Apart from his extensive work at Westminster Abbey, he restored as many as twenty English cathedrals: the sheer quantity suggests an inadequately meticulous and sensitive attention to detail. Partly in reaction to his work, William Morris founded the Society for the Protection of Ancient Buildings in 1877, and debate about the merits of different kinds and degrees of restoration of buildings, as well as of paintings, has continued unabated up to the present day.

Alfred Waterhouse (1830–1905), from a Liverpool Quaker family, is another immensely productive architect who must appear in a survey of this kind, but about much of whose work it is difficult to generate a warm enthusiasm. One building of his which always satisfies is Manchester Town Hall, designed in a

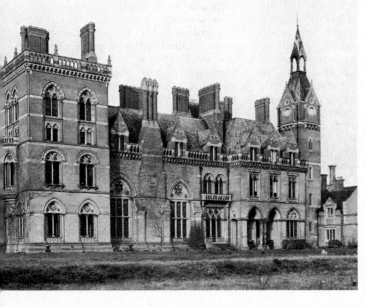

Kelham Hall, Notts., by George Gilbert Scott

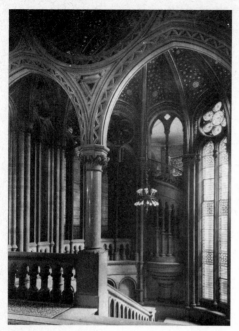

Manchester Town Hall, by Alfred Waterhouse, detail of the staircase

Late Victorian architecture

The later Gothic Revival:
Bodley, Pearson and the later Scotts

The passionate vigour of the High Victorian style had burnt itself out by about 1870. Its urgency was now replaced by a succession of softer, more compromising and more eclectic styles. Some of the architects who had been prominent in the style of 1850–70, like Bodley, Pearson and Shaw, were leaders of the new movement, though others, like Street, Burges and White, had nothing to do with it. The shift away from muscularity and back to Puginian sweetness is shown strikingly in Bodley's All Saints, Jesus Lane, Cambridge, which he had begun in his earlier strident manner in 1861 but suddenly remodelled about two years later in a quieter English fourteenth-century style. This was given even fuller expression in his St John, Tue Brook, Liverpool (1868), with its richly stencilled decorations derived from Pugin. Perhaps Bodley's most perfect church, Holy Angels, Hoar Cross (1872 onwards), lies in the heart of the Staffordshire countryside, where it was paid for by Mrs Meynell Ingram as a memorial to her husband. A strong and comparatively unadorned exterior is dominated by a magnificent crossing tower inspired by the Perpendicular tower at Ilminster church, Somerset. Inside, all is Decorated richness with intricate tracery, sculpture and stone panelling. Like all of Bodley's later work it has an immaculate *tastefulness* and refinement which set it apart from High Victorian design and from quite a lot of mediaeval design as well.

After his early work, John Loughborough Pearson (1817–97) quickly developed a somewhat chill Anglo-French thirteenth-century style which made up in spatial imagination what it lacked in colour and texture. Fine examples of his large, calm, generally stone-vaulted churches can be seen at St Augustine, Kilburn (1870–*c.* 1877), St Michael, Croydon (1876–85), St Agnes, Sefton Park, Liver-

competition held in 1867–68. In an animated Early English style it rises from a triangular site and contains impressive stone staircases and vaulted corridors. Waterhouse's magnificent civic style was less suited to country-house design, as could be seen at his immense Eaton Hall, Cheshire, for Earl Grosvenor (later first Duke of Westminster), built in 1870–82 but now largely demolished. Waterhouse was determined to prove that the Gothic style was suitable for the new building types of the nineteenth century and also the new materials like the rolled iron beams which he used extensively. A characteristic example of the impressive if rather charmless architecture which resulted from this ambition is his Prudential Assurance Buildings in Holborn, London (1877–79 and 1899–1906), constructed of imperishable terra-cotta and harsh red brick.

Holy Angels, Hoar Cross, Staffs., by G. F. Bodley, exterior (above) and interior (left) looking south-east

pool (1882–85), All Saints, Hove (1889–91), and Truro Cathedral (1880 onwards).

George Gilbert Scott junior (1839–97), eldest son and pupil of the famous Sir Gilbert Scott, was a more sensitive architect than his father. At Cattistock church, Dorset, there is an interesting contrast between the work of Scott senior, with a polygonal apse of 1855–57, lit by meagre Early English lancets, and the magnificent tower added by Scott junior, in 1872–76. His two London churches, St Agnes, Kennington (1874–77), and All Hallows, Southwark (1877–92), both now demolished, had nave and chancel under one roof, providing spacious interiors ornamented with rich fittings. The style was a simplified Perpendicular with the arcade mouldings dying into the piers with no capitals. These beautiful churches represented a new departure which was to be influential on later architects like Scott's

Truro Cathedral, by J. L. Pearson, from the north

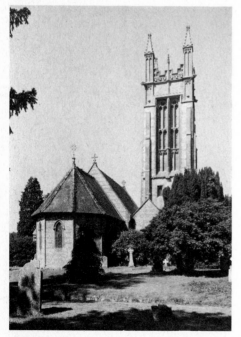

Cattistock church, Dorset, the apse by George Gilbert Scott senior, the tower by G.C. Scott junior

pupil, Temple Moore (1856–1920) and Leonard Stokes (1858–1925).

It may be appropriate at this point to mention Scott junior's son, Giles Gilbert Scott (1880–1960), who to much amazement won the important competition for the Anglican cathedral at Liverpool in 1903 while still doing his training with Temple Moore. The competition was judged by Bodley who was appointed joint architect with Scott when work began in 1904. Considerably redesigned in 1909–10 after Bodley's death, Liverpool Cathedral is a breathtaking masterpiece in a late-Gothic style, heavily dependent on Bodley though with some Spanish touches. It can be regarded as the triumphant climax of the whole Gothic Revival.

Richard Norman Shaw

The most brilliant of all later Victorian architects was Richard Norman Shaw (1831–1912). With Sir Edwin Lutyens (1869–1944), whom he resembles in many ways, he was one of the two great giants who dominated English architecture between the late 1860s and the Second World

Liverpool Cathedral, by Giles Gilbert Scott, exterior from the north-east (above), and interior (below) looking east

War. It is impossible to do full justice to the vast output and varied styles of either architect in a book of this size. Born in Edinburgh, Shaw was articled for five years from *c.* 1849 to the prolific master of the Scottish Baronial style, William Burn (1789–1870), who had opened a London office. He followed this with a period in Salvin's office in 1856–57. He was the principal assistant of G. E. Street from 1859 to 1863 when he set up his own practice, sharing an office with his friend, William Eden Nesfield (1835–88). Shaw's mature work is a remarkable synthesis of the two traditions in which he was trained: the Picturesque side of the work of Burn and Salvin, and the toughness of Street.

It is particularly with domestic architecture that Shaw's name is connected and he rose to fame with one house of 1866 that contemporaries found enthralling, Leyswood, West Sussex, for J. W. Temple, managing director of the Shaw Savill shipping line. As a reaction against the grandiose houses of the first half of the nineteenth century in Gothic, Baronial or Italianate styles, what was now wanted

173

was houses in local vernacular styles and materials, looking smaller and more homely than they really were. Philip Webb (1831–1915) was a pioneer in this field in the 1860s, but at Leyswood Shaw helped to create the 'Old English' style, with its tall brick chimneys, great tile-hung sweeps of roof and wall, and mullioned windows with leaded lights. Though apparently informal, the assembly of these motifs is brilliantly planned in a theatrical way, highlighted in Shaw's clever perspective drawings which attracted much attention when published in the architectural journals of the day.

Shaw developed the Leyswood theme at Grims Dyke, Harrow Weald, near London, which he built in 1870–72 for the genre painter, Frederick Goodall, R.A. Grims Dyke is a 'split-level' house with the main staircase wandering picturesquely through the building in a manner which Shaw was increasingly to exploit in his later work. From the half-landing stage a subsidiary wing, containing Goodall's studio, juts out at a canted angle to the rest of the house. As Viollet-le-Duc noted in

Leyswood, Sussex, by Richard Norman Shaw, original design (the house now largely demolished)

his account of this house in *Habitations Modernes* (1875), this kind of agglutinative plan gives the attractive suggestion that the house has grown through the centuries. The Leyswood-Grims Dyke theme is developed with spectacular panache at Cragside, Northumberland (1870–*c.* 1885), built on an improbably irregular but wildly romantic site for Sir William (later first Lord) Armstrong, scientist, inventor and armaments manufacturer. Quieter in tone and perhaps even more masterly is Adcote, Salop (1876–81), designed to resemble a mediaeval great hall with sixteenth-century additions.

The sprawling Old English style was not very suitable for urban architecture, so Shaw and Nesfield invented a new and equally pleasing style, suitable for town and country, which became known as 'Queen Anne'. It was enlivened with cheerful balconies and verandahs of white-painted wood, and details like shaped

gables and carved brickwork of seventeenth-century rather than Queen Anne origin. Variations of it can be seen in London in Shaw's Lowther Lodge (now the Royal Geographical Society) of 1875–77, near the Albert Hall, in his own house at 6 Ellerdale Road, Hampstead (1874–76 and 1885–86), in Swan House, Chelsea Embankment (1875–77), and in two exquisitely mannered houses of 1875 in Melbury Road for successful artists, number 8 for Marcus Stone and number 31 (formerly 11) for Luke Fildes. The style spread rapidly in the hands of talented architects like Ernest George, Bodley, Stevenson, G.G. Scott junior, Godwin, and Basil Champneys (1842–1935), who produced between 1874 and 1910 one of the most charming of all 'Queen Anne' compositions, Newnham College, Cambridge.

In the work of Edward Godwin (1833–86) the 'Queen Anne' Movement merged with the Aesthetic movement of Whistler and Wilde who had a keen interest in Japanese art. The originality of Godwin's style can be seen in his unexecuted design of 1878 for 44 Tite Street, London, for the artist Frank Miles, a friend of Oscar Wilde.

No. 44 Tite Street, London, by Edward Godwin, design for façade (house now demolished)

Newnham College, Cambridge, by Basil Champneys

*No. 170 Queen's Gate,
London, by Richard
Norman Shaw*

In the 1880s Shaw's style developed again, this time in the direction of a neo-Georgianism which was to be influential in the twentieth century. The landmarks of this style, which, like his 'Queen Anne', was much indebted to the seventeenth century, are 170 Queen's Gate, London (1888–90), for Frederick White, a wealthy cement manufacturer and dilettante; the immense Bryanston, Dorset (1889–94), for the second Viscount Portman; and the rebuilding of Chesters, Northumberland (1890–94). The style also appeared in commercial buildings like his Parr's Bank, Liverpool (1899–1900), and Allied Assurance office at 88 St James's Street, London (1901–05). The complex spatial variety and independent planning on different floors which Shaw always revelled in was made easier of execution in these later buildings by extensive use of iron and steel girders.

The Arts and Crafts Movement:
Webb to Bentley
Shaw was himself both influenced by and an influence on the loose body of opinion and design which has come to be known as the Arts and Crafts movement. This grew out of the Gothic Revival with its special emphasis on craftsmanship and materials. Pugin, who was important not only as a designer of buildings but of metalwork, furniture, textiles, tiles, stained glass and wallpaper, gathered round himself a group of manufacturers who executed his designs: Crace and Son for furniture, Minton's for tiles, and John Hardman & Co. for metalwork and glass. Great literary support came from Ruskin and in particular from the chapter 'The Nature of Gothic' in *The Stones of Venice* which became the bible of the two Oxford undergraduates who read it in 1853, William Morris (1834–96) and Edward Burne-Jones (1833–98). The firm of Morris, Marshall and Faulkner and Co., founded in 1861, continued the pattern established by Pugin in the production of stained glass, wallpaper, tiles, printed textiles, carpets, tapestries and, eventually, books. Characteristic Morris interiors of the 1860s, rich if somewhat gloomy, can be seen in the Green Dining Room at the

Victoria and Albert Museum, the Tapestry Room and Armoury at St James's Palace, and the Combination Room at Peterhouse, Cambridge.

Morris spent a short time in the office of G.E. Street from 1856, where he met Philip Webb (1831–1915), who became one of the founder members of Morris's firm. Reacting against the Victorian surfeit of styles and influenced by Pugin's belief that architecture could and ought to be truthful, Webb deluded himself into thinking that true architecture grew inevitably out of function and materials with the architect serving as a kind of anonymous coordinator of skilled craftsmen. As Warrington Taylor, one of the members of Morris's circle, wrote to the architect R.R. Robson, 'You don't want any style, you want something English in character', 'Style means copyism, the test of good work would be an absence of style'.

Webb's comparatively small output, mainly of London and country houses, can be interpreted as a brave attempt to put Taylor's advice into practice. Webb's practical blend of mediaeval with eighteenth-century features, intended to create a styleless vernacular, in fact created an astringent personal manner which is instantly recognizable. The celebrated Red House at Bexleyheath which he built for Morris in 1859–60 is a rather glum building, and his best surviving London works, all of the late 1860s, are 1 Palace Green, Kensington, for the aesthetic the Hon. George Howard; 35 Glebe Place, Chelsea; and offices at 19 Lincoln's Inn Fields. His major country house is Clouds, Wiltshire, designed in 1876–79 and built during the 1880s with the entertainment of large weekend parties in mind. Especially novel were the spacious, white, uncluttered rooms which marked a decisive and influential reaction against the earlier interiors associated with Morris's firm. Clouds has been much altered since Webb's day but fortunately his last major house, Standen, East Sussex, has survived intact with its original contents. It was built in 1891–94 for J.S. Beale, a successful solicitor, as a house for holidays and weekends, beautifully related to the valley

Standen, Sussex, by Philip Webb

Nos 10–12 Palace Court, Bayswater, London, by James MacLaren

in which it stands. Though a substantial house with thirteen bedrooms on the first floor, it has to look like a modest rambling farmhouse in order to suit Webb's aesthetic. The difficulties Webb experienced in achieving this can be sensed all too clearly in the crowded and rather strained composition, with its impression of having tried too hard and its almost grotesque determination to include as many local materials as possible: brick, tile-hanging, weather-boarding and local limestone, as well as the non-local and rather displeasing pebble-dashing.

The most important buildings of Webb, who had always shunned publicity, dated from the 1860s and 1870s, but he was rediscovered at the end of the century by two pupils of Shaw, E. S. Prior (1852–1932) and W.R. Lethaby (1857–1931). They were to carry into the twentieth century his search for a practical way of building that avoided style, and were joined by a fascinating group of experimental architects such as James MacLaren

(1843–90), whose unusual double house at 10–12 Palace Court, Bayswater (1889–90), was a work of great promise, A.H. Mackmurdo (1851–1942), Harrison Townsend (1851–1928), C.F.A. Voysey (1857–1941), Leonard Stokes (1858–1925) and C.R. Mackintosh (1868–1928), whose celebrated Glasgow School of Art (1896–99 and 1907–09), a combination of Scottish vernacular, functionalism and Art Nouveau, was the only British building of these years known and admired on the Continent.

One great building which, perhaps surprisingly, was welcomed by many of these architects as a fulfilment of their ambitions for a 'real' unaffected architecture, was Westminster Cathedral (1894–1903). This was designed by John Francis Bentley (1839–1902) whose most important previous work was the exquisite Catholic church of the Holy Rood, Watford, Hertfordshire (1883–90), in a manner indebted to Bodley. The choice of the 'Italo-Byzantine' style for the new Catholic cathedral at Westminster, though partly due to Cardinal Vaughan, fitted exactly the taste for Byzantine craftsmanship and architecture already current in the circle round Lethaby. The lively red-and-white striped exterior was a development of a technique familiar in the 1880s in buildings such as Bentley's St John's Preparatory School, Beaumont, Old Windsor, Berkshire, and in Shaw's better-known but slightly later New Scotland Yard. Bentley's mastery is chiefly displayed in the disposition of the interior spaces where the three broad domes of bare brick hover mysteriously over the huge, dark nave, glittering with marble and mosaic.

Westminster (Roman Catholic) Cathedral, by John Francis Bentley, interior looking east

The Twentieth Century

Edwardian Classicism

THE DIET AFFORDED by Edwardian architecture is rich and varied, but the stylistic ingredients were basically those already familiar in the nineteenth century. The Gothic Revival continued in church architecture, if in a somewhat muted form; the Arts and Crafts Revival of domestic architecture produced a rich crop of sensitive building in an English tradition, as well as a number of eccentrically experimental buildings which form a recognizable group of their own. Perhaps the most characteristically Edwardian contribution was the re-animation of the classical tradition for large-scale public buildings. The two most popular styles were a grandiose Baroque inspired by Wren and Vanbrugh and an up-to-date French classicism introduced by those who suddenly discovered that in France the classical tradition was a living force that had not been throttled by the Gothic Revival.

The building which more than any other drew the attention of architects to the potentialities of Baroque was Cardiff City Hall and Law Courts of 1897–1906 by H. V. Lanchester (1863–1953) and Edwin Rickards (1872–1920). The logical and spacious plan, inspired by the axial planning taught at the Ecole des Beaux-Arts in Paris, was combined with an exuberant and asymmetrically placed tower which satisfied the English demand for Picturesque effects. The building had not only grandeur but also panache and gaiety due to the sculptural gifts of the brilliant draughtsman, Rickards. He was a particular admirer of Austrian Baroque and the building has much lively sculpture executed from his designs by Henry Poole. The same architects produced work of similar quality, though on a smaller scale, at Hull School of Art (1904), and the exceptionally attractive Deptford Town Hall, London (1902–04), with its jaunty cupola. Their major work after Cardiff was the Wesleyan Central Hall at Storey's Gate, Westminster (1905–11), which was built to provide a vast hall capable of seating 2,500 people. One of the most remarkable of Edwardian buildings, it brought advanced modern technology to the service of the classical tradition of architecture. Approached by a complex swirling staircase of much beauty, the hall is covered by a reinforced concrete dome with a diameter of 80 feet (24·3 metres). As at St Paul's Cathedral, there is another dome above this to create visual impact from outside. This outer dome is a giant steel frame, boarded and covered with lead.

Domes were especially popular in the confident and prosperous days of Edward VII. A. Brumwell Thomas (1868–1948) provided a gigantic dome at Belfast City Hall (1897–1906), while his extravagant Stockport Town Hall, Greater Manchester (1904–08), is crowned by an elaborately Baroque tower. At Eton College, Buckinghamshire, there is the fine school hall and adjacent library built in 1906–08 as the South African War Memorial by L. K.

Deptford Town Hall, London, by Lanchester and Rickards

Institute of Chartered Accountants, London, by John Belcher

Hall of the firm, Hall and Greenslade. The library is a handsome domed polygon of dove-grey brick enlivened with a good deal of expensive carved decoration in Portland stone. As at the Wesleyan Central Hall, there is an inner dome of concrete and an outer one supported on a steel frame construction.

E. W. Mountford (1855–1908) is best known for his domed Central Criminal Courts, Old Bailey, London (1900–06), but his more restrained Lancaster Town Hall (1906–09), is perhaps a finer work. It was paid for by the local millionaire industrialist, Lord Ashton, to whose patronage is also due one of the most astonishing of all Edwardian domed buildings, the Ashton Memorial, Lancaster (1904–09), designed by John Belcher (1841–1913). Belcher was one of the most interesting and influential architects of the

day. His Institute of Chartered Accountants, Moorgate Place, London (1888–93), was a revolutionary statement of Genoese Baroque exuberance which caused a considerable stir in its day. Richly adorned with figure sculpture by two Royal Academicians, Hamo Thornycroft and Harry Bates, the building represented a remarkable fusion of the ideals of the Arts and Crafts movement and those of revived classicism. It should not be forgotten that this high standard of craftsmanship is one of the hallmarks of Edwardian buildings in whatever style. The interiors of large classical buildings were often lined with shimmering sheets of marble in delicately contrasting colours; there was much polished mahogany, bevelled glass and fine bronze light-fittings and door-furniture. The sumptuous interiors of the Central Criminal Courts are characteristic, with their rich marbles, their sculpture by Gilbert Seale and F. W. Pomeroy, and their paintings by Gerald Moira and Sir William Richmond.

A different and perhaps more sophisticated classicism is associated with the Gallic tastes of Charles Mewès and his English partner, Arthur Davis (1878–1951). Their Ritz Hotel of 1903–06 in Piccadilly, with its nineteenth-century Parisian façades and its Louis XVI interiors, stands as the perfect monument to the Entente Cordiale promoted by Edward VII as part of his love of French good living. What is especially memorable at the Ritz is the long corridor that leads from the east or Arlington Street entrance to the Palm Court in the centre of the building and so to the enchanting west-facing dining room. The building is also important as one of the first major examples in England of steel-frame construction, though this was carefully concealed beneath a facing of Norwegian granite and Portland stone.

Contemporary with the Ritz was Mewes and Davis's remodelling of Luton Hoo, Bedfordshire, a large neo-classical mansion owned by the South African diamond magnate Sir Julius Wernher.

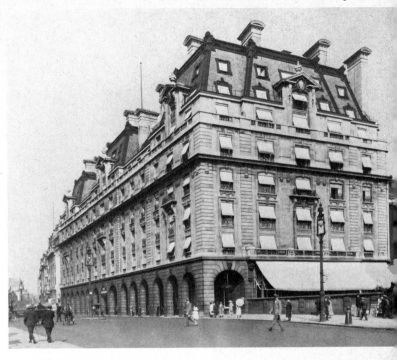

*The Ritz Hotel, London,
by Mewès and Davis*

Their finest contribution here is the circular staircase modelled on eighteenth-century French precedent. In 1906–07 they built Inveresk House for the *Morning Post* in Aldwych, London. Their beautiful domed treatment of this awkward corner site has been spoilt by later additions, but their Royal Automobile Club, Pall Mall (1908–11), survives untouched. Here they provided a club of exceptional size and luxury with an impressive street façade inspired by Gabriel's two palaces of the 1750s in the Place de la Concorde in Paris.

An indication of the strength of the admiration for French classicism in Edwardian England is that the partnership between Mewès and Davis was not the only one between an Englishman and a Frenchman. In 1905 Detmar Blow (1867–1939), who was an Arts and Crafts architect by training, turned to urban commissions in the West End of London and formed a partnership with the young Fernand Billerey, a Parisian-trained

architect of considerable ability. Their best work was the complete rebuilding of the interiors of Nash's 10 Carlton House Terrace, London, in 1906–07. The vaulted stone-walled staircase hall with steps of black marble and a rich bronze balustrade by Bainbridge Reynolds, derives from the French classical tradition of stone staircases from the sixteenth century onwards, and particularly from the staircase in the Sorbonne by Nénot, of the 1880s. The most important public building inspired by the practice of the Ecole des Beaux-Arts was the King Edward VII Galleries at the British Museum (1904–14) by Sir John Burnet (1857–1938), who had been a student at the Ecole in the 1870s. He had enjoyed an eclectic but exceptionally distinguished career in Scotland before he opened his London office in 1905.

The impact of French classicism also began to change the system of architectural education in England by gradually replacing the traditional custom of ap-

prenticeship in the office of a great master with organized education in a school of architecture, which itself might be part of a university: the first university professorship of architecture was established at Liverpool in 1894. *The Architecture of Humanism*, published in 1914 by Geoffrey Scott, secretary and librarian to Bernard Berenson, was an important and influential defence of classicism as well as a striking demolition of the theories that had sustained the Gothic Revival.

The last version of Edwardian classicism at which we should look is that sometimes known as Neo-Mannerism. It is particularly associated with two gifted assistants of John Belcher: Beresford Pite (1861–1934), who worked with him from 1885 to 1897, and J.J. Joass (1868–1952), who was with him from 1898 and was the key figure in the partnership, Belcher and Joass, from 1906 to 1913. The third architect in this group was Charles Holden (1875–1960), who had been a pupil of the highly individual Arts and Crafts architect, C.R. Ashbee. Just as Michelangelo, Giulio Romano and others had developed a form of architecture in sixteenth-century Italy which enlivened the High Renaissance by a consciously non-structural use of classical details, so Holden and Joass exploited the fact that the walls of a steel-frame building can be non-structural by clothing them with classical forms used in an anti-classical or even anti-rational way. Examples of this chunky angular style in London can be seen in Holden's library wing at the Law Society in Chancery Lane (1903–04) and the British Medical Association (now Rhodesia House) in the Strand (1907–08); also in two works by Belcher and Joass, Mappin House, 158 Oxford Street (1906–08), and the more confused Royal Insurance Building at the corner of Piccadilly and St James's Street (1907–08). In Liverpool Walter Thomas exploited similar themes on a larger scale in his Liver Building, Pier Head (1908–11), an early example of the use of a reinforced concrete frame.

The British Medical Association (now Rhodesia House) London, by Charles Holden, photograph taken before the mutilation of Epstein's sculpture

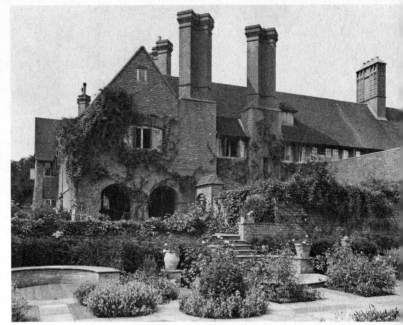

Orchards, Surrey, by Edwin Lutyens, view from south-east (right) and plan of ground floor (below): A courtyard; B hall; C dining room; D servants' hall; E kitchens; F stables and harness rooms; G parlour; H studio; I study; J cloister

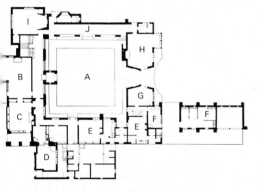

Sir Edwin Lutyens and the Traditionalists

Lutyens's country houses

The long and brilliant career of Edwin Lutyens (1869–1944) began with a group of clever and subtly designed Arts and Crafts houses in his native Surrey. He was a pupil of the extremely able architect Ernest George (1839–1922), from whom he learned how to compose asymmetrical tile-hung houses in the manner of Norman Shaw. The first was Crooksbury House of 1889, followed by Munstead Place (1891) and in 1896–97 Munstead Wood for Gertrude Jekyll, a landscape gardener of great genius who brought many clients to Lutyens and who helped to design the gardens at most of his country houses.

Perhaps his first design of real maturity is Orchards, near Munstead, built in 1897 round a courtyard, with the two-storey studio designed so as to look from the outside like the great hall. Despite appearances to the contrary, nothing is haphazard and the spatial control is

185

Little Thakeham, Sussex, by Edwin Lutyens, the staircase

extraordinary. The strong feeling for architectural geometry which is always present in his work can be sensed in the cleverly composed U-shaped entrance front of Tigbourne Court, Surrey, designed in 1899 for Edgar Horne, chairman of the Prudential Assurance Company.

All these houses were built of local materials: golden-yellow rubble, brown Bargate stone interlaced with thin bands of tiles, hand-made bricks and oak-framed mullions. They began to be the subject of illustrated articles in the magazine *Country Life*, founded in 1897 by Edward Hudson, which did much to heighten Lutyens's popularity. But *Country Life* was as much a symptom as a cause of Lutyens's success. The wave of nostalgia for country ways and lost crafts, of which the founding of the National Trust in 1895 is another example, hit England at the very peak of its industrial prosperity – and was, of course, made possible precisely by that prosperity. Lutyens built Marsh Court, Hampshire (1901), in clunch, a local chalky stone, for Herbert Johnston who had been introduced to Lutyens's work by reading an article on Crooksbury in *Country Life*. For Edward Hudson himself, Lutyens built one of the finest of all his houses, Deanery Garden at Sonning, Berkshire, in 1901. It is typical of the mood

of the moment that Hudson was anxious to preserve the existing old wall along the road in front of the house. This was the sort of game that Lutyens enjoyed playing. He used the wall to make the fourth side of a courtyard and pierced it with an unobtrusive doorway giving access to a passage that runs right through the house, past the two-storey great hall, and out into the garden.

Spatial play of a different kind is the hallmark of Little Thakeham, West Sussex, built of a local soft sandstone in 1902. Outside, it is a fairly symmetrical Tudor manor-house; inside, the visitor finds to his surprise that he is confronted with a long corridor running parallel to the front of the house. This is to provide greater contrast with the large two-storey hall at the back of the house, with its staircase drifting upwards, behind and above a classically designed open screen. Space from an upper level again penetrates the room immediately over the fireplace through a balcony opening off the transverse first-floor corridor. This spatial drama, which Lutyens learnt from Shaw, appears in the planning of an early house like Tigbourne Court and becomes the hallmark of his mature work, as at Castle Drogo, Devon, of 1910–30. In this immense granite country house built for

Julius Drewe, chairman of the Home and Colonial Stores, Lutyens spectacularly exploited the dramatic effects produced by changing floor levels and a web of masonry staircases.

A new departure came in 1906 with Heathcote, a striking palazzo in a suburban setting, for a businessman at Ilkley, West Yorkshire, in a style inspired by the vigorous way in which an architect like Sanmicheli handled the classical orders. It is not possible to imagine that an architect of Lutyens's fertility could have continued indefinitely to produce the quaint Shaw-inspired houses of his youth. Though many of these early houses contain classically inspired features we know that his discovery and adoption of the orders

came as a joyful revelation. He wrote of them in 1903:

The way Wren handled it was marvellous. Shaw had the gift. To the average man it is dry bones, but under the mind of a Wren it glows and the stiff material becomes as plastic as clayYou cannot copy. You find, if you do, you are caught and a mess remains. It means hard labour and hard thinking over every line in all three dimensions . . . If you tackle it in this way the Order belongs to you, and any stone being mentally handled must become endowed with such poetry and artistry as God has given you.

The finest of Lutyens's later classical houses is Gledstone Hall, North Yorkshire, of 1923–27. Despite its Palladian portico, it has a French elegance with its stately court-yard, its tall unbroken roofs and its little lodges like royal guard houses. The walls are all inclined or battered inwards, giving that sensitive recession akin to Greek

Heathcote, Yorks., by Edwin Lutyens

entasis which marks Lutyens's later works. Moreover, the height of each course of the creamy local limestone is diminished as the building rises. The formal geometry of the architecture is echoed in the Jekyll gardens behind the house, centred on a long canal-like pool.

Lutyens's public buildings

Though he made his name as a domestic architect, Lutyens was not content to restrict himself to that field but responded with brilliant panache to commissions for a variety of modern public and commercial buildings. He designed the two contrasting churches and their parsonages as well as the Institute and a number of houses at Hampstead Garden Suburb in 1908–10; in 1911 came the Rand Memorial and the Art Gallery at Johannesburg; in 1919–20 the abstract classical Cenotaph in Whitehall; and the neo-Georgian British Embassy in Washington in 1926–30. The

Britannic House, London, by Edwin Lutyens

high classicism he had initiated at Heathcote was deployed on a vast scale in his Britannic House of 1920 for the Anglo-Iranian Oil Company between Finsbury Circus and Moorgate, London. The steel frame of this great palace, which had also to incorporate a bank and an Underground station, is clad in a rippling Genoese-Baroque skin of Portland stone. His Midland Bank, Poultry, London (1924), is an even more original essay in rustication. The rustication is not continuous but leaves off every so often, and every time it does so the vertical plane recedes exactly one inch (25·4 millimetres). Moreover, each course of stone is an eighth of an inch (3·2 millimetres) less in height than the one below it. The whole front contracts as it rises and has been described as like a living thing that shapes itself upwards and backwards.

By far Lutyens's greatest executed classical masterpiece was the Viceroy's House at New Delhi, begun in 1912 as the centre of his plans for the whole of Delhi. These were occasioned by the transfer of the seat of government in India from Calcutta to Delhi, proclaimed at the Coronation Durbar in December 1911 by the King and Emperor, George V. Though this book is concerned with buildings in England, it would seem wrong not to mention, at least in passing, what is perhaps the greatest commission ever given to an English architect, and also one of the great buildings of the world. The austere grandeur of Lutyens's vast complex at Delhi is offset by the warm pink and cream Dholpur sandstone with which the buildings are faced. Though undeniably classical, Lutyens's style is now a personal, abstract synthesis of the classical language. It seems to represent the essence not the accidents of classicism, so that there are very few classical mouldings or features out of pattern-books. His system of entasis is a parallel to that used by the ancient Greeks and there is hardly a single vertical or horizontal line anywhere. Lutyens himself summed up in a letter the masterly inevitability which stamps the

The Viceroy's House, New Delhi, by Edwin Lutyens

whole of his work at Delhi, when he wrote of the classical orders, 'They have to be so well digested that there is nothing but essence left . . . the perfection of the Order is far nearer nature than anything produced on impulse and accident-wise. Every line and curve the result of force against impulse through the centuries.'

Delhi did not mark the end of Lutyens's development of this particular theme, for it recurs in two final masterpieces of which only one was executed. In 1917 Lutyens became consultant architect to the Imperial War Graves Commission, and in 1928–30 there arose from his designs the most powerful of the many monuments to the dead of the Great War, the Memorial to the Missing of the Somme on a ridge above the river Somme at Thiepval in northern France. Inscribed with the names of 73,357 missing men, the Thiepval Arch is a sublime stepped pyramid, 145 feet (44.2 metres) high, pierced by a complex series of intersecting arches increasing in height and proportionate width.

The proportional system of Thiepval and the superb massing of Delhi were applied with memorable effect in 1929 to the design for the Catholic Cathedral of Christ the King at Liverpool, which would have been the greatest church in the

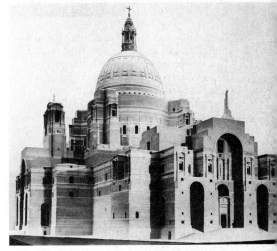

Liverpool Roman Catholic Cathedral, by Edwin Lutyens, wooden model; never built

world. Work on this domed cliff-like building of pinkish-buff brick interlaced with bands of grey granite began in 1933 and continued until 1941. Confidence ran out after the war and a flashy concrete wigwam, designed in 1959 by Frederick Gibberd (1908–), was erected incongruously on top of Lutyens's superb vaulted crypt. Inside Lutyens's cathedral,

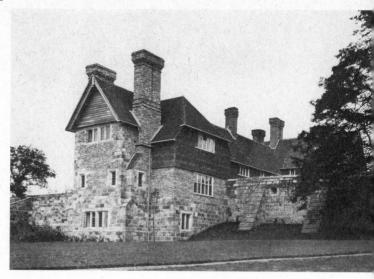

Oldcastle, Sussex, by Ernest Newton, who expanded an existing cottage into a substantial house in 1910

the narrowness of the nave compared with its height of 138 feet (42 metres) combined Gothic proportions with classical language. Interest culminated in the vast circular space beneath the dome, developed from his Durbar Hall at Delhi, which would have been capable of holding 10,000 people. The most magnificent part of the exterior, apart from the dome, was the south entrance-front with its huge portal arch flanked by side arches. The problem of adapting the Roman triumphal arch to buildings other than arches was one which had occupied the finest European architects from Alberti to Cockerell, not forgetting the Norman west front of Lincoln Cathedral. In his design for Liverpool Lutyens gave it its most impressive solution.

The Traditionalists

Although Lutyens was the greatest architect at work in England from the 1890s to the 1930s, it should not be thought that he was a lone or isolated figure between the wars. In England, as in North America, traditionalism was the norm in architecture until the 1940s, and we can form no accurate historical picture of these years without recognizing that. Architects re-

garded their 'traditionalism' as different from the 'revivalism' which they associated with the then unfashionable Victorian architects. During the first quarter of the century a group of competent architects, including Sir Mervyn Macartney (1853–1932), Ernest Newton (1856–1922), Sir Guy Dawber (1861–1938), C.F.A. Voysey (1857–1941), M.H. Baillie Scott (1865–1945), Arnold Mitchell (1863–1944) and P.R. Morley Horder (1870–1944), produced a vast quantity of public and private buildings developed carefully and simply from Tudor and Georgian styles. The garden cities or suburbs of Letchworth, Hampstead and Welwyn are also related architecturally to this tradition. Sir Walter Tapper (1861–1935), Sir Ninian Comper (1864–1960) and Sir Charles Nicholson (1867–1949) all specialized in the design of Gothic churches and fittings of great sensitivity as well as the careful restoration of mediaeval buildings.

The classical tradition was continued by architects like Sir Herbert Baker (1862–1946); Sir Edwin Cooper (1873–1942), whose large output included the swaggering Port of London Authority (1912–22); Sir Albert Richardson (1880–

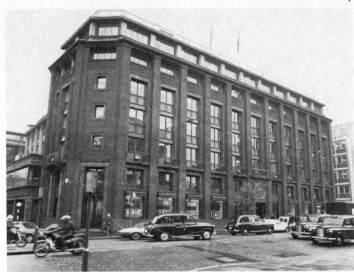

*Bracken House, London,
by Sir Albert Richardson*

1964), who built the finely detailed Bracken House, Cannon Street, London (1956–59), as an attempt to develop the manner of the great German neo-classicist, K.F. Schinkel (1781–1841); Vincent Harris (1879–1971); and Curtis Green (1875–1960), who produced two particularly fine, contrasting classical compositions in Piccadilly in the 1920s: Barclays Bank and, almost opposite, the National Westminster Bank.

One of the most successful architects was Sir Giles Gilbert Scott (1880–1960), whose great Gothic cathedral at Liverpool we have already admired. His chapel at Charterhouse School, Surrey (1922–27), continues in a simpler but no less powerful way the mood of Liverpool. At Cambridge he designed a large new court in pale brown brick for Clare College (1923–34) in a neo-Georgian style. This contrasts with his university library immediately adjacent (1931–34), in a more abstract and functional-looking style which is, in fact, closely related to the design of his exactly contemporary Battersea Power Station. The prolific Sir Edward Maufe (1883–1974), whose major work is the brick-built Gothic cathedral at Guildford (1932–66), was a paler echo of

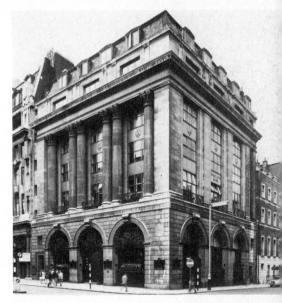

Barclays Bank, Piccadilly, London, by Curtis Green

Kennington, London, housing for the Duchy of Cornwall Estate by Adshead and Ramsey

Giles Scott, but by far the best traditionalist at work after the Second World War was Raymond Erith (1904–73). His work seems to carry on from that of Stanley Adshead (1886–1946) who, with his partner Stanley Ramsey, built a charming network of terraced houses in a late-Regency style on the Duchy of Cornwall Estate in Kennington, London (1913–14). At Oxford, Raymond Erith built the austerely classical provost's lodgings at Queen's College (1958–60), and the impressive Wolfson Quadrangle and Library at Lady Margaret Hall (1959–66). He also built two stylish neo-Palladian villas at Wivenhoe New Park, Essex (1962–64), and Kingswaldenbury, Hertfordshire (1969–71).

The Modern Movement

This section can be no more than a postscript, for the Modern Movement made little headway in England before the war and has thus flourished only since about 1950: that is a very short period out of the thirteen centuries covered by this book. In that time, of course, it has radically changed the face of England but, despite the high hopes with which the movement was launched, few would now say that those changes have left the country

more attractive than it was before. Moreover, it would be difficult to write about contemporary work with any real perspective in a general survey of this kind, particularly since it has fallen so markedly out of favour from the later 1970s onwards.

The Modern Movement in architecture arrived in England in the later 1920s as a Continental fashion imported from Germany and France for use in the design of private houses for clients drawn mainly from the professional classes. Resembling small factories or expensive refrigerators, these houses with their flat roofs and metal windows must have seemed chill and alien against the background of the Traditionalist mainstream of English architecture at the time. As a doctrinaire programme for a new architecture that would not tolerate the existence of any other kind of building, the Modern Movement curiously resembles the imposition by Lord Burlington of strict Palladianism on the fertile English Baroque. For their bible the members of the new movement had, instead of Palladio's *I Quattro Libri*, Corbusier's *Vers une architecture*, which was translated by Frederick Etchells in 1927 as *Towards a New Architecture*. This influential book proclaimed the poetry of pure functionalism and invested it with a binding moral significance.

Many of the architects involved were foreign or born in the Dominions: Amyas

Connell (1901–), Basil Ward (1902–76), George Checkley (1893–1960) and Raymond McGrath (1903–) came from New Zealand; Wells Coates (1893–1958) from Tokyo and Canada; Berthold Lubetkin (1901–) and Serge Chermayeff (1900–) from the Caucasus; and Ernö Goldfinger (1902–) from Hungary. There were also the émigrés from Germany: Erich Mendelsohn (1887–1953) who came in 1933 and formed a partnership with Chermayeff; Walter Gropius (1883–1969) who came the following year and joined with Maxwell Fry (1899–);

and Marcel Breuer who arrived in 1935 and joined with F. R. S. Yorke (1907–62). The special emphasis of this new movement was on the spatial freedom made possible by the reinforced concrete frame, wrapped round with glass. This kind of freedom was more revolutionary in France and Germany than in England, for the Continent had not experienced the tradition of asymmetrical planning and spatial complexity of the English Domestic Revival from Nash through Shaw to Lutyens. Thus what seemed most original at the time about houses like Connell, Ward and Lucas's 66 Frognal, Hampstead (1936–38), was their superficial appearance of aggressive modishness. Architects found this especially annoying since they believed that style had been brought to an end by the birth of the new architecture and of the new technological man it was designed to serve.

Though the war called a halt to new building, it did much to encourage the assumption of the Modern Movement that a new world was at hand in which old traditions would be ruthlessly scrapped and all would be made fine and fair by 'planners' bent on total reconstruction. Corbusier's proposals of the 1920s in the Plan Voisin for replacing much of the

No. 66 Frognal, Hampstead, London, by Connell, Ward and Lucas, exterior (above) and plan (right)

Royal Festival Hall, London, by Robert Matthew and Leslie Martin, after remodelling

historic centre of Paris with eighteen immense skyscrapers proved a fatally attractive image for the architects and town planners of the 1950s and 1960s. Inasmuch as their work can be regarded as town planning, it lies outside the scope of this book, and we should turn instead to the building which, more than any other, drew the attention of the public to the spatial possibilities of the new architecture. This was the Royal Festival Hall (1949–51), designed by Robert Matthew (1906–) and Dr J. L. (now Sir Leslie) Martin (1908–) as the only permanent structure associated with the Festival of Britain on the South Bank, London. The outside of the Festival Hall was never an impressive or coherent composition – indeed the river front was remodelled some years after construction – but the freely flowing web of staircases, galleries, landings and restaurants made a considerable visual impact at the time.

Apart from the Festival Hall, the best-known work of the 1950s is Coventry

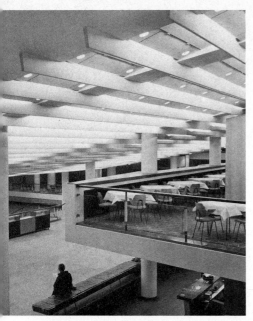

Cathedral (1951–62) by Sir Basil Spence (1907–76). Perhaps more popular with the general public than with architects, it has something of the whimsical mood of the exhibition buildings at the Festival of Britain. Like them it contains a large quantity of fittings or 'exhibits' by fashionable modern designers, culminating in the abstract stained glass by John Piper and Patrick Reyntiens, and the representational tapestry designed by Graham Sutherland.

A building especially admired by architects was the secondary modern school at Hunstanton, Norfolk (1950–53), designed by Peter Smithson (1923–) and

Royal Festival Hall, London, the foyer

Coventry Cathedral, by Basil Spence, with the bombed ruins of the old cathedral on the left

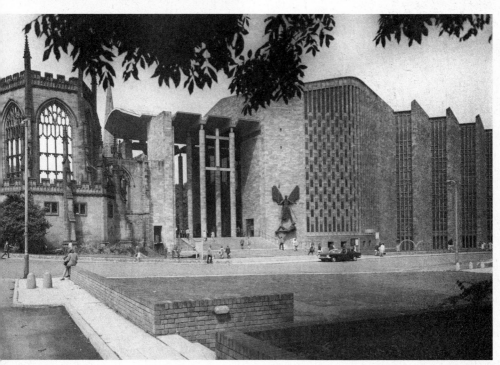

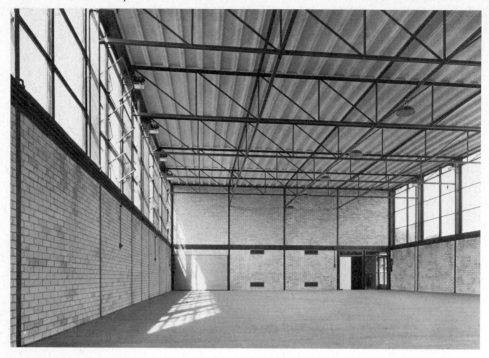

Hunstanton secondary modern school, Norfolk, by Peter and Alison Smithson, the gymnasium

his wife Alison (1928–). A ruthless intellectual exercise in the sophisticated but austere factory-aesthetic of Mies van der Rohe (1886–1969), this exposes internally its steel frame and yellow brick in a way that makes no concessions to charm or comfort. Its harshness helped to prepare the way for the abrasive use of concrete which is associated with the phase of architecture often known as New Brutalism. This succeeded the International Modern style and had its origins in the aggressive post-war work of Le Corbusier (1887–1966), from his Unité d'Habitation at Marseilles of 1947–52 to his Dominican priory at La Tourette of 1957. The University of Sussex, begun in 1960 from designs by Sir Basil Spence, is a direct echo of Corbusier, while the remarkable domed New Hall, Cambridge (1946–68), is a

further development of similar themes by Chamberlin, Powell and Bon. Also in Cambridge, and of the same date as New Hall, is the Faculty of History designed by James Stirling (1926–) as an exploration of themes he had originally stated in his remarkable Engineering Building at Leicester University (1959–63). Attacked by Sir Nikolaus Pevsner as an 'actively ugly' piece of 'anti-architecture', this bizarre building of harsh red brick and ostentatiously industrial glazing, has aroused widespread controversy which has centred as much on the question of its practical convenience as on its visual appearance. Scarcely less aggressive, though provoking less controversy, is the

University of Sussex, Falmer, by Basil Spence

New Hall, Cambridge, by Chamberlin, Powell and Bon

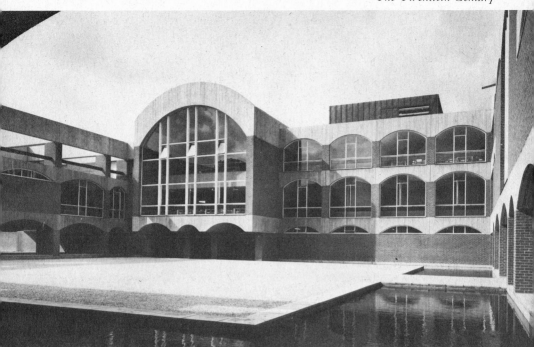

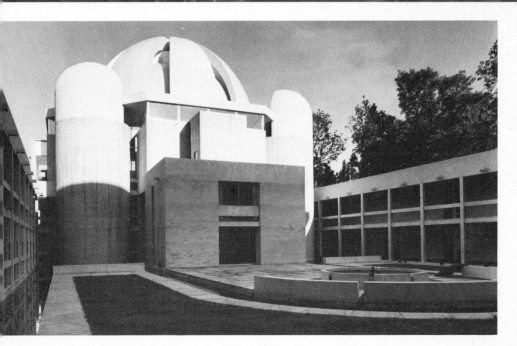

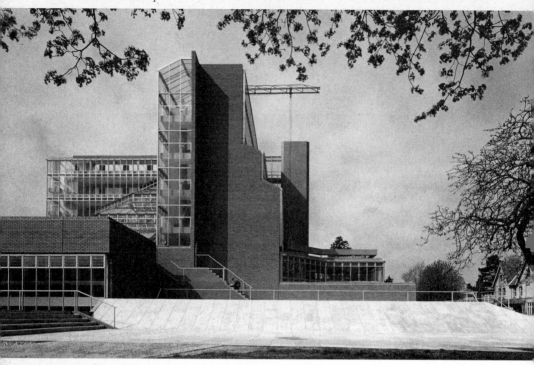

National Theatre, South Bank, London (1967–76), by the prolific Denys Lasdun (1914–), a pile of stepped terraces in concrete.

In the 1970s the thrusting confidence of the previous twenty years began to disappear. The vast new British Library, designed in 1977 by Colin St John Wilson (1922–), has a deliberately understated grouping and skyline so as not to compete with the immediately adjacent St Pancras Station hotel, the triumphalist Gothic extravaganza of the 1860s by Sir Gilbert Scott. Fashionable concern for conservation, rehabilitation, preservation and neo-vernacularism is beginning to alter the Modern Movement in an absolutely fundamental way. Who knows what may be revived next?

Faculty of History building, Cambridge, by James Stirling

The National Theatre, London, by Denys Lasdun

Project for the New British Library, London, by Colin St John Wilson

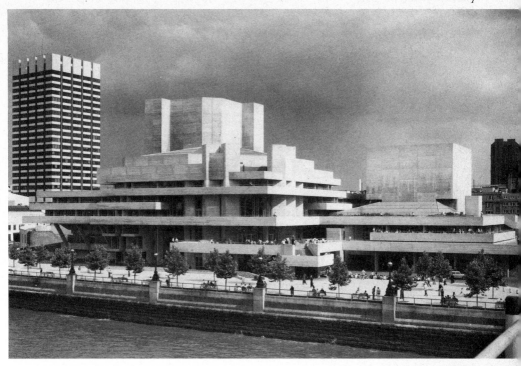

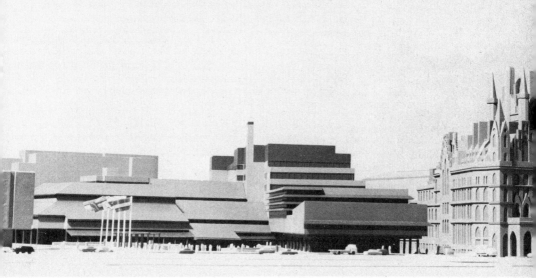

Glossary

alternating supports a system in which piers (*q.v.*) of complex section alternate with simple columns or pillars.

ambulatory aisle passing round the eastern end of a church.

antis a portico *in antis* is recessed so that the columns are flush with the walls of the building on either side.

apse part of a building that is semicircular or polygonal in plan.

astylar without columns.

attic storey top storey of a classical building above the cornice (*q.v.*).

barrel vault continuous stone roof, either semi-circular or pointed in section.

bar-tracery tracery consisting of stone ribs forming patterns.

basilica originally a Roman judgment hall; later used to mean a building with arcades, aisles and clerestoreys (*q.v.*)

battered leaning inwards.

bay (1) division of a church between one pier and the next; (2) division of a façade corresponding to one window.

belvedere tower or loggia (*q.v.*) for enjoying the view.

billet-moulding a moulding (*q.v.*) shaped like a long roll cut up into thick slices.

boss carved stone marking the meeting of ribs in a vault.

campanile bell tower.

canted sloping at the edges or set at a slight angle.

cantilever a projecting beam supported by a weight on the other end.

capital upper part of a column or pier, usually carved with abstract or figural ornament.

Carolingian pertaining to the Emperor Charlemagne.

cartouche a heraldic panel, generally with curved sides.

caryatid female figure supporting a capital or entablature.

centralized plan a plan in which length and width are equal.

centring temporary wooden scaffolding on which an arch or vault rests until the mortar has set.

chancel easternmost part of a church containing the altar; in a large church, east of the choir; in a smaller one, east of the nave or crossing.

chevet the apsidal east end of a church with chapels radiating from it.

chevron zigzag.

choir in a monastic church or cathedral, the part under or east of the crossing occupied by the choir; loosely, the eastern arm of a large church.

cinquefoil with five foils or cusps.

clerestory the upper part of the walls of a church or large hall, where light is admitted through high windows usually above the level of the aisle roof.

coffered made up of sunken panels.

colonnade a row of columns.

colonnette a small column.

compound complex in section, not simply rectangular or circular.

corbel a projecting stone held in place by a weight above; a type of cantilever (*q.v.*).

cornice the topmost element of a classical entablature (*q.v.*).

Curvilinear style of tracery using ogees (*q.v.*) in which the patterns assume free curving shapes resembling leaves, flames, etc.

dormer vertical window in a sloping roof.

double pile a house two-rooms thick in plan.

drum cylindrical substructure of a dome (though it can occur without the dome).

Dutch gable a gable with curved sides, convex, concave or both, usually with a small pediment (*q.v.*) at the top.

engaged built into a wall.

entablature horizontal series of mouldings (*q.v.*) resting on the capitals of a classical order (*q.v.*).

entasis the slight bulge introduced into Greek verticals, especially columns, and horizontals.

fan vault vault consisting of concave-sided inverted half-cones.

flying buttress a buttress consisting of a half-arch leaning against a wall.

frieze a continuous band of sculpture.

frontispiece decorated composition emphasizing the entrance bay of a Renaissance house.

galilee a large enclosed porch at the west end of a cathedral or abbey-church.

gallery any upper storey of a building with a passage open to the interior or exterior; more specifically, in larger churches, the middle storey of a three-storey elevation, between the arcade and the clerestory (*q.v.*).

Geometrical style of tracery in which the patterns are formed by regular circles or segments of circles.

giant order an order (*q.v.*) running through two or more storeys.

Greek cross a cross with equal arms.

groin vault vault formed by the meeting of two tunnel vaults (*q.v.*) at right angles to each other, the edges (groins) meeting in a cross.

hall church an aisled church in which the aisles are as high as the body of the building.

hammerbeam type of roof construction in which the braces rest on cantilevered (*q.v.*) beams supported on brackets.

hexastyle having six columns.

lancet tall narrow window with a pointed top.

lantern topmost section of a dome, with small vertical windows admitting light to the interior.

lierne short vaulting rib connecting two other ribs.

loggia a gallery open to the air on one or more sides.

long-and-short work Saxon type of stonework in which long stones are set alternately upright and horizontal in a vertical strip.

longitudinal plan a plan in which length exceeds width.

moulding any continuous ornamental feature, especially round an arch, doorway or window.

mullion vertical division of a window.

narthex a large porch at the west end of a church.

nave the western part of a church, used by the congregation.

nodding arch an arch which bends forward at the apex, away from the wall.

ogee a double or S curve; an ogee arch is two ogees meeting at a point.

order (1) the Greek and Roman system of column, capital (*q.v.*) and entablature (*q.v.*), of which the three main types are Doric, Ionic and Corinthian; (2) one of the religious fraternities of the Catholic Church for monks or friars bound by a common rule of life.

oriel a projecting window; a small bay window on a bracket.

pediment the triangular gable of a classical temple or portico.

pendentive concave triangle of masonry between the base of a dome and the arches which support it; a three-dimensional spandrel (*q.v.*).

piazza literally, a public square (Italian); in seventeenth- and eighteenth-century England it came to denote a covered arcade surrounding a square.

pier any supporting member of an arcade; if cylindrical, called a pillar or column.

pilaster a flattened, almost two-dimensional version of a classical column and capital.

plate-tracery tracery consisting of apertures apparently punched in the masonry.

porte-cochère a porch wide enough to drive a coach in and out.

portico projecting porch consisting of columns and (nearly always) a pediment (*q.v.*).

presbytery the eastern part of a church, lying between the choir and the retrochoir, and containing the high altar.

quadripartite of vaults, divided into four by groins or ribs.

refectory dining hall of a monastery.

reinforced concrete concrete strengthened by an inner core of steel wire, making it equally effective in tension and compression.

reredos carved or painted superstructure forming the back of an altar.

retrochoir space to the east of the choir and high altar.

rib vault a vault in which the groins (*q.v.*) are replaced by stone ribs, which may be structurally independent of the surface behind them.

ridge rib longitudinal rib extending the whole length of a vault.

Romanesque in English architecture, the same as Norman; characterized by thick walls, round arches and small windows without tracery.

rustication massive blocks of masonry, sometimes with roughened surfaces, separated by deeply cut joints; often used at the base of classical buildings to give an impression of strength.

Glossary

saddle-back type of tower roof consisting of two steeply sloping sides and two gables.

sedilia seats (generally double or treble) for the priests in the chancel of a church.

sexpartite of vaults, divided into six by ribs; an extra transverse arch (*q.v.*) intersects the diagonals where they cross.

spandrel the triangular space between the tops of two arches.

spherical triangle a triangle with convex curving sides.

springing the point where an arch begins.

stiff-leaf stylized foliage; long leaves with tops curling outward.

strapwork form of ornament resembling leather cut into pieces which slot into one another.

string-course a horizontal moulding (*q.v.*) running right across an elevation.

term classical sculptured figure whose lower half turns into a pedestal.

tierceron a vaulting rib going from the springing (*q.v.*) to the ridge rib (*q.v.*), but neither a transverse nor a diagonal rib.

transept the arm of a cruciform church.

transom horizontal division of a window.

transverse arch an arch at right angles to the main body of a building.

trefoil with three foils or cusps.

tribune same as gallery (*q.v.*).

triforium an arcaded wall-passage forming the middle storey of a three-storey elevation in a church between arcade and clerestory.

truss beams or struts fixed together in a triangle to make a rigid component, generally of a roof.

tunnel vault a continuous stone roof, either semicircular or pointed in section.

tympanum semicircular or pointed panel above a door or window, between it and the containing arch.

Venetian window a triple window consisting of a round-headed light flanked by two slightly lower flat-headed ones.

vermiculated rustication rustication (*q.v.*) carved into tiny writhing lines, like worms.

waterleaf stylized smooth foliage with tips curving inward.

Bibliography

Place of publication is London unless otherwise stated.

General

G.W.O. Addleshaw & F. Etchells, *The Architectural Setting of Anglican Worship*, 1948; G. Beard, *Decorative Plasterwork in Great Britain*, 1975; B.F.L. Clarke, *Parish Churches of London*, 1966; A. Clifton-Taylor, *The Pattern of English Building*, 1972; H.M. Colvin, *A Biographical Dictionary of British Architects, 1600–1840*, 1978; H.M. Colvin, ed., *The History of the King's Works*, 6 vols., 1963 – in progress; H.M. Colvin & J. Harris, eds., *The Country Seat*, 1978; *Country Life*, 1897 – in progress (articles on country houses, with a cumulative index published twice annually); E. Croft-Murray, *Decorative Painting in England, 1537–1837*, 2 vols., 1962–70; J. Fawcett, ed., *The Future of the Past, Attitudes to Conservation, 1147–1974*, 1976; M. Girouard, *Life in the English Country House*, New Haven & London 1978; H. Hobhouse, *Lost London*, 1971; F. Jenkins, *Architect and Patron*, Oxford 1961; B. Kaye, *The Development of the Architectural Profession in Britain*, 1960; P. Kidson, P. Murray & P. Thompson, *A History of English Architecture*, Harmondsworth 1965; B. Little, *Catholic Churches since 1623*, 1966; E. Mercer, *English Vernacular Houses*, 1975; N. Pevsner, *The Buildings of England*, 46 vols., 1951–74; *Royal Commission on Historical Monuments* (England, Scotland and Wales), *Reports and Inventories*, 1910 – in progress; Royal Institute of British Architects, *Catalogues of the Drawings Collection*, 16 vols., 1969 – in progress; F. Saxl & R. Wittkower, *British Art and the Mediterranean*, Oxford 1948; M. Seaborne & R. Lowe, *The English School, 1370–1970*, 2 vols., 1971–77; R. Strong, M. Binney & J. Harris, *The Destruction of the Country House, 1875–1975*, 1974; J. Summerson, *Heavenly Mansions*, 1949; J. Summerson, ed., *Concerning Architecture*, 1968; *Survey of London* (Greater London Council), 39 vols., 1900 – in progress; *Victoria History of the Counties of England* (University of London, Institute of Historical Research), 166 vols., 1900 – in progress; D. Ware, *A Short Dictionary of British Architects*, 1967; R. Willis &

J. Clarke, *Architectural History of the University of Cambridge*, 3 vols., Cambridge 1886.

Chapter 1

A.W. Clapham, *English Romanesque Architecture before the Conquest*, Oxford 1930, *English Romanesque Architecture after the Conquest*, Oxford 1934; E.A. Fisher, *The Greater Anglo-Saxon Churches*, 1962; D. Talbot Rice, *English Art, 871–1100*, Oxford 1952, *English Art, 1100–1216*, Oxford 1953 (corrected impression 1968); H.M. & J. Taylor, *Anglo-Saxon Architecture*, 3 vols., Cambridge 1965 & 1978; G. Webb, *Architecture in Britain: the Middle Ages*, Harmondsworth 1956 (2nd ed. 1965); G. Zarnecki, *English Romanesque Sculpture, 1066–1146*, 1951, *Later English Romanesque Sculpture, 1140–1210*, 1953.

Chapters 2 and 3

H. Bock, *Der Decorated Style*, Heidelberg 1962; P. Brieger, *English Art 1216–1307*, Oxford 1957; J.C. Dickinson, *Monastic Life in Mediaeval England*, 1961; J. Evans, *English Art 1307–1461*, Oxford 1949; J.M. Hastings, *St Stephen's Chapel*, Cambridge 1955; J. Harvey, *Henry Yevele*, 1944 (rev. ed. 1946), *Gothic England*, 1947 (rev. ed. 1948), *English Mediaeval Architects: a Biographical Dictionary*, 1954, *The English Cathedrals*, 1956 (rev. ed. 1963), *The Mediaeval Architect*, 1972; D. Knoop & G. P. Jones, *The Mediaeval Mason*, Manchester 1933; W.A. Lethaby, *Westminster Abbey and the King's Craftsmen*, 1906, *Westminster Abbey Re-examined*, 1925; L.F. Salzman, *Building in England down to 1540, a Documentary History*, Oxford 1952 (corrected impression 1967); G. Webb, *Architecture in Britain: the Middle Ages*, Harmondsworth 1956 (2nd ed. 1965); R. Willis, *Architectural History of Some English Cathedrals* (papers delivered in 1842–63, reprinted in 2 vols., 1972); M. Wood, *The English Medieval House*, 1965; A Gardner, *A Handbook of English Mediaeval Sculpture*, Cambridge 1935 (2nd ed. 1951).

Chapter 4

M. Girouard, *Robert Smythson and the Architecture of the Elizabethan Era*, 1966; J.A. Gotch, *Architecture of*

the Renaissance in England, 1894, *Early Renaissance Architecture in England*, 1901 (2nd ed. 1914); J. Lees-Milne, *Tudor Renaissance*, 1951; E. Mercer, *English Art 1553–1625*, Oxford 1962; J. Shute, *The First and Chief Groundes of Architecture*, 1563 (L. Weaver, ed. 1912).

Chapter 5

GENERAL

H.M. Colvin, '50 New Churches', *Architectural Review*, March 1950; K. Downes, *English Baroque Architecture*, 1966; J. Harris, S. Orgel & R. Strong, *The King's Arcadia: Inigo Jones and the Stuart Court*, 1973; O. Hill & J. Cornforth, *English Country Houses, Caroline 1628–1685*, 1966; J. Lees-Milne, *English Country Houses, Baroque 1685–1715*, 1970; M. Whiffen, *Stuart and Georgian Churches outside London*, 1947–48; M.D. Whinney & O. Millar, *English Art 1625–1714*, Oxford 1957.

INDIVIDUAL ARCHITECTS

K. Downes, *Hawksmoor*, 1959 and 1969, *Christopher Wren*, 1971, *Vanbrugh*, 1977; B. Little, *The Life and Work of James Gibbs*, 1955; E. Sekler, *Wren and his Place in European Architecture*, 1956; J. Summerson, *Inigo Jones*, 1966; M. Whiffen, *Thomas Archer*, 1950; M.D. Whinney, 'William Talman', *Journal of the Warburg and Courtauld Institutes*, vol. xviii, 1955, *Wren*, 1971; L. Whistler, *Sir John Vanbrugh*, 1938, *The Imagination of Vanbrugh and his Fellow Artists*, 1954; *Wren Society*, 20 vols., 1924–43.

INDIVIDUAL BUILDINGS AND PLACES

D. Green, *Blenheim Palace*, 1951; J. Harris, 'Inigo Jones and the Prince's Lodging at Newmarket', *Architectural History*, vol. 2, 1959, 'The Hampton Court Trianon Designs of William and John Talman', *Journal of the Warburg and Courtauld Institutes*, vol. xxiii, 1960; S. Lang, 'By Hawksmoor out of Gibbs' (the Radcliffe Library), *Architectural Review*, April 1949; P. Palme, *Triumph of Peace, a Study of the Whitehall Banqueting House*, Stockholm 1957; J. Summerson, 'The Penultimate Design for St Paul's,' *Burlington Magazine*, March 1961; F. Thompson, *A History of Chatsworth*, 1949; M.D. Whinney, 'John Webb's Drawings for Whitehall Palace', *Walpole Society*, vol. xxxi, 1943.

CONTEMPORARY TEXTS

J. Gibbs, *A Book of Architecture*, 1728, *Rules for Drawing the Several Parts of Architecture*, 1732, *Bibliotheca Radcliviana*, 1747; R.T. Gunther, *The Architecture of Sir Roger Pratt . . . from his Note-books*, Oxford 1928; W. Kent, ed., *Designs of Inigo Jones*, 2 vols., 1727; G. Webb, ed., *The Complete Works of Sir John Vanbrugh*, vol. IV (the letters), 1928; C. & S. Wren, *Parentalia*, 1750 (reprinted 1965).

Chapter 6

GENERAL

Arts Council of Great Britain, *The Age of Neo-Classicism*, 1972; J. Burke, *English Art 1714–1800*, Oxford 1976; J.M. Crook, *The Greek Revival*, 1972; J. Fowler & J. Cornforth, *English Decoration in the 18th Century*, 1974; C. Hussey, *The Picturesque*, 1927 (new impression 1967), *English Country Houses, Early, Mid* and *Late Georgian*, 3 vols., 1955–58, *English Gardens and Landscapes, 1700–50*, 1967; J. Lees-Milne, *Earls of Creation*, 1962; D. Pilcher, *The Regency Style*, 1947; A.E. Richardson, *Monumental Classic Architecture in Great Britain and Ireland during the 18th & 19th Centuries*, 1914; J. Summerson, *Architecture in Britain, 1530–1830*, Harmondsworth 1953 (5th ed. 1969); R. Wittkower, *Palladio and English Palladianism*, 1974.

INDIVIDUAL ARCHITECTS

A.T. Bolton, *The Architecture of Robert and James Adam*, 2 vols., 1922, *The Works of Sir John Soane, R.A.*. 1924; H.M. Colvin, 'A Scottish Origin for English Palladianism?' (James Smith), *Architectural History*, vol. 17, 1974; A. Dale, *James Wyatt*, Oxford 1936 (2nd ed. 1956); T. Davis, *The Architecture of John Nash*, 1960, *John Nash, the Prince Regent's Architect*, 1966; J. Fleming, *Robert Adam and his Circle*, 1962; T. Hamlin, *B.H. Latrobe*, Oxford & New York 1955; J. Harris, *Sir William Chambers*, 1970; M. Jourdain, *The Work of William Kent*, 1948; L. Lawrence, 'Stuart and Revett', *Journal of the Warburg Institute*, vol. ii, 1938–39; D. Linstrum, *Sir Jeffry Wyatville*, Oxford 1972; E. Malins, *The Red Books of Humphry Repton*, 1976; D. Stillman, *The Decorative Work of Robert Adam*, 1966; D. Stroud, *Capability Brown*, 1950 (3rd ed. 1975), *The Architecture of Sir John Soane*, 1961, *Humphry Repton*, 1962, *Henry Holland*, 1966, *George Dance, Architect, 1741–1825*, 1971; H. Stutchbury, *The Architecture of Colen Campbell*, Manchester 1967; J. Summerson, *John Nash*, 1935 (2nd ed. 1949), *Sir John Soane*, 1952; R. Turnor, *James Wyatt*, 1950; D.J. Watkin, *Thomas Hope (1769–1831) and the Neo-Classical Idea*, 1968, *The Life and Work of C.R. Cockerell, R.A., 1974;* K. Woodbridge, 'William Kent as a Landscape Gardener', *Apollo*, August and October 1974.

INDIVIDUAL BUILDINGS AND PLACES

J.M. Crook, *The British Museum*, 1972; M. Gibbon, 'Stowe, Buckinghamshire, the House and Garden Buildings and their Designers: a Catalogue', *Architectural History*, vol. 20, 1977; J. Harris, G. de Bellaigue & O. Millar, *Buckingham Palace*, 1968; H. Hobhouse, *A History of Regent Street*, 1975; W. Ison, *The Georgian Buildings of Bath*, 1948, *The Georgian Buildings of Bristol*, 1952; H.D. Roberts, *The Royal Pavilion, Brighton*, 1939; H.C. Smith, *Buckingham Palace*, 1931; D. Stillman, 'The Gallery of Lansdowne

House', *Art Bulletin*, vol. 52, 1970; J. Summerson, *Georgian London*, 1945 (rev. ed. 1970), 'The Beginning of Regent's Park', *Architectural History*, vol. 20, 1977; D.J. Watkin, *The Triumph of the Classical*, *Cambridge Architecture 1804–34*, Cambridge 1977; M. Whinney, *Home House*, 1969; L. Wilkes & G. Dodds, *Tyneside Classical, the Newcastle of Grainger, Dobson and Clayton*, 1964; K. Woodbridge, *Landscape and Antiquity, Aspects of English Culture at Stourhead, 1718–1838*, Oxford 1970; A.J. Youngson, *The Making of Classical Edinburgh*, Edinburgh 1966.

CONTEMPORARY TEXTS

R. Adam, *Ruins of the Palace of the Emperor Diocletian at Spalato*, 1764, *Works in Architecture of Robert and James Adam*, 3 vols., 1773–1822; C. Campbell, *Vitruvius Britannicus*, 3 vols., 1715–25, *The Five Orders of Architecture*, 1729; W. Chambers, *Designs of Chinese Buildings, 1757, Treatise on Civil Architecture*, 1759, *Plans . . . Views of the Gardens and Buildings at Kew*, 1763; R.P. Knight, *The Landscape, a Didactic Poem*, 1794, *An Analytical Inquiry into the Principles of Taste*, 1805; G. Leoni, *The Architecture of A. Palladio*, 1715–20, *The Architecture of L. B. Alberti*, 3 vols., 1726; J. Paine, *Plans, Elevations and Sections of Noblemen and Gentlemen's Houses*, 2 vols., 1767–83; U. Price, *Essay on the Picturesque*, 1794; H. Repton, *Sketches and Hints on Landscape Gardening*, 1795; J. Soane, *Plans, Elevations and Sections of Buildings erected in . . . Norfolk, Suffolk, etc.*, 1788, *Sketches in Architecture*, 1793, *Designs for Public and Private Buildings*, 1828, *Description of the House and Museum on the North Side of Lincoln's Inn Fields*, 1832 & 1835–36; J. Stuart & N. Revett, *The Antiquities of Athens*, 3 vols., 1762–95; R. Wood, *The Ruins of Palmyra*, 1753, *The Ruins of Balbec*, 1757.

Chapter 7

GENERAL

W. Ames, *Prince Albert and Victorian Taste*, 1967; P.F. Anson, *Fashions in Church Furnishings, 1840–1940*, 1960 (rev. ed. 1965); T.S.R. Boase, *English Art 1800–70*, Oxford 1959; K. Clark, *The Gothic Revival*, 1st ed. 1928; B.F.L. Clarke, *Church Builders of the 19th century*, 1938 (reprinted 1969); R. Dixon & S. Muthesius, *Victorian Architecture*, 1978; S. Durant, *Victorian Design*, 1972; H.J. Dyos & M. Wolff, eds., *The Victorian City, Image and Reality*, 2 vols., 1973; J. Fawcett, ed., *Seven Victorian Architects* (Burn, Hardwick, S. Smirke, Pearson, Bodley, Waterhouse, Lutyens), 1976; P. Ferriday, ed., *Victorian Architecture*, 1963; P. Frankl, *The Gothic, Literary Interpretations and Sources through Eight Centuries*, Princeton 1960; G. Germann, *Gothic Revival in Europe and Britain*, 1972; M. Girouard, *The Victorian Country House*, Oxford 1971, *Sweetness and Light, the 'Queen Anne' Move-*

ment, 1860–1900, Oxford 1977; H.S. Goodhart-Rendel, *English Architecture since the Regency*, 1953; G. Hersey, *High Victorian Gothic, a Study in Associationism*, Baltimore 1972; H.-R. Hitchcock, *Early Victorian Architecture in Britain*, 2 vols., New Haven & London 1954 (reprinted 1972), *Architecture, 19th and 20th centuries*, Harmondsworth 1958 (rev. ed. 1968); S. Jervis, *High Victorian Design*, Ottawa 1974; J.R. Kellett, *The Impact of Railways on Victorian Cities*, 1969; J. Macaulay, *The Gothic Revival, 1745–1845*, Glasgow & London 1975; S. Muthesius, 'The "iron problem" in the 1850s', *Architectural History*, vol. 13, 1970, *The High Victorian Movement in Architecture*, 1971; N. Pevsner, *Some Architectural Writers of the 19th century*, Oxford 1972; M.H. Port, *600 New Churches, a Study of the Church Building Commission, 1818–56*, 1961; J. Steegman, *Consort of Taste, 1830–70*, 1950; J. Summerson, *Victorian Architecture, Four Studies in Evaluation*, New York & London 1970; Victoria & Albert Museum catalogues: *Marble Halls, Drawings and Models for Victorian Secular Buildings*, 1973, *Victorian Church Art*, 1971; D.J. Watkin, *Morality and Architecture, the Development of a Theme from the Gothic Revival to the Modern Movement*, Oxford 1977; J.F. White, *The Cambridge Movement: the Ecclesiologists and the Gothic Revival*, Cambridge 1962.

INDIVIDUAL ARCHITECTS

W. De l'Hôpital, *Westminster Cathedral and its Architect* (Bentley), 2 vols., 1919; H. Hobhouse, *Thomas Cubitt – Master Builder*, 1971; T. Howarth, *Charles Rennie Mackintosh and the Modern Movement*, 1952 (2nd ed. 1977); W.R. Lethaby, *Philip Webb and his Work*, Oxford 1935; A. Saint, *Richard Norman Shaw*, New Haven & London 1976; P. Stanton, *Pugin*, 1971; M. Trappes-Lomax, *Pugin, a Mediaeval Victorian*, 1932; P. Thompson, *The Work of William Morris*, 1968, *William Butterfield*, 1971.

INDIVIDUAL BUILDINGS AND PLACES

H.J. Dyos, *Victorian Suburb* (Camberwell), Leicester 1961; P. Ferriday, 'The Oxford Museum', *Architectural Review*, vol. 132, 1962, pp. 408–16, 'Syllabus in Stone' (the Albert Memorial), *Architectural Review*, vol. 135, 1964, pp. 422–28; A. Gomme & D. Walker, *Architecture of Glasgow*, 1968; C. Hussey, 'Dorchester House', RIBA *Journal*, vol. xxxv, 1928, pp. 623, 667; D.J. Olsen, *The Growth of Victorian London*, 1976; M.H. Port, 'The new Law Courts competition, 1866–67', *Architectural History*, vol. 11, 1968; M.H. Port, ed., *The Houses of Parliament*, New Haven & London 1976; C. Stewart, *The Stones of Manchester*, 1956; J. Summerson, *The London Building World of the 1860s*, 1973, *The Architecture of Victorian London*, Charlottesville 1976.

CONTEMPORARY TEXTS

A. Barry, *The Life and Works of Sir C. Barry*, 1867;

Bibliography

C.L. Eastlake, *Hints on Household Taste*, 1868 (reprinted 1970), *A History of the Gothic Revival in England*, 1872 (reprinted 1970); B. Ferrey, *Recollections of A.N. Welby Pugin*, 1861 (reprinted 1972 & 1978); O. Jones, *The Grammar of Ornament*, 1856; R. Kerr, *The Gentleman's House*, 1864; W.H. Leeds, *The Travellers' Club House . . . and the Revival of the Italian Style*, 1839; J.C. Loudon, *An Encyclopaedia of Cottage, Farm and Villa Architecture*, 1833; A.W.N. Pugin, *Contrasts*, 1836 (rev. ed. 1841, reprinted Leicester 1969), *The True Principles of Pointed or Christian Architecture*, 1841 (reprinted Oxford 1969), *The Present State of Ecclesiastical Architecture in England*, 1843 (reprinted Oxford 1969), *An Apology for the Revival of Christian Architecture in England*, 1843; T. Rickman, *An Attempt to Discriminate the Styles of English Architecture*, 1819; E.R. Robson, *School Architecture*, 1874; J. Ruskin, *The Seven Lamps of Architecture*, 1849, *The Stones of Venice*, 1851–53, and see K.O. Garrigan, *Ruskin on Architecture*, Wisconsin 1973, and J. Unrau, *Looking at Architecture with Ruskin*, 1978; G.G. Scott, *Remarks on Secular and Domestic Architecture*, 1857, *Personal and Professional Recollections*, 1879, and see G. Stamp, 'Sir Gilbert Scott's Recollections', *Architectural History*, vol. 19, 1976; R.N. Shaw, *Architectural Sketches from the Continent*, 1858; R.N. Shaw & T.G. Jackson, eds., *Architecture, a Profession or an Art?*, 1892; H.H. Statham, *Modern Architecture*, 1892; J.J. Stevenson, *House Architecture*, 2 vols., 1880; A.E. Street, *Memoir of G.E. Street*, 1888; G.E. Street, *Brick and Marble in the Middle Ages, Notes of a Tour in the North of Italy*, 1855.

Chapter 8

GENERAL

R. Banham, *The New Brutalism*, 1966; N. Cooper, *The Opulent Eye. Late Victorian and Edwardian Taste in Interior Design*, 1976; T. Dannatt, *Modern Architecture in Britain* (with introduction by J. Summerson), 1959; G. Darley, *Villages of Vision*, 1975; V. Glasstone, *Victorian and Edwardian Theatres*, 1975; H.S. Goodhart-Rendel, *English Architecture since the Regency*, 1953; J. Gould, *Modern Houses in Britain, 1919–1939*, Society of Architectural Historians of Great Britain, Monograph no. 1, 1977; H.-R. Hitchcock, *Architecture, 19th and 20th centuries*, Harmondsworth 1958, 3rd. ed. 1968; A. Jackson, *The Politics of Architecture, a History of Modern Architecture in Britain*, 1970; M. Macartney, *Recent English Domestic Architecture*, 1908; R. Macleod, *Style and Society, Architectural Ideology in Britain 1835–1914*, 1971; C. Marriott, *Modern English Architecture*, 1924; H. Muthesius, *Die englische Baukunst der Gegenwart*, Leipzig 1900, *Das englische Haus*, 3 vols., Berlin 1904–05; C. Nicholson & C. Spooner, *Recent English Ecclesiastical Architecture* (n.d.); C.H. Reilly, *Representative British Architects of the Present Day*, 1931; A.S.D. Service, ed., *Edwardian Architecture and its Origins*, 1975; A.S.D. Service, *Edwardian Architecture*, 1978; D. Taylor & D. Bush, *The Golden Age of British Hotels*, 1974; L. Weaver & R. Randal Phillips, *Small Country Houses of Today*, 3 vols., 1922–25; M. Webb, *Architecture in Britain Today*, 1969.

INDIVIDUAL ARCHITECTS

H. Baker, *Architecture and Personalities*, 1944; A. Bennett, H. Lanchester & A. Fenn, *The Art of E.A. Rickards*, 1920; R. Blomfield, *Memoirs of an Architect*, 1932; A.S.G. Butler, *The Architecture of Sir Edwin Lutyens*, 3 vols., 1950; W.A. Coles, 'The Architecture of Raymond Erith, R.A.', *Classical America*, IV, Toronto 1977, pp. 125–52; D. Gebhard, *Charles F.A. Voysey, Architect*, Los Angeles 1975; W. Curtis Green, RIBA Drawings Collection Exhibition Catalogue 1978; *Ernest Gimson: his Life and Work*, Stratford-on-Avon 1924; C. Hussey, *Sir Robert Lorimer*, 1931, *The Life of Sir Edwin Lutyens*, 1950 and 1953; G. Jekyll & L. Weaver, *Gardens for Small Country Houses*, 1912; J.D. Kornwolf, *M.H. Baillie Scott and the Arts and Crafts Movement*, Baltimore 1972; D. Lasdun, *A Language and a Theme, the Architecture of Denys Lasdun & Partners*, 1976; W.G. Newton, *The Work of Ernest Newton, R.A.*, 1923; C.H. Reilly, *Scaffolding in the Sky*, 1938; M.H. Baillie Scott, *Houses and Gardens*, 1906; P. & A. Smithson, *Without Rhetoric, an Architectural Aesthetic 1955–1972*, 1973; J. Stirling, *Buildings and Projects, 1950–74*, 1975; P. Tilden, *True Remembrances*, 1954; L. Weaver, *Houses and Gardens by E.L. Lutyens*, 1913 (2nd. ed. 1931).

INDIVIDUAL BUILDINGS AND PLACES

C. Amery, ed., *The National Theatre*, 1977; M. Banham & B. Hillier, eds., *A Tonic to the Nation, The Festival of Britain 1951*, 1976; V.E. Cotton, *The Book of Liverpool Cathedral*, Liverpool 1964; G. Stamp, 'London 1900', special number of *Architectural Design*, vol. 48, 1978, 'How Hillingdon Happened', *Architectural Review*, February 1979.

Acknowledgments for Illustrations

References are to page numbers; t=top, b=bottom, l=left, r=right, m=middle

Photographs have been reproduced by courtesy of the following:

Her Majesty, Queen Elizabeth II 100t
Aerofilms Ltd 28
Architectural Press Ltd 193t & b, 196, 197t
John Bethell 120b
Brecht-Einzig Ltd 198
British Architectural Library 158, 174
Peter Burton 149m
Copyright *Country Life* 25b, 77r, 93b, 103t, 105m, 115t, 137t, 140t, 142, 177, 185, 186, 187, 189t & b.
Crown Copyright, reproduced with permission of the Controller of Her Majesty's Stationery Office 49b, 78tr, 84t, 91, 98r, 99t & b, 113t & b
Kerry Downes 117b, 123t
Financial Times 191t
Keith Gibson 115b
Birnie Philip Bequest, Hunterian Art Gallery, University of Glasgow 175t
Philip Gotlob 194
André Goulancourt 181
The Greater London Council Photograph Library 154, 162, 182
Martin Hürliman 13b, 17, 35, 45, 56t, 110t
A.F. Kersting 15tr & b, 19, 20t, 22b, 24, 27t, 29, 33b, 38, 39t & br, 42l & r, 47t, 54l, 59tl, 60tr & b, 63tr & b, 70, 73, 74t, 75r, 76t, 79t, 80bl, 87t, 88tl & tr, 90b, 93t, 95t, m & b, 101t, 102, 103b, 106, 107, 112bl & br, 114bl, 116t, 120t, 126b, 128t, 129, 130b, 134r, 135, 137b, 138, 140b, 143b, 148, 152b, 159b, 164b, 171b, 175b, 199t
Neville Kuypers, C.J. Studios, Cheshire 173b
Emily Lane 46r, 101b, 151b, 192
Leeds City Museum 139
Bedford Lemere 183
British Library, London 147
British Museum, London 125
Courtauld Institute of Art, University of London 15tl, 26b, 52b, 60tl, 66t, 68t, 71r, 109bl, 122b

Trustees of Sir John Soane's Museum, London 109br, 110b, 145t
Victoria and Albert Museum, London 132
John Maltby Ltd 197b
Manchester Public Library 163b
Eric de Maré 149t, 152t, 176, 195t
National Monuments Record, courtesy B.T. Batsford 9tl, 143t, 151t
National Monuments Record 9b, 10l & r, 14t, 20b, 21t, 21bl, 31tl, 33tl, 36b & t, 37, 39bl, 41, 43, 44t, 48, 51, 55t, 56b, 57b, 59tr & b, 63tl, 72, 76b, 79b, 80t, 81b, 84b, 85, 86tl & tr, 87m, 89, 90t, 92t & b, 94t & b, 100b, 105t, 112t, 114t & br, 117t, 118, 121, 122t, 123b, 127, 141l, 144, 149b, 150, 153, 155, 157t, 163t, 165b & t, 166l & r, 167b & t, 169, 171t, 172t & b, 173t, 184, 188, 190
Sydney W. Newbery 178
Edwin Smith frontispiece, 9tr, 11l & r, 12, 13tr, 14b, 16, 21br, 22t, 23, 25t, 26t, 31tr & tl, 32t, 33tr, 46l, 49t, 52t, 53, 54r, 55b, 61, 64, 66b, 71l, 74b, 75l, 77l, 78b, 83, 86br, 109t, 119tl & tr, 130t, 131, 133b & t, 134l, 145b, 146t & b, 159t, 160, 161t, 164t, 168l & r, 170, 179, 195b
The Times 111t
Eileen Tweedy 105b
Universal Pictorial Press and Agency Ltd 191b
Colin Westwood 182
© Colin St John Wilson and Partners (photo David Gibson) 199b
Shepherd Building Group Ltd, York 32b, 67, 68b, 69

A. Barry, *The Life and Works of Sir C. Barry*, 1867 161b
F. Mackenzie, *The Architectural Antiquities of the Collegiate Chapel of St Stephen*, 1844 65
W.H. Pyne, *History of the Royal Residences of Windsor, St James's Palace and Kensington Palace etc.*, 1819 104, 141l
L. Weaver, *The Houses and Gardens of Edwin Lutyens*, 1913 185b
R. Willis, *The Architectural History of the University of Cambridge*, 1886 80

Index

Scott, Sir George Gilbert 75, 158, 164, 167–69, 171, 191–92, 198; *164, 169, 172*

Scott, George Gilbert, junior 171–72, 175; *172*

Scott, Sir Giles Gilbert 172; *173*

Scott, Lt.-Col. H.Y.D. 164

Scott, M.H.Baillie 190

Seale, Gilbert 182

Seaton Delaval, Northumberland 117, 118; *117*

Second World War 172–73, 189, 192

Séez Cathedral 65, 68

Selby Abbey, North Yorks. 53, 68

Selsley, Glos., church 165

Sens Cathedral 32, 34, 50

Serlio, Sebastiano 86–87, 94, 96, 106

Seton Castle, Lothian 138

Sharington, Sir William 85

Shaw, Richard Norman 156, 170, 172–76, 178, 185–86; *174, 176*

Sheffield Place, East Sussex 139

Sherborne Abbey, Dorset 11, 71; *71*

Shireburn, Sir Richard 86

Shrewsbury, St Chad 140; *141*

Shrewsbury, 16th Earl of 159

Shrewsbury, Elizabeth, Countess of 88–89, 93

Shute, John 85–86

Sicily 12

Simeon, Abbot of Ely 13

Skelton, near York, church 45

Sledmere House, Humberside 138; *138*

Sleter, Francesco 120

Smirke, Sir Robert 150

Smithson, Peter and Alison 195–96; *196*

Smythson, John 93–95; *94–95*

Smythson, Robert 87–89, 93; *87–89*

Soane, Sir John 142–45, 149, 151; *144, 145*

Society for the Protection of Ancient Buildings 169

Society of Dilettanti 131

Somerset, Duke of, Lord Protector 85

Sompting, West Sussex, church 11–12; *12*

Sonning, Berks., Deanery Garden 186

Soufflot, J.-G. 132, 133

South Wingfield Manor, Derbys. 79

Southampton, National Provincial Bank 163

Southill Park, Beds. 140–42

Southwell Minster, Notts. 28, 40, 41, 55; *55*

Spalato, Yugoslavia, Diocletian's Palace 131, 134

Spence, Sir Basil 195–96; *195, 197*

Spenser, Edmund 93

Standen, West Sussex 177–78; *177*

Stapleford Park, Leics. 95; *95*

steel construction 154, 165, 176, 180, 182, 184, 188, 196

Stephen, King of England 18

Steuart, George 140; *140–41*

Stevens, Alfred 163; *163*

Stevenson, J.J. 175

Stirling, James 196; *198*

Stockport (Greater Manchester), Town Hall 180

Stoke Bruerne, Northants. 101; *101*

Stokes, Leonard 172, 178

Stone, Kent, church 52

Stone, Marcus 175

Stonyhurst, Lancs. 86; *86*

Stourhead, Wilts. 124

Stow, Lincs., church 11

Stowe, Bucks. 129; *130*

Strawberry Hill, Twickenham (London) 156

Street, G.E. 157, 159, 165–68, 170, 173, 177; *166, 168*

Stuart, James 129, 131, 149

Suffolk, 1st Earl of 91

Summerson, Sir John 87, 94

Sussex, University of 196; *197*

Sutherland, 2nd Duke of 162

Sutherland, Graham 195

Sutton Place, Surrey 84–85

Swakeleys, London 95

Sykes, Sir Christopher, 2nd Bart. 138

Sykes, Godfrey 164

Syon House, Brentford (London) 135; *134*

Talman, William 113–15, 116, 117, 120, 127; *114*

Tapper, Sir Walter 190

Tattershall Castle, Lincs. 78; *78*

Tatton Park, Cheshire 140

Taunton, Somerset, church 75; *75*

Taylor, Sir Robert 130

Taylor, Warrington 177

Temple, J.W. 173

Teulon, S.S. 165; *165*

Tewkesbury Abbey, Glos. 16, 20, 46, 58; *16*

Thiepval, France, Memorial Arch 189

Thomas, A. Brumwell 180

Thomas, Walter 184

Thomas à Becket, St 34

Thomson, Alexander 153, 162

Thornhill, Sir James 113, 120–21; *120*

Thornton Abbey, Lincs. 54

Thornycroft, Hamo 182

Thynne, Sir John 85

Tigbourne Court, Surrey 186

Tijou, Jean 113

Tivoli, Italy, Temple of Vesta 129, 135, 144

Todmorden, West Yorks., Town Hall 163

Torrigiano, Pietro 82, 84

Tours Cathedral 49, 65

Townsend, Harrison 178

Townshend, Sir Roger 95

tracery 48–57, 62, 64–70, 74

Trentham Hall, Staffs. 162

Tresham, Sir Thomas 90

Trier, Germany, basilica 16

Troyes, Cathedral 65

St Urbain 65, 68

Truro Cathedral 171; *172*

Tudor country houses 82–91

Tydd St Giles, Cambs., church 46

Tynemouth Priory, Tyne and Wear 33–34; *33*

Vanbrugh, Sir John 115–17, 118, 119, 120, 121, 129, 134, 138, 142, 145, 180; *115–17*

Vaughan, Cardinal 178

Vaux-le-Vicomte, France, château 113, 116

Vendôme, France, La Trinité 65

Venice 97

S. Giorgio Maggiore 129

Sta Maria della Salute 123

Verona, Italy 167

Verrio, Antonio 104, 113, 120

Versailles, France, château 112

Vertue, Robert and William 71

Vicenza, Italy 126

Palazzo Thiene 126–27

Villa Rotunda 126

Victoria, Queen of England 162

Vignola, Giacomo Barozzi da 101

Viollet-le-Duc, E.-E. 174

Vitruvius 108, 117, 124, 126, 127, 129, 135

Vitruvius Britannicus 123, 124, 126

Voysey, C.F.A. 178, 190

Vulliamy, Lewis 162–63; *163*

Vyne, The, Hants 104; *105*

Walkelin, Bishop of Winchester 12–13

Walpole, Horace 141, 156

Walter de Grey, Archbishop of York 41

Walters, Edward 163; *163*

Wanstead House, Essex 124; *125*

Ward, Basil 193

Warkworth Castle, Northumberland 77–78; *78*

Wars of the Roses 70–71